Today's methods of horse husbandry are in stark contrast to our existence, and that of our horses, before the arrival of modern development. In those harsh circumstances, both man and horse shared meagre rations in a precarious environment.

We must here acknowledge our appreciation of and loyalty to the companion and support of the Arabian horse, the camel, which has carried its food and water through the ages. Without it the *asil* breed would not have survived and thrived in desert conditions, for the horse may drink as much as eight times the amount of water needed by a camel.

Despite the hardships of the desert, we always took pains to ensure that our horses were fed before ourselves. Our lives, after all, might very well depend upon them. A bowl of *mereesy* (dried milk rubbed in water), a little water twice a day, once in the morning and then at nightfall, and fresh camel's milk and dates when available.

Undernourished from birth, enduring intense heat during the day and severe cold at night, only those horses with the strength and will to live survived. It is perhaps for this reason that the Arabian has such special powers of stamina and endurance.

The Arabian's evolution through selective in-breeding has been recorded through the centuries. This helps us today to trace the origins of the breed. Its history, mystery and magic are well recorded in this important book, which also celebrates its beauty through magnificent photography.

Fleet of foot, with perfect symmetry in body and motion, endowed with endurance and speed, fearless and vigorous yet docile and friendly, the Arabian is of august and ancient lineage, a player in history as the charger of men who have changed the world, as far apart as Saladin and George Washington. It is deserving of all the accolades which have been heaped upon it.

Proud, independent and generous like its desert master, as sturdy and adventurous as the spirit of the land, the Arabian horse can truly conquer the imagination. As we enter a new millennium, it warms my heart to see the progeny of the mythical horse of Baz spread across the globe and to witness the ever-increasing interest shown internationally in this superb animal whose beauty and spirit can once again be seen to grace its homeland.

September 1998

*To create the Arab horse, God spoke to the south wind: 'I will create from you
a being which will be a happiness to the good and a misfortune to the bad. Happiness
shall be on its forehead, bounty on its back and joy in the possessor.'*

(EARLY ARAB SAYING)

DRINKERS OF THE WIND

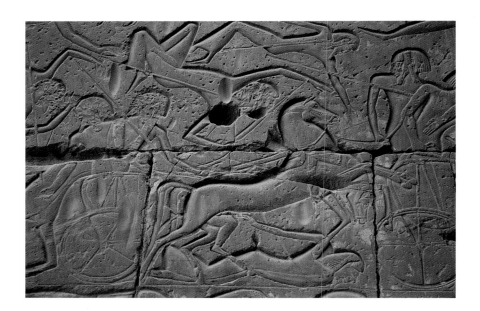

The horse has always held an important place in myth and legend. Astarte, the Babylonian goddess of love and war, is often portrayed riding a horse as a symbol of fertility. Demeter, the Greek goddess of the earth, changed into a mare to escape from Poseidon, god of the sea, who had fallen in love with her; Poseidon changed into a stallion in order to possess her. Pegasus, the fabled winged horse said to have sprung from the blood of the severed head of Medusa, was a source of inspiration to the Muses, and is probably ultimately related to the fabled winged horses of paradise described by the 14th-century Arab writer al-Damiri.

Material evidence for the ancestors of the Arab horse comes from both archaeological and written sources. At an ancient fort in the Sinai peninsula beside Horus's Road, the route to Syria, a horse skeleton has been unearthed by archaeologists. Dated to *c.* 1700 BC, this skeleton is the earliest physical evidence for the horse in Egypt: it appears to have the wedge-shaped head, straight under-jaw, large eye socket and small muzzle that are characteristic of the Arab horse. The horse may have belonged to the Hyksos, who many historians believe brought it to Egypt, for after their invasion, horses of Arab type feature prominently in Egyptian tomb paintings and inscriptions. Such depictions have been found in the tombs of the Pharaoh Akhenaten (*c.* 1365–1347 BC) and Horemheb (*c.* 1332–1305 BC).

ABOVE: Relief decoration on the mortuary temple of Ramses III at Medinet Habu, Egypt. The high tail-carriage and head of the horse show the Arab type as early as the 12th century BC. OPPOSITE: Studio of John Frederick Herring, Pharaoh's Horses, *1854.*

THE
ARABIAN HORSE

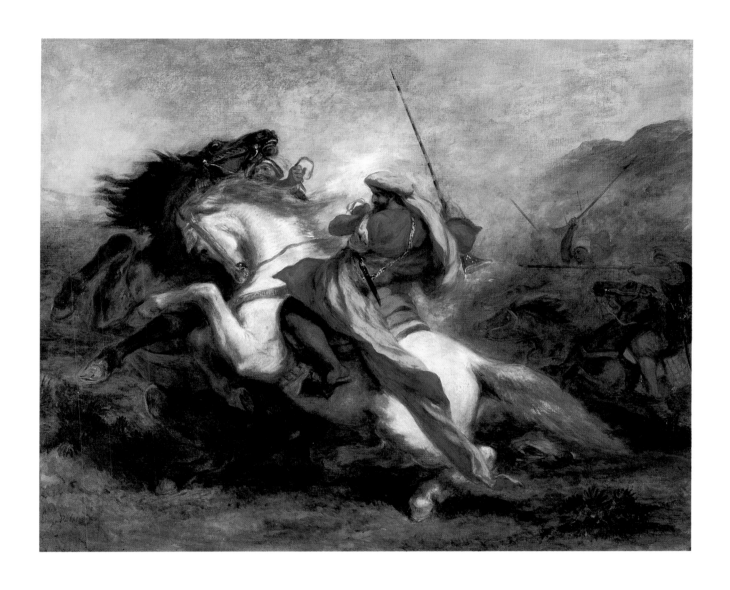

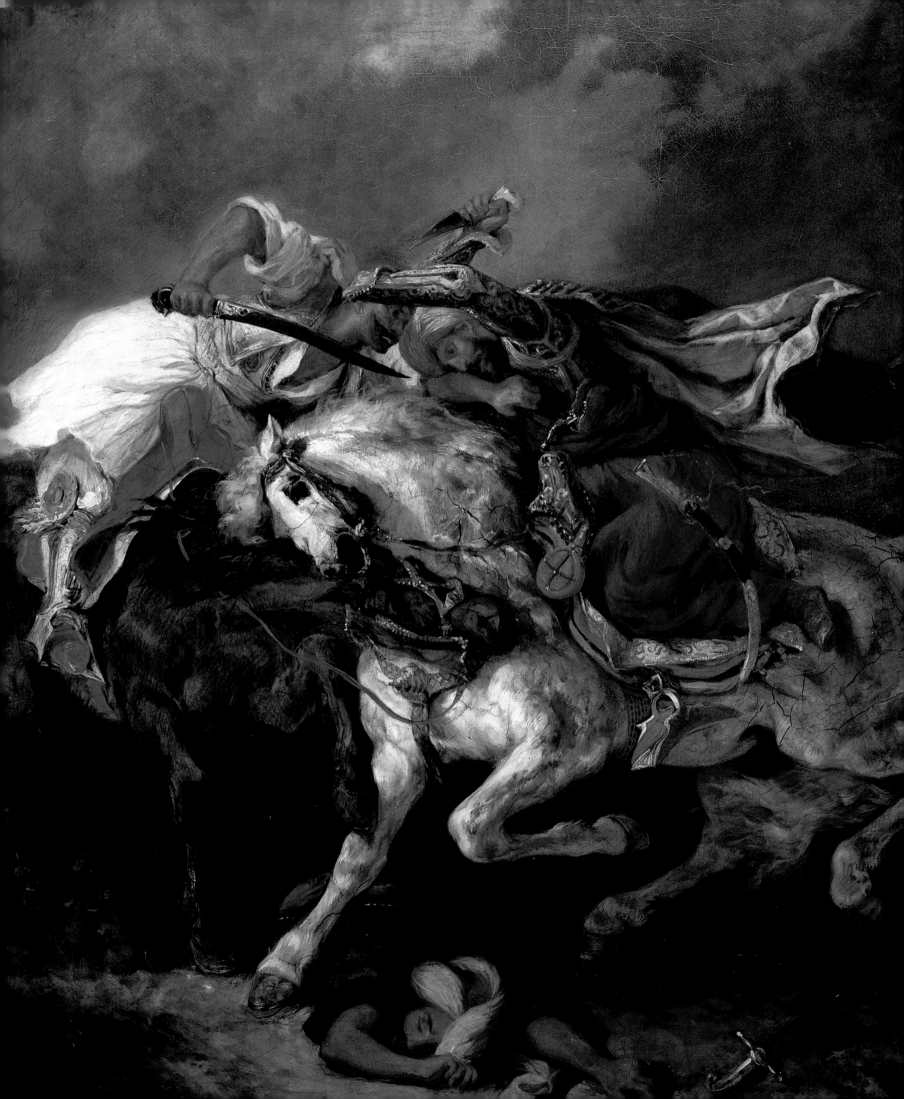

THE ARABIAN HORSE

History, Mystery and Magic

Introduction by H.H. Sheikh Zayed bin-Sultan al-Nahyan
Edited by Hossein Amirsadeghi
With photographs by Rik van Lent, Sr & Jr
Text and captions by Peter Upton and Hossein Amirsadeghi

Thames & Hudson

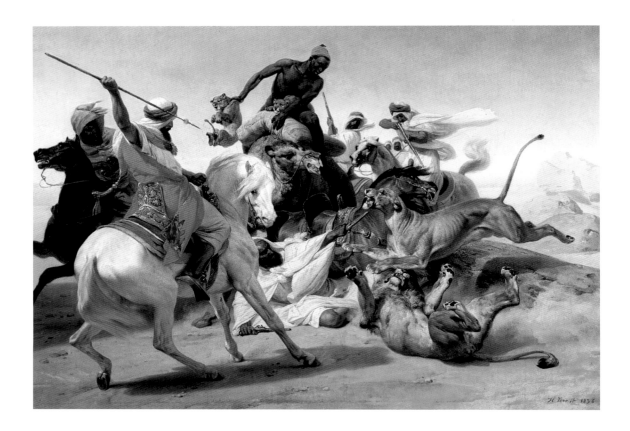

ON THE HALF-TITLE: *Eugène Delacroix,* Collision of Arab Horsemen, *c. 1843–1846.*
FRONTISPIECE: *Eugène Delacroix,* Combat of the Giaour and the Pasha, *1835.*
ABOVE: *Horace Vernet,* The Lion Hunt, *1836.*

Designed by Isobel Gillan

In transliterating Arabic personal names, the publishers have adopted the system
recommended by the University of Chicago Press *Manual of Style*. The names of horses are given
in the form in which they are registered.

First published in the United Kingdom in 1998 by Thames & Hudson Ltd,
181A High Holborn, London WC1V 7QX
www.thamesandhudson.com

© 1998 Hossein Amirsadeghi
First paperback edition 2005

British Library Cataloguing-in-Publication Data
A catalogue record for this book is available from the British Library
ISBN 13: 978-0-500-28562-6
ISBN 10: 0-500-28562-4

Printed and bound in Singapore by C.S. Graphics

CONTENTS

FOREWORD

I learnt to ride on a black Arabian stallion whose feisty nature I will not easily forget; I can still feel the wind in my face, and the fear, hanging on for dear life, yet relishing the power of that horse on the stony, desert plain.

Years have passed, and lives come and gone, yet the memory of the horse lingered. And when, by chance, I came across a project that inspired another, I determined that this magnificent animal deserved to have a special book in praise of his beauty and magic.

And by the grace of God, I've managed to produce such a book. Not just through my own efforts, but also through the love and dedication to the pure-bred Arab of people who have helped along the way.

I'd never imagined that so many the world over had made the Arab horse their life's work, and were so willing to help. That much commitment in itself posed a dilemma: what kind of a book did I want to create to satisfy interested laymen like myself and still hold the interest of the initiate and the expert – yet not to fall foul of the many divergent schools of thought and interest within the global horse-breeding fraternity?

Choosing to walk a tightrope, I've opted to present a visual feast by catering to those who love horses, period. While providing more than a general sweep of technical background and area coverage, we've peppered the text with a human touch, animating the story with sense and emotion distilled from the commotion of history. For this my thanks to Peter Upton and the editorial team, including Dr Joseph Spooner; Peter's proven a real long-distance endurance partner.

The magnificent photography belongs mostly to Rik van Lent, Sr and Jr, father and son, who have dedicated their life to capturing the magic of the Arabian horse, my imagination running away with their origination, and I've been lucky to find a group of worthy photographers to supplement their work, such as Pat Slater, Teresa Zoltowska, Christine Osborne, Pat Aithie, Zofia Raczkowska and Luiz Rocco.

There are others who have travelled this road with me, enduring the fitful stops and starts. And I've met with faith and friendship along the way, carrying me through the days when nights fell early. Many will want to remain nameless, but let honour be done where honour is due.

My foremost gratitude is to His Highness Sheikh Zayed bin-Sultan al-Nahyan for sharing his love and knowledge of the Arabian horse with the readers of this book. And to his son Sheikh Mansour, a true devotee of the *asil* horse, whose dedication to the propagation of the breed has encouraged my endeavours. And to another true prince, Sheikh Abdullah bin-Zayed al-Nahyan, whose foresight and imagination have these past several years set my sights higher for the reaches of excellence.

H.H. Sheikh Mohammed bin-Rashid al-Maktoum has been a source of expertise, and inspirational in his devotion; as was Sheikh Tahnoon bin-Zayed al-Nahyan at the start of my journey.

A host of leading lights in the realm of the Arabian pure-bred, both in the Middle East and in the rest of the world, have supported my endeavour. Princess Alia al-Hussein made me promise at the start to keep faith with a difficult task, while others like Ronald Ferrier, Deirdre Hyde, Pat Slater, Judith Forbis, Rosemary Archer, Dr Hans Nagel, Kees Mol, Jane Kadri, Birgitta Foch, Luiz Rocco, Yves Richardier, Mary Qaraqozlou, Sami al-Nohait, Peggy Arthurs, Johann Theron, Celina Pavlosky, Amid Abdelhamid, Wilfred Brinkhuis, Jenny Lees, Dr Pesi Gazder and many more have helped along the narrow straits.

My special thanks to Ibrahim al-Abed, Colonel E. B. Wilson, Sultan al-Marzouqi … I'll stop here and let the work speak for itself.

Hossein Amirsadeghi, London, August 1998

INTRODUCTION

His Highness Sheikh Zayed bin-Sultan al-Nahyan

[1918–2004]

Founder and President of the United Arab Emirates

In The Name of God, The Merciful, The Compassionate

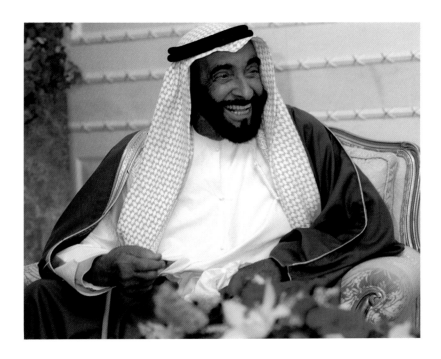

Among my earliest childhood memories are the beautiful Arabian horses owned by my father, Sheikh Sultan bin-Zayed al-Nahyan, Ruler of Abu Dhabi from 1922 to 1926. In the family we had up to 180 horses in Abu Dhabi and in our summer home of Al Ain.

I have been able to ride as long as I can remember. My elder brothers used to joke that 'Zayed could ride before he could even walk.' In the years since, my love of the Arabian horse has continued to grow.

Riding and hunting have been my twin passions in life, ever since, at the age of eight, I went on my first hunting expedition or *ganas*. I had just learnt how to train falcons to pursue the *houbara* bustard and how to shoot a rifle.

Our ancestors have been horsemen from time immemorial. As is shown by recent discoveries of 2,000-year-old horse burials at Mileiha, each animal carefully equipped with its bridle and bejewelled trappings, the horse has long been given an honoured place in our culture.

My grandfather, Sheikh Zayed bin-Khalifa, who became known as 'Zayed the Great', was a fearless horseman and a great warrior who has been a source of inspiration to me throughout my life. He was tall and powerful, and a fine horseman, sometimes riding out to battle on a favourite steed. Indeed, in one such conflict in 1868, his charger was shot under him in man-to-man combat.

I have inherited his love of the horse, a love rooted deeply in the history of our people. It has become part of my belief in the essential goodness of nature and of man. Such beliefs, emanating from the religious faith in Islam, have sustained Arabs throughout history. The Arab horse, the *asil* breed of the desert, noble harbinger of strength, beauty, courage and fidelity, has always been a part of this history.

It was the Prophet himself, may peace be upon him, who proclaimed: 'Bounty and happiness are on the back of the horse, they throw gold which people may hold.' And it was he who said: 'He who keeps a mare for the sake of God deserves his mercy and generosity.'

The horse has always meant more than just a means of transport to us. It has been a treasured possession in war and peace, a measure of wealth, and finally a source of pride and joy. The Arabian horse has, indeed, been a partner to our people, a beloved companion, a giver of strength in times of need, whether in battle, in the hunt or for the values it has personified – values shared with the true desert Bedu: those of chivalry, generosity, mercy, strength, endurance and self-reliance.

As children we learnt to love the horse, the foal becoming part of the family in the care that each member took in its rearing. And the horse in turn learnt to become a partner to man, enduring physical hardship and facing any danger for its master – a permanent presence around the tent and camp fire, often sharing the place of sleep. So close did the relationship become that the Arab horse developed an uncanny, almost human, intelligence.

The precarious and fluctuating existence of the Arabian desert has not only created the *asil* pure-bred Arab horse, but has moulded its owner-companion; both have had to develop hardiness and grace under the most trying of nature's conditions.

Living in the desert defines the man as one who has shifted his own rocks in life, caught his own game, planted for himself, hunted and squeezed his own trigger. A man steadfast in his spirituality and belief in simplicity; one who turns for guidance to his faith. For God alone has power and there is no power apart from Him.

With the onset of development, I feared for the disappearance from the Middle East of the true desert Arabian. Over the past thirty years, therefore, I have taken pains to collect horses of the best bloodlines from all over the world; horses of great beauty, of speed and of endurance. These are now being bred in Abu Dhabi and in the desert to stimulate a revival of interest within the region in the *asil* Arabian and in its survival for future generations. I, and others, can now say with some satisfaction that there has been a renaissance in the fortunes of the *asil* breed throughout the Arabian Peninsula and the rest of the world.

My young horses are brought up in freedom in the desert, where they roam at will and adapt to their natural surroundings. Camel's milk and dates are an essential part of their daily rations, as they were for the horses of my youth. Like those horses, my youngsters must grow to be brave, tough and strong. As one of our leading poets puts it:

> *Good horses are few, like good friends,*
> *Though they appear many to the inexperienced eye.*

We Arabs have a natural empathy with our horses. This has helped me both as a horseman and as a breeder to look for the best attributes of the *asil* horse: a long arched neck and a deep body culminating in powerful quarters. The head should have short ears, a broad forehead, wide between large eyes, large flexible nostrils and deep jaws. The hocks should be set well down, giving the horse power and ability to manoeuvre. These are the characteristics for which I seek in my breeding stock.

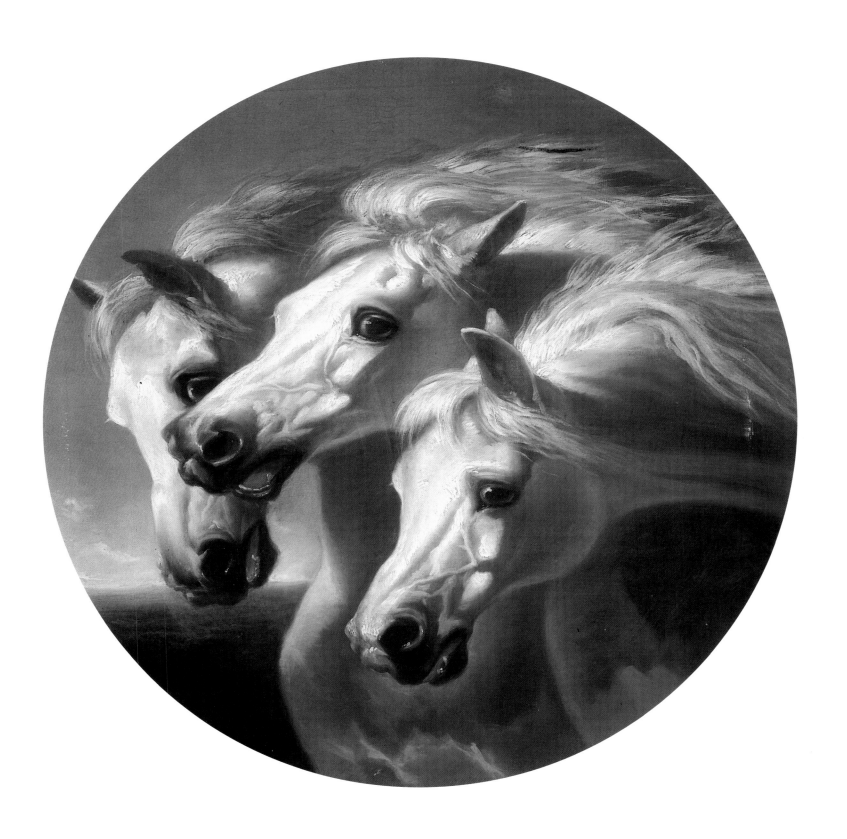

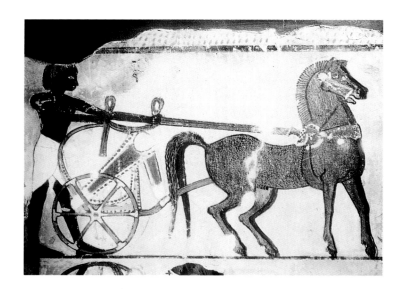 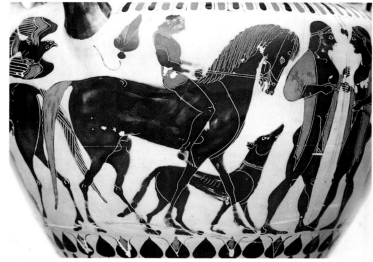

ABOVE LEFT: Fragment of a wall painting from Thebes, dating from the 18th century BC, showing a charioteer restraining a pair of spirited horses. The Egyptians took many horses in war from the Syrians. ABOVE RIGHT: Athenian vase (c. 500 BC), depicting an Arab-type horse. It comes from Chalcedon in Asia Minor (an ancient city in Bithynia, south of Scutari).

One of the earliest written records of the horse appears on a Babylonian tablet dating to *c.* 1750 BC; and further Assyrian inscriptions describe how King Sargon drove herds of horses from Arabia into Syria and received gifts from King Hamar of Sabaa (Yemen). Hamar was a celebrated horseman and the ancestor of Balkis, whom the Arabs consider to be the Queen of Sheba. When the Queen of Sheba paid a state visit to King Solomon, among the many gifts she brought to present to him was an Arab mare named Safanad ('the pure one'). Solomon was one of the earliest known collectors of Arab horses, and the Bible notes that he owned some twelve thousand, imported mostly from Egypt and from Kue (probably Cilicia in southern Turkey); one horse imported from Egypt cost the King 150 silver shekels. Solomon also gave gifts of horses to the kings of the Hittites and the Arameans in Syria.

The early history of the Arab horse may also be traced among the legends and traditions of the Bedouin people, the pastoral nomads who moved with their horses and camels, goats and sheep across the Arabian Peninsula. The Bedouin depended on the camel as a beast of burden, mount and milk-provider. They lived in tents (*beyt es-shaar*) woven of hair from their flocks and traditionally described as black, and their horses lived intimately with them, carrying them in swift skirmishes with other Bedouin tribes.

Many stories of the Arab horse were recorded in the time of Harun al-Rashid (*c.* AD 786) by el-Kelbi. Tales of the Prophet Mohammed concerning the creation of the Arab horse support the belief that it was born of the south wind, and that the first horses came from Hoshabeh, now Yemen. Hoshabeh was the home of Baz ibn-Umaym, who lived *c.* 3200 BC, and counted among his cousins the ancestors of the Arab tribes. Baz was a descendant of Shem, the son of Noah, and owned a mare which he mated to a colt out of her; this in time produced a colt named Fayad and a filly named Qasameh.

Joktan (Qahtan) was the first king of Yemen, and Ibrahim (Abraham) a descendant of Joktan's brother, Peleg. With his son Ishmael, Ibrahim was granted the site of Mecca for a place of worship. Abulfeda, an early recorder of Bedouin and Arab legend and history, relates how Ibrahim set out from Syria with Ishmael and Hagar, Ishmael's mother, and went with them to Mecca; Ibrahim then returned to his own country. Ishmael married the daughter of Modad, the last leader of the Jorhamites, a tribe descended from Qahtan and, according to the writings of al-Naseri, he (Ishmael) was the first to mount a horse. His descendant Salaman is recorded as the owner of five kehilets (pure-bred Arab mares), which may be the source of the legend regarding *al-khamsa* ('the five [strains]'), a story which only gained currency in later writings of non-Bedouin inspiration.

Through the union of Ishmael and Modad, the families of Qahtan and Peleg were united. From Qahtan are descended the 'indigenous Arabs', the Muteyr, the Banu Hajar and the Ajman, and through the sons of Ishmael the line descends to Rabiah al-Faras, and Anazah, who lived at Khaibar and whose tribes spread throughout the Nejd. Rabiah al-Faras lived in the time of King David and was the 'owner of the horses of his ancestors', a title clearly demonstrating his family's long association with the horse. The tribes of Yemen, according to the Arab historian Masudi, migrated northward in AD 120, having been warned that the dam at Mareb would break. They took with them eighty thousand horses, and the Azd went to Hira (Iraq) and the Glassan to Syria. The flood that followed was to devastate their fertile lands. From Wail, the son of Anazah, who is known as 'the first ancestor', can be traced the Dhana Muslim, forefathers of the noble desert tribes known as the Roala and Wuld-Ali, and the Bishr, from whom the Amarat, Sebaa and Fedaan are descended.

Tradition also records the stories of individual horses. Qasameh, the filly produced by the mare belonging to Baz ibn-Umaym, produced a filly called Sawadeh ('the dark one'); Sawadeh in turn produced a filly, Sabal. Sabal belonged to the Banu Amr, who were descendants of Qahtan, and she was famous as the mother of two stallions, Awaj I and Awaj II. Awaj I was the most celebrated Arab sire of his time, despite being crippled. Al-Asmai (*c.* AD 800) relates in his book *Kitab al-Khayl* how Awaj I's back was damaged: as a new-born foal he had been placed in a saddle bag on a camel during days of forced marches, while his dam, a war-mare, was taking part in a raid against another tribe. The Arab poet al-Mutanabbi (AD 915–65) relates a slightly different version. Some raiders approached the stallion and his rider one dark night; the stallion, sensing danger, raced away and eluded the enemy, thereby saving his master. However, the horse's back was injured by these exertions, and the horse was known thereafter as Awaj, 'the ancient one'.

Awaj I belonged to the Banu Ghani, who trace their descent back to Qays ibn-Ailan, a nephew of Rabiah al-Faras. Stallions by Awaj I include Thul Sufa and Thul Akal (who is mentioned by the Arab poet Antara

Assyrian kings gathered horses of varying types, but they also imported horses as tribute from Arabia. This sculpted relief from Ashurbanipal's palace at Nineveh (c. 645 BC) reputedly shows the Assyrian King engaged in battle mounted on an Arab.

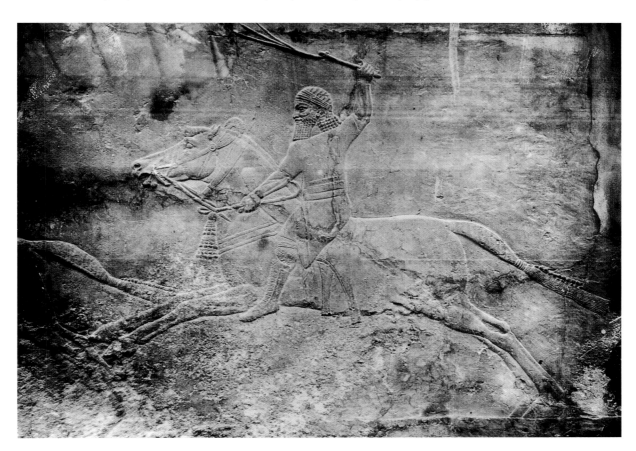

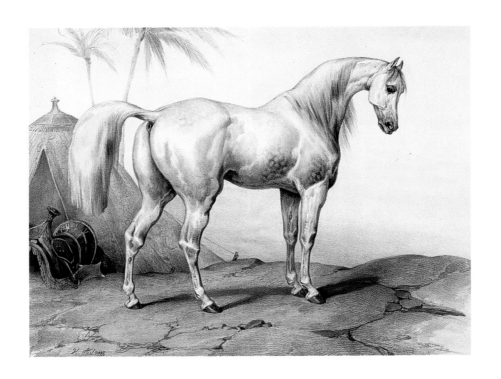

ABOVE: *Victor Adam,* A Mare, c. *1824.*
BELOW: *Victor Adam,* Two Turkish Horses, c. *1824.*

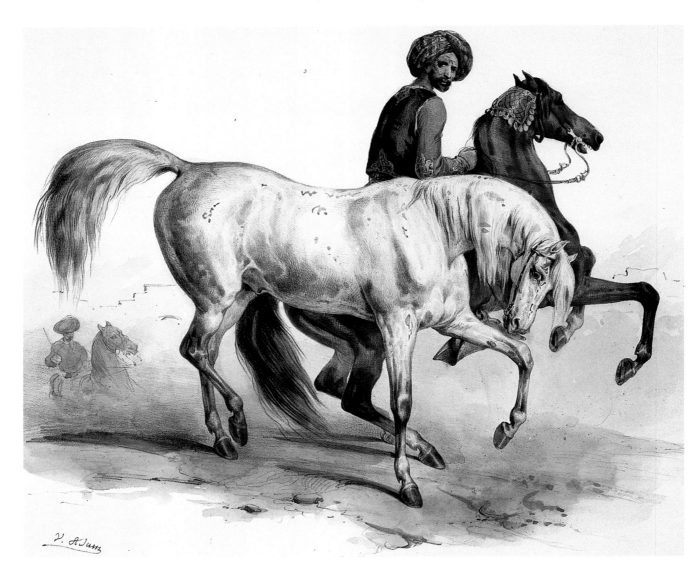

ibn-Shaddad [*fl.* AD 533]: '… a stayer traced in his lineage back to Thul Akal'). The line of descent from Thul Sufa leads to the unbeaten racehorse Harun; to Nawab, the horse of Ziyad ibn-Umeyya; and to Ashgar Merwan, a one-eyed chestnut racehorse, celebrated among the tribes for his speed.

Another great stallion of legend is Zad el-Rakib, who had been given to the Banu Azd by King Solomon; the Arab historian Hisham tells of his fame throughout the desert as a great sire. Indeed, he is considered the first horse to give descent in Arabia, for el-Kelbi informs us that one of his male offspring, Hojeys ('the young lion'), gave his name to the certificate of authenticity or record of pedigree, the *hojjah*.

In his *Gleanings from the Desert of Arabia*, the 19th-century English Army officer and desert traveller Major Roger Upton records the story of two horses called Dahes and Gabraah, who were to cause a great war between the Banu Dhobyan and the Banu Abas. Hadif, a man of the Fazarah (a sub-tribe of the Dhobyan) wanted to match his horses against those of King Kais, the son of Zohair ibn-Jadaimah of the Banu Abas. Kais was the owner of a stallion called Dahes and a mare named Gabraah, which he had obtained while in the Hejaz; some accounts say that he bred the mare and that she was the daughter of Dahes. King Kais then visited the Fazarah tribe with his celebrated horses. He was the guest of Hadif, who was eager to match his mares Khattara and Hansa against the King's horses. Eventually, the King agreed that a race should be run over a course of one hundred bowshots at a place called Dhatala Fadus, the prize being one hundred camels. Dahes quickly opened up a commanding lead, but Hadif had arranged for some of his men to lie in ambush and to intercept the stallion should it be in front; however, Gabraah took the lead and won the race. Hadif, who was a dishonourable man as well as a bad loser, contested the result, and a dispute arose between the two tribes which was to last for forty years.

Chivalry was the subject matter and inspiration of the early warrior poets of Arabia, and they have also left us many vivid descriptions of the Arab horse, the 'Swallowers of the Ground' or 'Drinkers of the Wind'. One of the earliest poems was written by Rabia al-Kheyl in *c.* 50 BC, although the most famous of these pre-Islamic poets is probably Imral Qays. Many of his verses are dedicated to the Arab horse, which Imral Qays describes as high-pedigreed, great in strength and fearless in battle. Al-Wakidi describes the horsemen of Mathhaj, mounted on their pure-bred horses, and Amru ibn-Kulthum asks: 'Are not these the inheritance of our fathers?' Antara ibn-Shaddad, the poet son of an Abyssinian slave girl, gained the acceptance of his tribe through great courage in battle. It appears that he rode Abjar, a bay stallion: 'While I my red horse bestriding ride … Lo, now he rusheth, the fierce one, singly in the midst of them.' We also have an early description of Arab horses from one of the kings of Hira (Iraq): '… with tails held aloft, wide nostrils and eyes as those most admired in women', but perhaps one of the finest descriptions appears in abu-Zeyd's romance *The Stealing of the Mare*.

The grey mare the renowned, in the world there is none like her …
Spare is her head and lean, her ears pricked close together;
Her forelock is a net, her forehead a lamp lighted
Illumining the tribe; her neck curved like a palm branch
Her wither clean and sharp.… Her forelegs are twin lances,
Her hooves fly forward faster ever than flies the whirlwind,
Her tail-bone held aloft, yet the hairs sweep the gravel.

Go and wash the feet of your mare and drink of the water.

(B E D O U I N S A Y I N G)

PEOPLES OF THE DESERT

We have seen that the tribes of Anazeh spread northwards across the desert from Khaibar. Further tribal movements began in the 1650s, when the Shammar conquered the north. At the time, the Ottoman Empire, which had held nominal control over the area for centuries, found itself occupied on its European front, so the Shammar moved northward, occupied the Hamad (western Syrian Desert), destroyed the city of Tadmor (Palmyra), and overpowered the northern tribes, including the Moali. They soon controlled the Euphrates valley. However, fortune is fickle in war, and the Shammar soon found themselves being pushed eastward across the Euphrates by Anazeh tribes that had swept up from the south. The first tribes to hold the desert north of Aleppo were the Fedaan and Hesenneh. They were followed by the Sebaa and Wuld-Ali, and finally by the Roala under the leadership of the Shaalans.

For the next two hundred years there was little change. Then in 1862, following the end of the Crimean War, Omar Pasha marched back into Arabia with his troops, and the Turkish government recovered some

George Henry Laporte, A Dark Bay Stallion Held by an Arab Groom in an Encampment, *1849. 'We cannot but be saddened at the final disappearance of what was in its day a noble thing, a type of Oriental magnificence past away for ever.' Wilfrid Scawen Blunt, poet and horseman.*

of its old authority over the desert peoples. The Arab revolt led by Sherif Hussein during World War I was to mark the end of the Turkish presence, and to lead eventually to the founding of the Arab states of today.

The Bedouin are a proud, independent, courageous, hospitable and generous people. A tribe's strength lay in its unity under the leadership of its sheikh. The well-being of the individual was subordinate to that of the tribe and, although all men were equal, certain families were accorded special status and received fanatical respect on account of their high birth. The two great tribal groups, the Anazeh and the Shammar, were bitter enemies. The Bedouin's lot, therefore, was one of incessant raids and forced marches in an unforgiving environment where death was a constant companion. The object of a raid was to take the enemy's property, particularly horses, and fighting was conducted in a chivalrous manner. (The Age of Chivalry in Europe was inspired by a code of honour brought back from Arabia by the Crusaders.) Later, the use of firearms and the struggles for supremacy between the great tribal dynasties forced a change in the code of battle, which marked the end of traditional Bedouin warfare. The desert tribes' respect for ethnic purity is mirrored in their breeding of the *asil* (pure-bred) horse. To the Bedouin, the Arab horse is the only horse, a breed apart, the original and sacred breed of the Arab people; any other horse is *kadish* (impure) and not worthy of consideration.

Many of the tribes which bred the finest horses were from the Anazeh. The ibn-Sbeynis of the Fedaan were famed for their seglawieh strain, and the ibn-Mirshids of the Gomussa (a sub-tribe of the Sebaa) were also notable breeders. The seglawieh jedraniehs of ibn-Sudan of the Roala were so celebrated that it is said that Abbas Pasha, Viceroy of Egypt from 1848 to 1854, bought up all that were to be had until none of that strain remained in the desert. The sheikhs of the Shammar, Ajman, Muntifik, Wuld-Ali, Dhafir, Harb, Oteybeh, Qahtan, Banu Sakr and Muteyr were all famous for their Arab horses. The Al-Dawish of the Muteyr guarded so jealously their krushieh strain that few were able to obtain any.

Life in the desert was harsh, for man and for horse. Half-starved from birth, often short of water and enduring intense heat and fearful cold, only those horses with the strength and the will to live survived. In *Travels in Arabia Deserta*, the Englishman Charles Doughty says that, when considering a mare, the Bedouin

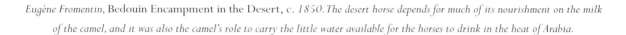

Eugène Fromentin, Bedouin Encampment in the Desert, *c. 1850. The desert horse depends for much of its nourishment on the milk of the camel, and it was also the camel's role to carry the little water available for the horses to drink in the heat of Arabia.*

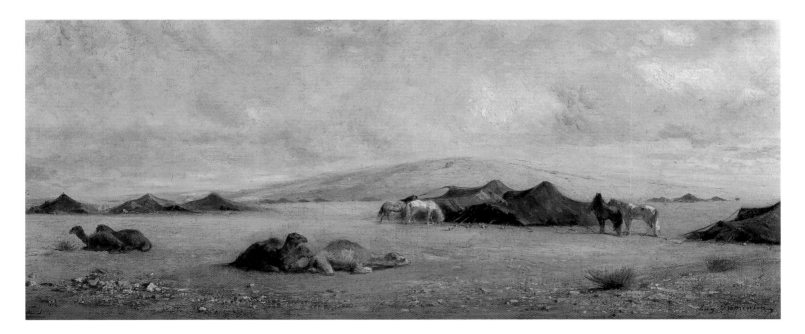

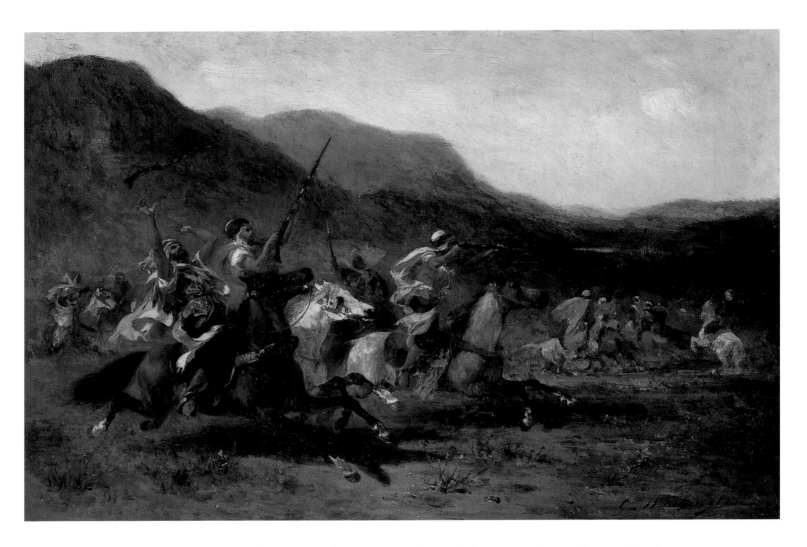

Georges Washington, The Attack, *c. 1880. The* ghazu, *or raid, was the means by which desert tribes gained booty, including horses.*
A strict code of honour was observed on all sides.

'look only that she be of the blood and able to serve her master in warfare.... Who has wife or horse, after the ancient proverb, may rue, he shall never be in rest, for such brittle possessions are likely to be always ailing. Yet under that serene climate, where the element is the tent of the world, the Beduw have little other care of their mares; it is unknown in the desert so much as to rub them.' In a land short of feed and water, the horses relied for sustenance on the milk of the foster camel, or a bowl of *mereesy* (dried milk rubbed in water), so the horses would seek their own tents when they wanted to drink. Doughty describes how one mare, having got cold and wet in a sudden and rare rainstorm, 'returned of herself through the falling weather, and came and stood at our coffee fire, in half human wise, to dry her soaked skin and warm herself, as one among us'. After describing a particular beautiful full-blooded mare, he comments that 'A Bedouin never parts with such an animal as this, and if she dies the whole tribe goes into mourning.'

The Bedouin believed in telegony – that if an *asil* mare is covered by anything other than an *asil* stallion, then all her future foals would be tainted by that inferior blood. This belief provided ground for the Bedouin obsession with purity of blood. When going on a march or *ghazu* (raid) in enemy territory, a rider would sew up the vagina of his war-mare, to ensure that no strange or inferior stallion could mate with her.

Like most peoples who lead harsh or dangerous lives, the Bedouin have age-old beliefs and superstitions; traditionally, small blue beads or talismans are often bound into a horse's mane or forelock to protect against the evil eye. The Bedouin displayed great pride in their horses, as is evidenced by the numerous poems and

songs that praise them and their deeds. The best brood mares of pure blood were valued above all others among the Arab tribes.

Although certain Arab horses in history have been famed for their speed, for the Bedouin endurance and agility were of greater importance in the war-mare, since the desert terrain is seldom flat or the course straight. The Bedouin rode mares in war, as opposed to stallions, for they were not apt to challenge, and so alert, other horses.

Though many of the tales of both the speed and endurance of the Arab horse are exaggerated in the telling, it cannot be denied that the 19th-century Europeans who travelled to the deserts thought the Arabian incomparable. They comment that the Bedouin mare will travel 50 miles (80 kilometres) without stopping; in times of necessity , she may be urged to cover incredible distances over which neither horse nor rider may taste food for days. Few horses would survive on the scanty nourishment given to an Arab horse. The mare usually has but two meals a day; at night she receives a little water and a small amount of barley, and a similar meal in the morning, sometimes with camel's milk. Mares often stand through the heat of the day saddled, ready for a hunt or *ghazu*, or are turned loose to search for a little grazing.

Breeders today may wonder how the reliability of pedigrees was ensured in an environment where no written records were kept. It must be remembered that, in the open life of tent dwellers, there are witnesses to every action: this precludes any deception, which would, in any case, bring dishonour on a tribe. In fact, the most extraordinary care was taken to preserve the purity of the breed. Contemporary European witnesses recorded that the parentage and birth of a foal were carefully noted by witnesses. A foal was not allowed to fall to the ground during birth, but was caught in the arms of one of those standing by, and washed and caressed as though it were an infant. A mare and foal shared the men's tent with them. The neck of the mare often served as a pillow for her master, and the children played with the foals. In this way, mares and foals acquired an affection towards man. The foal was constantly with people, for at the end of a month it was often weaned and then fed on camel's milk for one hundred days; after that, a little barley was allowed and the amount gradually increased, although milk continued to be the principal food. Being loose, the foals grazed about the tents, but were mostly fed by hand. Sheikh Mansur of the Ajman claimed that his grandfather, a great horseman celebrated by the poets, would allow his wife to crush the barley and stone the dates for most of his horses, but only he prepared the meal for his favourite mare.

The story of the 19th-century European travellers to Arabia is interwoven with the history of the Arab horse, and is told in more detail later. However, it is worth relating here a few of these travellers' first impressions of the Bedouin and their horses. Colonel von Brudermann, the head of the Babolna stud in Hungary, visited the desert in 1856 on behalf of the Austrian horse-buying commission. In December of that year, he visited the Roala and saw a white mare of unequalled beauty and quality; she was in foal, very noble and very nearly perfect. Brudermann bought two stallions from the Roala, one seglawi and a kehilan ajuz.

Carlo Guarmani was an Italian horse dealer whom Napoleon III had commissioned to buy Arab stallions for France and Italy, and also to act as a spy. Early in 1864, he arrived at the camp of the Banu Sakr and there saw some fifty Arab mares. He describes them as tough, hardy and fast, and more prized by their owners than were their wives. The day after his arrival, the men mounted their mares and galloped off on a leopard hunt. Once they had run the leopard down, they surrounded it; as the leopard tried to break free, the horseman closest to the beast pulled his horse to a stop beside it and speared it through the neck.

Major Roger Upton visited the Sebaa in 1875 on his second visit to the desert, and there met Sheikh Suleyman ibn-Mirshid of the Gomussa. He could not fail to notice some differences between the Anazeh, 'this great and independent race', and other tribes of Bedouin he had visited, in both their demeanour and their occupation. Days were spent in examining the horses, mares, colts and fillies which were daily brought for him to view. Sheikh Suleyman would often be present to give details of, or confirm, their breeding.

Lady Anne and Wilfrid Scawen Blunt played a decisive role in the history of the Arab horse, both in Egypt and in England – a role that will be described in detail later. In 1878, during a trip to buy Arabians with which to begin their own stud in England, the Blunts also visited the Gomussa camp, where they met Sheikh Beteyen ibn-Mirshid, cousin to Sheikh Suleyman. They spent some days looking at horses and Lady Anne recorded that 'several very fine ones have been brought for us to look at'. Men of the Gomussa came to talk to the Blunts, for they were among the great breeders of horses in the desert. They told them that their horses were the same as those of their forefathers, before they came from the Nejd.

Earlier, the Blunts had visited Sheikh Faris of the northern Shammar, whose ancestor – another Faris – had led the Shammar from the Nejd at the time of their conquest two hundred years previously. The Sheikh's mare was a tall bay shueymeh sbah, but among the tribes' horses the most handsome was a grey saadeh. Faris confirmed all they had heard about Arab horses from Smeyr, his cousin: that ibn-Rashid obtained his mares from the Bedouin, mostly from the Anazeh, and that ibn-Saud obtained horses from ibn-Rashid and the Bedouin. The best horses, he stated, were those of the Anazeh, especially the Sebaa and the Fedaan. Perhaps the deepest impression, however, of the desert tribes left on the Blunts was that of the Roala camp. Wilfrid and Lady Anne were nearing the end of their first desert journey, and when they looked down over the plain of Saighal, they saw it covered as far as the eye could see with thousands of tents, men, mares and camels. In the centre of the camp was the tent of Sheikh Sotamm ibn-Shalaan, the great leader of the tribe, which was then at war with the Sebaa.

Georges Washington, The Oasis, *c. 1880. The importance of water was crucial to the Bedouin, and the oasis not only offered welcome shade, but provided the other principal life-giving nourishment of the desert, the fruit of the date palm.*

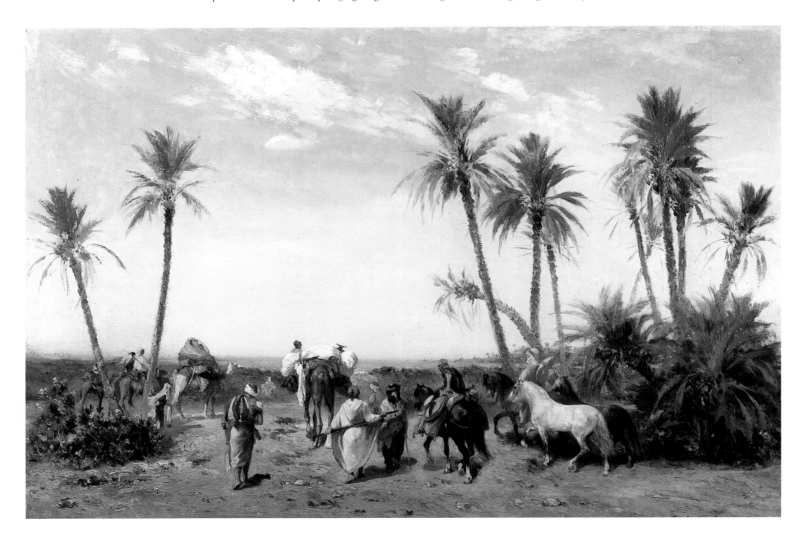

And if that which was withheld of the reins is restored to her, she lets herself go at full speed like the darting flight of a sand-grouse which hawks pursue.

(YAZID, ARAB POET AND WARRIOR, COMPANION OF THE PROPHET MOHAMMED)

THIS NOBLE BREED

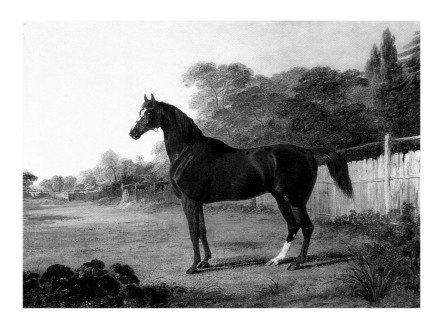

In *The History of the Decline and Fall of the Roman Empire*, Gibbon wrote that 'Arabia … is the genuine and original country of the horse. The climate is most propitious, not indeed to size, but to the spirit of that generous animal.' The Arabian is the oldest breed of horse in the world. A genuine Arab horse of pure descent is unrivalled and unmistakable, for it possesses a beautiful symmetry and harmony of proportion. Hallmarks of the breed are its exquisite head and high tail carriage, and it is to these that the Bedouin will first give his attention. Other notable features are a short back, a certain arch of the neck and, above all, an imposing presence. The Arab horse is also noble, intelligent and affectionate, with a gentle but spirited disposition; yet when roused or excited, it is famed for its vigour, courage and great powers of endurance.

According to Upton's *Gleanings from the Desert of Arabia*, the Arabs were very particular with regard to three points concerning the head of their horse; the *jibbah*, the *mitbeh*, and the shape, size, direction and attitude of the ears. 'The *jibbah*, or forehead, can scarcely be too large or too prominent to please an Arab. The formation of the frontal bones … is most marked in the Arabian. The shape of the *jibbah* gives a large brain cavity, adds greatly to the beauty of the head and gives an expression of great nobility…. The *mitbeh* is a term used to express the manner in which the head is set on to the neck and especially refers to the form

John Frederick Herring, Sr, Pantaloon, a Spotted Stallion Standing in a Paddock, *1846. The fantastic success of oriental horses in contributing to the foundation of the British Thoroughbred in the 17th and 18th centuries ensured their continued importation into England.*

of the windpipe, and the manner in which the throat enters or runs between the jaws, where it should have a slight and graceful curve.... The ears to be perfect should be so placed that they point inwards, so that the tips may almost touch; the outline of the inner side of the ear should be much curved. In the horse the ears are generally smaller and more pricked, in the mare they are usually longer and more open. These three features *jibbah*, *mitbeh* and ears ... of the above description, go a long way to form the perfect head.'

A description of the Arab horse by Wilfrid Blunt, which appears in Lady Anne's *A Pilgrimage to Nejd*, also deserves our attention here: 'The head of the Arabian has great depth of jowl and width between the cheekbone. The ears are fine and beautifully shaped, but not very small. The eye is large and mild, the forehead prominent ... and the muzzle fine, sometimes almost pinched.... The head, too, and this is perhaps the most distinguishing feature, is set on at a different angle [to that of the British Thoroughbred] ... the neck of the Arabian horse is light ... the shoulder is good [laid-back] and the wither often high. The forearm ... is of great strength, the muscle standing out with extraordinary prominence. The back is shorter than it is in our Thoroughbreds and the barrel rounder. The Arabian is well ribbed up ... the tail is set on higher, but not, as I have heard some people say, on a level with the croup.... The tail is carried high, both walking and galloping; and this point is much looked to, as a sign of breeding. The hind-quarter in the Arabian is much narrower than in our horses ... the line of the hind quarter is finer, the action freer, and the upper limb longer in proportion.... The hocks are larger, better let down, and not so straight. The cannon bone is shorter. The legs are strong, but with less bone in proportion to back sinew. This last is perhaps the finest point of the Arabian, in whom a 'breakdown' seldom or never occurs. The bones of the pastern joints are fine sometimes too fine for strength and the pastern itself is long even to weakness. Its length is a point much regarded by the Arabs as a sign of speed. The hoofs are round and large and very hard.... It is commonly said in England that the Arabian has but one pace, the gallop; and in a certain sense this is true ... trotting is discouraged by the Bedouin. No pure-bred Arabian is a high stepper, his style is long and low. He is a careless walker.... It is considered a great point of breeding that a horse should look about him to right and left as he walks. The horse is too sure of his footing to be careful, except on rough ground and there he never makes a false step.'

It is clear then that the form of an Arab horse's head is extremely important; indeed, it is one of its most distinctive features. When viewed from one side, the head should appear wedge-shaped, broad across the cheekbone and tapering to a fine muzzle. The eyes, which should be set low in the head, should be large, round, and of a limpid dark brown. Some Arab horses have a 'human eye', with white around the pupil; occasionally a wall eye appears, which is considered unattractive. It is important that the nostrils of the Arab horse, when in repose, lie parallel to the profile of the face, and that they are capable of real expression and great expansion. The cheekbones should be large, sharp-edged, with a clearly defined bone structure, and set sufficiently wide apart that a clenched fist might fit between them. The shafts of the under-jaw must be straight. During teething, around the age of two to three years, bumps often occur along the jawline, but these usually disappear in time.

From the front, the head should appear broad across the forehead, the eyes set well apart and the muzzle small. The nostrils must be finely edged and extremely flexible, and have a delicate curl. The ears should be quite close together and finely chiselled; in some cases, the tips of the ears curl backwards and inwards, giving a particularly pleasing effect. The head joins the neck at a wide angle, so that it appears to spring out in a natural curve. This gives the neck an arched appearance, and obtains the gently curving throat-line, the *mitbeh*; there should be no acute or abrupt angles. Stallions normally have a crest, giving greater thickness to the throat, but mares should have lean necks and slender throats.

It is usual for the Arab horse to be somewhat shorter in the neck than is the Thoroughbred, but the neck's fineness, natural curve and topline give the horse an appearance of length. The length of the topline is influenced by a well-laid-back shoulder, which should be long and sharply defined. The prominence of the

John Frederick Herring, Sr, Chestnut Arab Stallion in a Stormy Landscape, *c. 1850. 'When God wanted to create the horse he said to the South Wind: I want to make a creature out of you. Condense — and the wind condensed.' Arab saying.*

withers may be adversely affected by the fatness of the horse, but the Arab, like all riding horses, requires a good, large, clean wither. Underneath, the neck should spring out from high up, leaving the chest clear and the shoulders free. The back must be short and strong. A slight concave line is required between the withers and the loins, which should spring strongly in an upwards curve to the quarters. (This is what W. G. Palgrave, another 19th-century English desert traveller, describes in his *Personal Narrative of a Year's Journey through Central and Eastern Arabia* as 'a little saddle-backed'; see page 31). The body is deep, both at the girth and at the flank, for the ribs are particularly round and well sprung, giving the Arab horse a closely coupled look. Good length from the hip to the buttock is necessary and both hips should be set high, so that from behind the quarters appear well rounded and not peaky. The tail should appear as a natural extension of the croup, and be elevated when the horse is moving or excited.

It is important that the horse stand over much ground, with the forelegs set well forward. The upper arm is strongly muscled and long with large, flat knees and short cannon bones. Tendons should be clean, clearly defined, parallel to the bone, and with the appearance of steel cords. Pasterns need reasonable length and enough slope to give elasticity to the action. The joints should be clean-cut, the hocks large and clean, and the thighs well muscled. When viewed from behind, the legs should be parallel, although, once the

ABOVE LEFT: Giulio Rosati, Mounted Arab Soldiers Galloping, c. 1890. *ABOVE RIGHT: January Suchodolski,* The Schosslands' Portrait on Horseback, c. 1850. *The contrasting elegance of the desert horsemen and the European aristocracy.*

horse moves, the hocks may swing inwards slightly on the forward movement, particularly at extended paces, so that the stifle can move outside the floating ribs. The feet should be circular and open in form, though the hind ones are more oval. The surface of the hoof should be hard and smooth, giving a naturally polished look. The action of the Arabian should be free, expressive and true with a natural balance, so that the horse moves lightly and easily over the ground. There must be good flexion of all the joints, the forelegs showing unrestricted shoulder and knee action, giving a long stride which covers the ground. The hind legs should track up well, providing the impulsion behind the movement. The whole action must be full of such harmony that the horse appears to float and dance, moving lightly over the ground. The Arab horse's pride and spirit are often best seen when it is in movement.

The quality of the Arab breed is evidenced by the fineness of its skin and hair. The coat should be silky and so fine that the veins and skin-markings show through; around the eyes and muzzle there should be little hair, so that the dark skin colour is revealed; manes and tails should not be too profuse.

Arab horses may be grey, chestnut, bay, brown or, occasionally, black, but whatever the colour, it should be strong. Among the Anazeh horses, Wilfrid Blunt reckoned that of 100 horses, 35 would be bay, 30 grey, 15 chestnut and 20 brown or black – though he professed never to have seen a black horse in the desert that he thought any good. All greys, except for the rare albino, are born bay or chestnut, but the coat turns prematurely white due to pigment loss in the hair. To produce a grey, either the dam or the sire must be grey. With some greys, the skin tends to darken with age. This is probably due to the retention in the skin of melanin, or dark pigment, which would otherwise have contributed to the hair colour. Other greys become 'flea-bitten' as they age, displaying flecks of the original coat colour throughout the white coat. This is considered to be one of the most attractive colourations for an Arab horse, and in some cases the animals

are so heavily marked that the colour of the flecks almost dominates the grey base. A notable feature on certain greys, rather like a birthmark and known as the 'bloody shoulder mark', is the retention of partial flecking in one or more places anywhere on the horse's body. Mehrez, the old desert stallion formerly at the Royal Jordanian stud, had this unusual mark. White markings are a common and notable feature of the Arab horse, and have been for generations. In Prince Mohammed Ali's translation of the Abbas Pasha manuscripts (see page 35), a number of the horses listed have white markings: 'a sorrel mare, that had white marks on its two forelegs … on its lip it had a white spot, its mane was light of hair … its head was beautiful, its forehead broad and not projecting [no *jibbah*] its eyes big, but no white at all …'. References to 'the parti-coloured mare wadnah al-khursani' and the 'parti-coloured mare saglawieh jedranieh' probably indicate that these horses had liberal white markings, not that they were piebald or pinto. Many of the chestnut horses bred by Ali Pasha Sherif in Egypt were also liberally marked with white. His stallion Aziz is described by Lady Anne Blunt, who first saw him on 25 November 1880 during her first visit to Ali Pasha Sherif's horses in Cairo: 'a handsome chestnut (dahman shawan) with 4 white stockings who has badly curbed hocks – 4 years old only and used for breeding in spite of the defect. Ali Pasha made no allusion to the hocks, but said that this horse had been used for the stud at 3 years old, for he had been curious to see whether the 4 white legs would be inherited. He does not like 4 white legs.' The characteristic was indeed inherited by many of Aziz's offspring. Jamil had four white feet, a blaze, white hairs on the flanks and the nearly human eye, with white around the pupil. Kerima, a bright chestnut, had an off hind white nearly to the hock, a broad blaze, white splotches under the barrel and on the flanks extending to both stifles, a few inside the hocks and also on top of the tail and between the front legs. The most famous son of Aziz was Mesaoud; he also had four white stockings, a blaze, a white mark under the chin, a group of white specks under the jowl and flecks on the flanks.

Alberto Pasini, Horse Market, Syria, *c. 1873. Damascus, capital of Syria and for so long the centre of Arab learning and the seat of the Caliphate until the 13th century, was also an important trading city. The great horse-breeding tribes of the Syrian desert have provided some of the best bloodlines in the history of the Arab horse.*

The outward signs will enable you to guess at the race, but it is by the moral qualities alone you will receive full confirmation of the extreme care displayed in coupling the sires and dams, and of the pains taken to prohibit all misalliances.

(LETTER FROM EMIR ABD-EL-KADER, IN E. DAUMAS, *THE HORSE OF THE SAHARA*)

THE HORSE OF PURE DESCENT

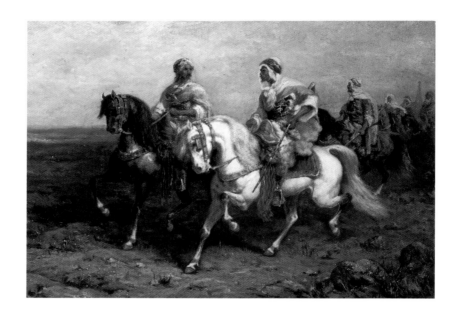

Although natural selection was an important factor in the development of the Arab breed, man's influence was the major contribution. The Arab horse's lineage and the purity of its blood were the result of a process of selection; the development of other characteristics, the result of further selection. Each of the early breeders in the desert tribes had his own particular idea of what constituted equine perfection, towards which he would strive. An outstanding mare would be procured, and with good fortune would prove fertile and pass on her merits to her offspring. In this way different strains were to develop. Even today, every breeder has his own idea of equine perfection, and it may be argued that all successful programmes in Arab horse breeding have depended on exceptional foundation mares.

There are over two thousand sayings and recommendations concerning the horse by the Prophet Mohammed, which, for Moslems, conferred on the Arabian a status that no other breed has ever attained.

It is accepted that all strains originated in the *kehilet ajuz*, the ancient pure-bred Arab horse. All pure-bred Arab mares therefore are *kehilet* (stallions *kehilan*). However, variation in certain characteristics was inevitable, given breeders' different ideals, and this led to mares, particularly celebrated ones, being named according to some special characteristic, or being given the name of their owner. This name, or strain, was thereafter

ABOVE: Adolf Schreyer, Arab Horsemen, *c. 1870. The 19th century saw intense interest in procuring and breeding Arab horses for their own sake, rather than for the sole purpose of improving other breeds.* OPPOSITE: *Alberto Pasini,* An Arab Caravan, *c. 1873.*

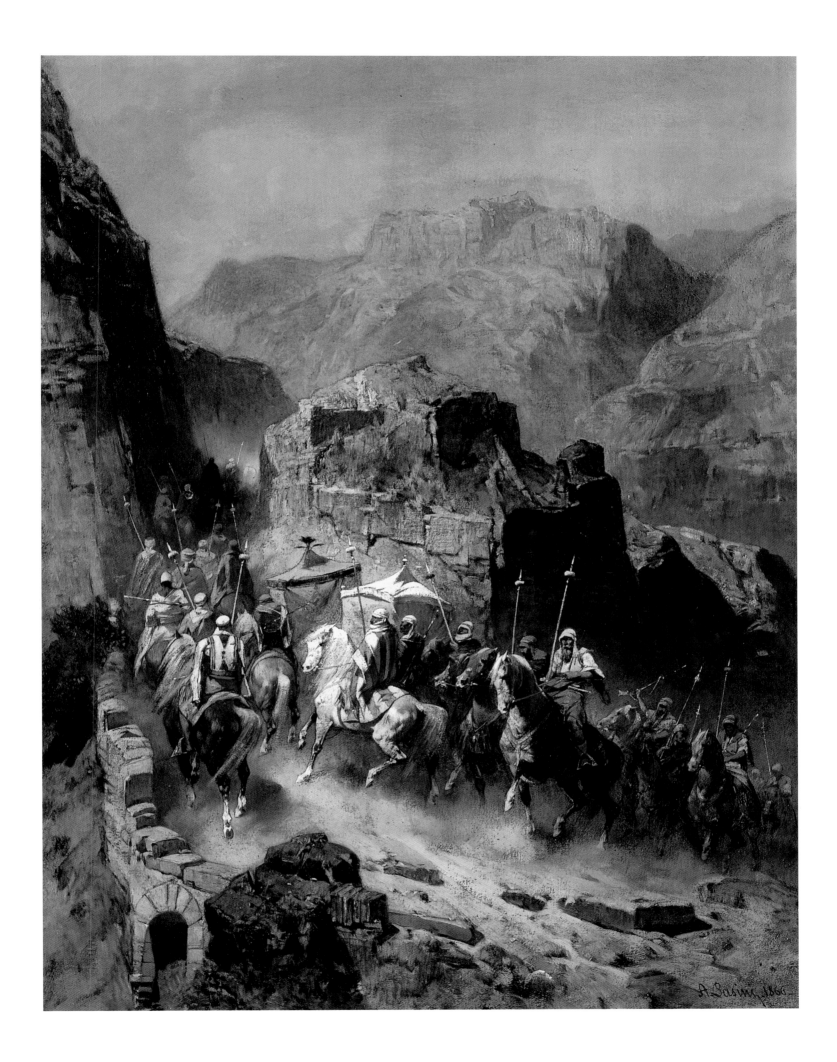

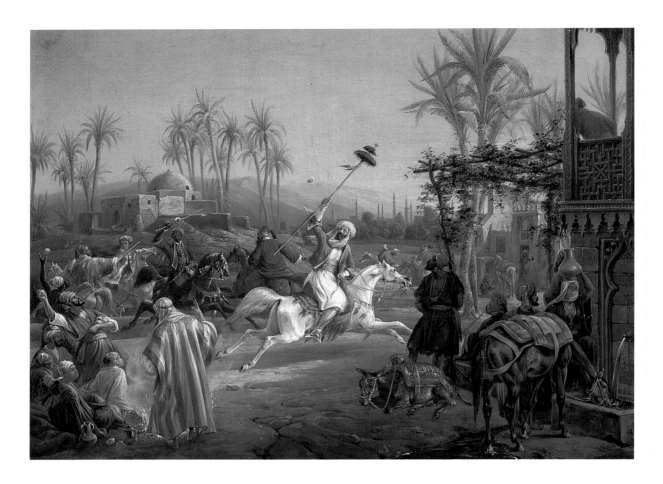

Heinrich von Mayr, Arab Horsemen at Play, *1846. Good horsemanship was highly regarded within Arab society and showmanship in the form of fantasias was often displayed in town and village throughout the Arab world.*

given also to their offspring. *Kehileh* was used as a prefix to confirm or support the family name, at least until the strain name became sufficiently established for it to stand alone; it is still used in this manner in many strain names, such as kehileh nowagieh, kehileh rodanieh and kehilet el-krush. The fact that the strain name was continued through the tail-female line was a reasonable and practical way of recording a brood mare's family, particularly for the Bedouin, who kept no stud books and depended on oral tradition.

It is interesting to examine some examples of how sub-strains evolved. All dahmeh horses ('the dark ones') which came from the mare of abu-Shahwan of Ubayda were known as dahmeh shahwanieh. Later, this strain passed to Kunayhir of the Ajman tribe, where it became known as dahmeh kunayhir. Eventually, Abdullah al-Khalifa of Bahrain obtained some kunayhir mares. One old dahmeh bought by al-Nejib of the Banu Hussein had a filly whose offspring were known by the name dahmeh nejiba. As described later, Abbas Pasha, ruler of Egypt, kept detailed records of the pedigrees and strains of his horses, the research being carried out by a slave known as al-Lallah. The Abbas Pasha manuscripts include a list of 34 dahmehs (21 kunayhirs, 7 nejibas and 6 shahwaniehs) known to al-Sharif Sa'ad.

When questioned by al-Lallah regarding the history of the kehileh nowagieh, Sheikh Feysul al-Shaalan replied that the nowagieh was originally a kehilet ajuz which Mirshid al-Nawaq of the Gomussa tribe had acquired from Himyar al-Amawi of the Dhafir. When old men of the Gomussa tribe were questioned about the history of the seglawieh sudanieh, they said that Ali ibn-Sudan of the Roala bought a chestnut filly, the offspring of the seglawieh bred by Jedran ibn-el-Derri; the filly was grand-dam to a chestnut by the hamdani simri of al-Jasim. The horses of this breeding became celebrated as the seglawieh jedranieh of ibn-Sudan, eventually becoming known as seglawieh sudanieh.

The question of strains exercised Lady Anne Blunt and Major Upton. Writing in 1916, Lady Anne mentions particular families of horses which 'occasionally went through periods of renown owing to remarkable exploits in war of individual mares. But there has never been one [strain] that permanently retained a superior rank, nor indeed is any strain kept separate – very rarely are both parents of a foal of the same family. The family name, corresponding to a surname with human beings, is given by the mare, according to Arab custom. And all families or strains go back to, or in other words, originate in "Kehilet Ajuz", which is the generic term for "pure-bred".' At every opportunity on his desert journeys, Major Upton would make enquiries of Bedouin sheikhs regarding strains, and they all insisted that all families and strains were kehilet. Upton asked Sheikh Ahmed abu-Salus whether there had been a time when the abayan sherraki were not kehilan. The Sheikh expressed great surprise that there could be any doubt on the subject and replied that 'the abayan is most surely kehilan'. Another said to the Sheikh: 'I suppose you will next tell us that the seglawi jedran, and other families … are also kehilan.' Abu-Salus smiled and replied: 'Certainly they are all kehilan.' Suleyman ibn-Mirshid, the great sheikh of the Gomussa tribe, also insisted to Upton that the seglawieh was a strain derived from the kehilet ajuz.

As strains and sub-strains evolved, it was inevitable that some would be replaced and overtaken. The list provided in the appendix will therefore not be definitive, although it endeavours to include most of the strains mentioned in the Abbas Pasha manuscripts, and also by those who travelled among the desert tribes in order to purchase Arab horses during the latter part of the 19th century. Unfortunately, few Europeans understood the relevance of strains; the origins of many Arab horses imported from the deserts of Arabia were described as no more than 'desert-bred' or 'high-caste Arabian'. Others, particularly those who had travelled among desert people, realized the value of recording as many details as possible, as a way of authenticating the pedigree of the horses they purchased.

The development of new sub-strains came to an abrupt halt with the arrival of desert horses in Europe. Today, many generations later, the influence of a tail-female line can have little genetic relevance. Most Arab horses outside Arabia are ten generations removed from the original imported stock, and over ten generations an original mare would account for only a minute percentage of a horse's blood. That being so, it is not really possible to say, as it once may have been, that type can now be associated with a particular strain. However, we can still see family characteristics following through certain female lines, but not all hamdaniehs in the world, for example, look alike. If we had continued to evolve new sub-strains, then the matter would be more relevant today. The value of strains, however, is that breeders can identify to which family the horses belong and from which original mare they descend.

Georges Washington, The Lookout, *c. 1880. When going into battle or on a raid, the Bedouin only took mares for reasons of stealth, as stallions were too noisy.*

The Arabian stallion alone is able to improve all breeds of horse
around the world, just as he remains the only preserver of his own Arab breed,
the original breed.

(CARLO GUARMANI, *NORTHERN NEJD, JOURNEY FROM JERUSALEM TO ANAIZA IN KASIM*)

IN SEARCH OF THE ARAB HORSE

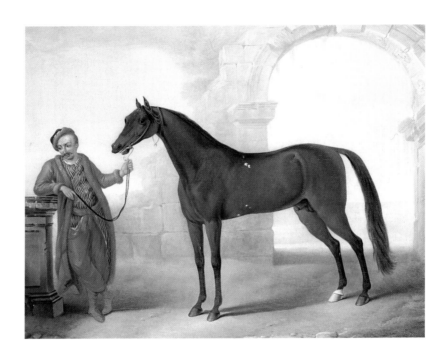

For a thousand years or more, the superior qualities of the Arab breed have been recognized abroad. It came to be regarded as the one pure and noble breed. Its value was understood for, being pure-bred, it displayed a prepotency which was sought for the improvement of native stock. In those early years, these Eastern horses were known as 'running horses', for none other were faster. Arab horses were therefore eagerly sought by all those rich and powerful enough to send emissaries to the Levant to purchase them. Stallions were more readily obtainable, and their influence was seen as greater, so new desert blood was introduced on the sire's side at regular intervals on principle. All British Thoroughbred racehorses today claim descent from three stallions: the Byerley Turk, a war prize at the siege of Buda imported to England in 1688; the Godolphin Arabian, which arrived in England in 1728; and the Darley Arabian, the greatest of the trio, purchased in Aleppo in 1704 by the British Consul in the Levant, who sent the horse to his brother, Richard Darley.

It was not until the 19th century that Europeans imported Arab horses on any scale expressly for the purpose of establishing studs for breeding Arabs, rather than improving native breeds. By this time, the

John Wootton, The Godolphin Arabian, *1731. The Godolphin Arabian, foaled in 1726, was originally named 'Sham' (Damascus). The Godolphin, with the Darley Arabian and the Byerley Turk, is credited with being one of the three main foundation sires of the modern racing Thoroughbreds.*

number of horses in the desert was decreasing, on account of continual warfare, the use of firearms, and years of drought and famine, which had reduced the prosperity of the tribes and driven them to sell their mares – something rarely considered before. This is why Europeans, Egyptians and Americans were able to procure so many Arab mares during the 19th and early 20th centuries.

In the middle years of the 19th century, Emir Feysul ibn-Turki al-Saud had collected together the finest stud of Arab horses anywhere in the Arabian deserts. The Englishman W. G. Palgrave visited the ibn-Sauds' stud in 1862, which numbered more than six hundred horses. He wrote: 'Never have I seen or imagined so lovely a collection. Their stature was indeed somewhat low; I do not think any were above 15hh., fourteen appeared to be about their average: but they were so exquisitely well-shaped that want of greater size seemed hardly, if at all a defect. A little, a very little saddle-backed, just the curve that indicates springiness without weakness; a head broad above and tapering down to a nose fine enough to verify the phrase of "drinking from a pint pot". A most intelligent and yet singularly gentle look, full eye, sharp thorn-like little ear, legs fore and hind that seemed as if made of hammered iron, so clean and yet so well twisted with sinew; a neat round hoof, just the requisite for hard ground; a tail set on or rather thrown out at a perfect

Baron Jean-Antoine Gros, Bonaparte Addressing His Army before the Battle of the Pyramids, 21 July 1798, *1806. Napoleon fell in love with the Arab horse during his Egyptian campaign. Marengo, his favourite, is pictured in this famous painting.*

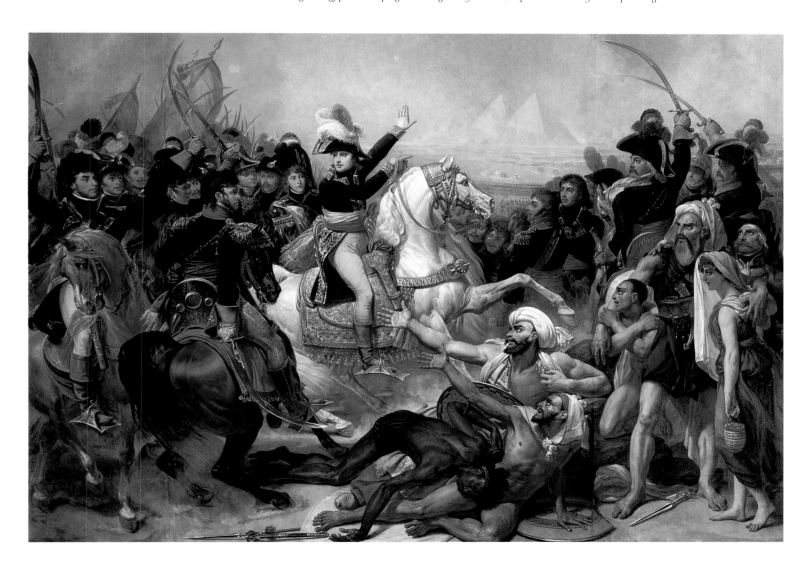

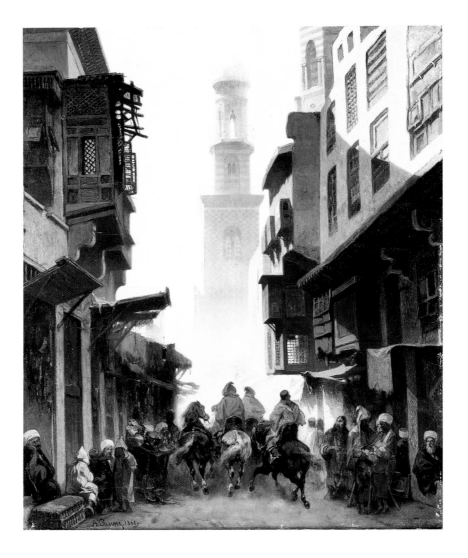

Alberto Pasini, Street Scene in Damascus, *c. 1878. Traditionally in the desert, there were no pedigrees as we know them, the record of ancestry being kept by memory and passed on from one generation to the next.*

arch; coats smooth, shining and light; the mane long but not overgrown nor heavy; and an air and step that seemed to say "look at me, am I not pretty?"' The tribe from which the ibn-Sauds got their best strains, the hamdanieh simrieh and kehilet el-krushieh, was the Muteyr, but they also procured other horses from the Muteyr, as well as from the Banu Khaled, Dhafir, Shammar and Anazeh.

In 1874, Major Roger Upton made the first of two journeys to the desert in order to procure horses. His aim (and this is significant) was not to improve native British breeds, but to establish the breeding of pure-bred Arab horses in England. In Aleppo, he met the British Consul, Mr Skene – an important and fortunate encounter. A year later, in the company of Mr Skene, who was interested in Syrian traditions and practices of breeding Arab horses, Upton set out from Damascus to visit the Sebaa, one of the tribes of the Anazeh. He describes his meeting with the Sheikh of Sheikhs, Suleyman ibn-Mirshid, in *Gleanings from the Desert of Arabia*: 'A man is seen to jump on the back of a mare and rides forward to meet us … springing from his mare he bids us welcome and brings us to his tent.' Days were spent in examining the horses brought for them to see, including some nowagieh mares, two of which Upton describes as beautiful and blood-like, with fine, noble heads. Eventually, Upton returned to England with three mares and two stallions of the finest strains. Two of the mares were the nowagiehs, Kesia and Keren-Happuch, named after the daughters of Job; the stallions, Ishmael and Joktan, went to the stud of the Hon. Henry Chaplin. The third mare was

Jemima, purchased for Messrs W. J. and A. A. Dangar in Australia; Upton and Skene had previously procured a stallion, Alif, for the Dangars. Sadly, financial difficulties, ill-luck and lack of support bedevilled Upton's enterprise, which had little success. However, descendants of some of the horses he had so carefully selected in the desert are still to be found today.

In December 1877, Wilfrid and Lady Anne Blunt arrived in Aleppo. This was to be the start of their lives' work and dedication, for which they are now justly famous. In Aleppo, the Blunts also met with Skene. Lady Anne wrote in her journal: 'We sat talking … about horses…. [Skene had] come to the conclusion that the Arab blood should be kept pure and that the only way to improve the breed of horses in England would be to breed pure Arabs there.' They therefore decided to purchase Arab horses from the Bedouin with Skene's help, in order to found a stud at their Sussex home, Crabbet Park. Upton's great project was now enthusiastically adopted by the Blunts, with Skene's encouragement.

The Blunts' first two desert journeys in search of Arab horses are well documented in Lady Anne's books *Bedouin Tribes of the Euphrates* and *A Pilgrimage to Nejd*. During the Blunts' first visit, they succeeded in purchasing mares and stallions with which to found their stud. The first purchase was a kehilet which they named Dajania, whose only filly, Nefisa, founded one of the most influential lines at Crabbet. They next bought a mare, Hagar, from an Arab of the Moali; he himself had brought her from the Roala, who had recently taken her in war from the Sebaa. Hagar accompanied the Blunts on their first desert journey, during which the horse demonstrated the tough and resilient characteristics of the desert mare, carrying the Blunts hundreds of miles, and out-galloping any other horse.

On 5 January 1878, Lady Anne wrote in her journal about another purchase, named Kars, who was 'a picture of distinction and beauty'. During their visit to the Gomussa, the Blunts also saw for the first time a three-year-old abeyeh sherrak; Beteyen ibn-Mirshid had just purchased from one of his people a half-share in the horse (known as 'the bridle half'), and the Blunts thought her to be the finest mare they had seen

Lady Anne Blunt riding Kasida at Crabbet Park and Wilfrid Scawen Blunt, dressed in traditional Bedu garb and holding an Arab spear, mounted on Sherifa outside Newbuildings Place.

in the desert, and worth a king's ransom. The mare's dam, a fine old brood mare, though less handsome than her filly, was brought for them to view. As the Blunts were leaving on their second desert journey, they heard that Mr Skene had been able to purchase for them Beteyen's mare, the Queen of Sheba, and a seglawi colt, Pharaoh. The sale of these had caused quite a sensation among the tribes, as they were considered to be among the best horses in the whole of Arabia.

A third desert expedition in 1881 enabled the Blunts to purchase further mares, although Lady Anne noted that, 'on the whole I have seen fewer and less good mares than three years ago'. However, they were able to obtain two seglawiehs, one being half-sister to Pharaoh, and a chestnut kehileh, an old and celebrated mare which they named Rodania after her strain. While at Meshur ibn-Mirshid's camp, they tried, unsuccessfully, to buy another half-sister to Pharaoh; however, at her side was a yearling colt, which Lady Anne noted would be a wonderful horse. They did not forget that colt, and in 1887 a trusted Arab was sent to the desert expressly to purchase the grey stallion Azrek, celebrated among the tribes both for his speed and as a sire; later at Crabbet, his offspring were considered superior to those of any other sire in the stud.

In all, the Blunts purchased or received as gifts twenty-one desert mares and nine stallions. These were supplemented by those horses which they obtained in Egypt which were descendants of the original horses of Abbas Pasha's collection, and will be discussed later. The Blunts sent twelve mares and six stallions to Crabbet from among these Egyptian horses.

In the land of the Pyramids, Ahmed ibn-Tulan, the son of a mercenary and a Turkish slavegirl, and founder of the Tulunid dynasty, became Governor of Egypt in AD 868. Warrior slaves, mostly of Turkoman and Circassian origin, were to rule Egypt for the next thousand years as sultans; these formidable soldiers and expert horsemen were later known as the Mamelukes. Salah al-Din Yusuf ibn-Ayyub (Saladin), one of the great Mameluke sultans, is probably best known as the Muslim leader who prevented Richard the Lion Heart and his Crusaders from taking Jerusalem. The English noted ruefully that 'the infidels … were a constant trouble … one may liken [their horses] to swallows for swiftness.' In 1517, Egypt was conquered by the Turks and became part of the Ottoman Empire, but administration remained in the hands of the Mameluke governors, known as beys.

In 1798, Napoleon Bonaparte's army defeated Murad Bey at the Battle of the Pyramids, but the French stayed only a short time in Egypt, being driven out in 1801 by a Turkish-British alliance. Among the soldiers in the Ottoman forces was an Albanian, who was to rise to power as Mohammed Ali the Great. So rapid was his rise that, in 1805, the Sultan of Turkey conferred on him the pashalik of Cairo. However, in order to consolidate his position, Mohammed Ali had to crush the power of the Mamelukes, and in 1811 he invited them to a ceremony at the citadel. Once within the walls, the unsuspecting Mamelukes were massacred on the Pasha's orders; only one, Amin Bey, having put his horse at the great walls, was able to leap to safety, although his horse was killed in the endeavour.

At the request of the Sultan, Mohammed Ali also invaded southern Arabia, where the Wahhabis had grown powerful with the help of the ibn-Sauds. Toussan, the second son of Mohammed Ali, led an Egyptian campaign which took the Holy Places there, and two years later Mohammed Ali was able to make the *haj* (pilgrimage to Mecca). Fighting continued, however, so a second Egyptian army, now under the command of Mohammed Ali's eldest son Ibrahim, marched against the Saudi Emir, Abdullah ibn-Saud. The Emir was captured and sent to the Turks, who beheaded him, while his precious stud of Arab horses was taken by Ibrahim as spoils of war. The British, now wanting an alliance with Egypt, sent a Captain Sadlier to meet with Ibrahim Pasha in 1819 near Medina. The Captain wrote in his diary: 'His Excellency's stud … consists of 300 mares and horses, the choicest breeds of Arabia.' Sadly, many died before reaching Egypt, but those which did survive joined the collections of Mohammed Ali and his sons.

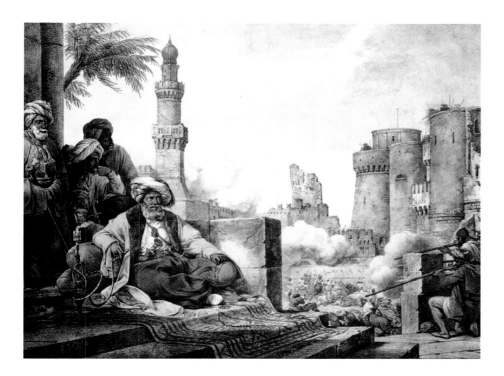

ABOVE LEFT: Lithograph by Horace Vernet, c. 1840, depicting the treacherous slaughter in 1811 of the Mameluke rulers of Egypt. They governed for a thousand years and were fierce warriors and superb horsemen. ABOVE RIGHT: Lithograph by Carl Vernet, c. 1820, of a Mameluke warrior.

The Egyptians were eventually forced to withdraw from Arabia in 1841, but during their years in the peninsula, they had taken hundreds of Bedouin horses to add to the Pasha's great collection at Shoubra. By 1842, Mohammed Ali's stud had 32 stallions and 450 mares, according to the French veterinarian Monsieur Hamont, who was employed to manage the stud. Although he had despaired of ever improving conditions, he sought for fourteen years to do so, and achieved some success. Hamont also visited the stud of Ibrahim Pasha at Kasserling, close to the Nile near Cairo. Most of the four hundred horses there were Nejdi, or had been taken at Acre; but again, the stables were poorly managed, little better than those at Shoubra. The foaling rate was poor, the mares standing tethered to their mangers, getting little or no exercise.

Abbas Pasha became ruler of Egypt in 1848 on the death of his uncle Ibrahim, who had assumed power due to the sickness and serious mental condition of Ibrahim's father, Mohammed Ali (who was to die the following year, unaware of the changes that had taken place). Abbas Pasha's great passion was the Arab horse and, while still a young man, he had started to collect choice mares and stallions. It was one of his slaves, Ali Pasha Gamali, known as al-Lallah, who was sent to enquire from the sheikhs the histories of the horses, their strains and their owners. This information was later recorded in manuscripts for Abbas Pasha. Abbas had spent some months living with the Roala, one of the horse-breeding tribes, and became friendly with their supreme sheikh, Feysul ibn-Shaalan. This friendship was to prove most beneficial, since Sheikh Feysul was to act often as an intermediary and adviser in Abbas's acquisition of some of the best horses and in the verification of their pedigrees.

The Saudi Emir, Feysul ibn-Turki al-Saud, also provided Abbas Pasha with valuable assistance in securing horses for his collection. Following the Egyptians' invasion of Arabia, in which hundreds of horses were taken as war booty, the Emir had been captured and taken to Cairo. During his years as prisoner, the desert prince was to meet and become friends with Abbas Pasha. They must have talked about Arab horses, a subject dear to both of them, and this friendship was to have important consequences for the future of the breed. Eventually, in 1842, with the connivance of Abbas Pasha, Feysul escaped from Cairo and returned to the Nejd.

The Abbas Pasha manuscripts contain lists of some of the mares and stallions he possessed: by 1843, he had already acquired 40 mares and 16 stallions, and by 1851 he had 133 mares. The horses were stabled in magnificent palaces at Abbassia, on Roda Island, and at Dar el-Beyda, out in the desert. In the Bedouin manner, camels were kept to provide milk for the foals, and Bedouin grooms employed to care for the horses. By the 1850s, Abbas Pasha is reported to have had some one thousand Arab horses.

The fame of Abbas Pasha's horses was such that agents, emissaries and princes travelled to Cairo in order to view, and if possible to obtain, some of these classic stallions and mares. One such was the German Baron von Hügel (equerry and Master of the Horse to Wilhelm I, King of Württemberg), who arrived in Cairo in 1852 with horses for Abbas Pasha; but his mission was to procure Arab horses for the stud at Weil. After some initial problems, von Hügel was eventually granted an audience with the Pasha, who presented him with the brown four-year-old desert-bred stallion Hedban. Von Hügel also purchased two grey mares, Saklawia and Koheil Aguse. At Weil, the artist Emil Volkers was asked to paint a portrait of the kehileh, which shows her to have been the most perfect of Arab mares.

Only two years after von Hügel's visit, Abbas Pasha, barely forty years old, was dead. Some say two of his servants poisoned him. His eldest son, al-Hami, inherited the stud, but lacking his father's love and enthusiasm for Arab horses, he gave many of them away. Being married to a sister of Sultan Abdul Aziz, he was ordered to live in Constantinople. Of course, he presented horses to the Sultan, but became unhappy, took to drink and, under its influence, wrote blank cheques. In 1860 he died owing millions, so what remained of his father's world-famous stud was put up for public auction. The auction started on 10 December 1860 and was to last nearly three weeks, as only twenty or so horses were sold each day. Ishmael Pasha purchased some of the horses, and gave many of them away as gifts. The French government bought eighteen horses, Piedmont twenty, Austria two stallions; von Hügel got two more stallions and three mares for Weil, including the desert-bred Gadir. The Italian stud book of 1861 includes eleven Abbas Pasha horses among its entries, but apparently King Victor Emanuel never paid for them. In 1870, Ishmael Pasha re-imported 142 horses from Italy to Egypt, at a cost of twenty thousand Egyptian pounds.

The most important buyer at the auction, as far as the history of the Arab horse is concerned, was a rich young Egyptian named Ali Bey. Better known as Ali Pasha Sherif, he was already the owner of a stud of fine Arabians, and he bought forty of the best at the auction. By purchasing Abbas Pasha's horses, Ali Pasha Sherif became the most influential breeder in Egypt. He was also to receive Italian citizenship as payment in lieu for the horses King Victor Emanuel had acquired at the auction. During the next thirty-five years, Ali Pasha Sherif bred numerous wonderful Arabs, such as the celebrated white stallion Wazir, the mare Horra (out of the same dam and by the same sire) and the chestnut stallion Mesaoud, who, as Lady Anne Blunt explained, 'had that indescribable air of distinction which marks the horses and mares of Ali Pasha Sherif, or rather I should say of Abbas Pasha's breeds, the breeds collected by him … so it is however, the moment one sees other horses beside them, when moving one sees the style of the Abbas Pasha Collection.' Ali Pasha Sherif, like his predecessor, also looked to the desert for new blood, and among his purchases were a white seglawi stallion from the Roala and a chestnut mare from the Qahtan.

The Blunts had first met Ali Pasha Sherif in the autumn of 1880 when he invited them to visit his Arab stud, where they were able to observe: '… the horses most [of whom] were white or grey. The first, Shueyman and of that breed [strain] – handsome with fine head, not very good shoulder. The second called Vizier, a Seglawi Jedran of Ibn Soudan, fine all round, eighteen years old but with no appearance of age … all the horses have splendid legs except a handsome chestnut, Dahman Shahwan [Aziz]. Since our visit to the stud Ali Pasha has promised to let us have in writing a list of his different strains, those he now possesses and those he lost at the time of the disease. Several of them are probably quite extinct as he got them from Abbas Pasha, who had swept the whole of Arabia for specimens of the particular breeds he fancied.' The

Mesaoud, one of the most influential stallions of the breed, bred at Ali Pasha Sherif's famous stud in Egypt. He is pictured here in 1891 at Crabbet Park in England after being purchased by the Blunts in 1889.

Blunts visited his stud again on 14 January 1881, and again on 3 December, when they learnt that he had sold several and given others away. In February 1882, Wilfrid and Lady Anne bought their own establishment in Egypt, the pomegranate garden called Sheykh Obeyd, where they started a second Arab stud. On their next visit to Ali Pasha Sherif's stud, after an enforced absence of some years, they found the palace rather dilapidated, but the horses mostly well. Then on 15 January 1889, Lady Anne was given a list of ten horses and mares that Ali Pasha intended to sell. The Blunts bought three young chestnuts for £220, including Mesaoud, who was to become one of the most celebrated stallions in the history of the breed.

A letter to *The Times* from Wilfrid Blunt, dated 18 January 1897, about Ali Pasha Sherif's celebrated stud in Cairo is worth quoting in part:

This unique stud traced its origin to that famous collection of pure Arab mares and horses made by Abbas I, Viceroy of Egypt, some fifty years ago to obtain which he ransacked the desert of Arabia and broke down by the enormous prices offered the traditional refusal of the Bedouin breeders to part with their best mares.... He thus got together some two hundred mares with stallions to match, the absolute pick of the desert which still are spoken of there with wonder and regret as the most authentic collection of pure blood ever made outside the peninsula. These he established as a breeding stud in a fantastic desert home he created for them half way between Cairo and Suez.... The ruins of the Viceroy's desert palace of Dar-El-Beyda in connection with this establishment and which at a distance look as large as Windsor Castle are still to be seen ... a desolate and romantic spot.... Nevertheless at Abbas' death in 1854 the whole of this desert establishment was broken up. The palace, which had cost a million to build, was abandoned to the bats and owls, and the priceless stud was sent by his heirs to the hammer. At the public auction in that year [1860] great prices were realised ... [of the majority of the horses] so the Arabs affirm, the

most valuable remained in Cairo, the best mares and stallions having been bid for and bought on the advice of Hasher, Abbas' chief Bedouin groom … who best knew the ins and outs of the pedigrees, by Ali Pasha Sherif, then a young man of high family, the largest landowner after the vice-regal family in Egypt and as great an enthusiast as Abbas himself had been about horses.

Under the new management and transferred to Cairo, the stud maintained itself for twenty years or more in full efficiency and continued to be recognised still as beyond question the first and most authentic Arab stud out of Arabia. Ali Pasha made it his one hobby and delight. The brood mares were seldom seen abroad, being kept secluded in their harem like the Eastern Princesses they were, but the horses were a feature in the Cairo streets. They were entered from time to time in the local races and generally won, the horse Wazir being the most prominent of those that were put into training. The Pasha was too much of a Grand Seigneur to sell but he gave away royally to Sultans, Kings and Eunuchs, and the finest stallion now in Abd El Hamid's stables at Constantinople is an old one of his breeding. They were nearly all pure white, the fortunate colour of the East.…

Then misfortunes came. With the Khedive Ishmael's downfall the reign of gold in Egypt ended and Ali Pasha in spite of his immense landed possessions became indebted to his master. The horse plague followed and swept off half his breeding stock in a single year and little by little and year by year since 1882 something was shorn from the magnificence of the stud which was not replaced.… Then came the scandal of the Pasha's arrest two years ago on a charge of slave buying, a somewhat cruel advantage taken of an old-fashioned Turkish gentleman by modern official zeal, and then its consequence his formal interdiction as one no longer capable of managing his own affairs.… It was a sad spectacle when at last the few high born descendants of a race secluded for forty years were led into the light of day and put up to common auction by a common Italian salesman. The broodmares were still beautiful and with all the marks of their high breeding though from long in-breeding and lack of the rigorous conditions of outdoor life somewhat fragile and unsubstantial. Half starved too by the penury of the old Pasha's establishment their ribs could all be counted and it was not surprising that they realised small prices at the bidding. Seven of them, I am glad to think, have been added to the credit of England at the Crabbet Stud, as also one of the three aged stallions, a venerable but splendid ruin … we cannot but be saddened at the final disappearance of what was in its day a noble thing, a type of oriental magnificence past away for ever.

The Blunts were able to make further purchases of horses from the Pasha's stud in December 1896, a few weeks before the auction, which was held on 15 January 1897 and in which sixteen horses were put up for sale. Lady Anne bought the twenty-one-year-old white stallion Ibn Nura for thirty Egyptian pounds and Badia, a chestnut mare of the dahmeh nejiba strain, for seventy Egyptian pounds. She missed getting others, which she regretted, but was able in the following days to purchase Bint Bint Jamila and Bint Bint Fereyha. On 26 January, she learnt from Ali Pasha's attorney that another fifteen horses were to be sold, and she noted in her journal: 'We must get one or two more Ali Pasha Sherif mares, we cannot let others take them.' Within a month, Ali Pasha Sherif was dead and the last remnants of his once celebrated stud were auctioned on 26 March 1897. The stallion Aziz looked glorious despite his twenty years, but he was not sold, there being only one bid of £20 for him. Lady Anne was able to purchase two more mares, Bint Nura es Shakra and Bint Horra with her foal. 'Now,' she said, 'we really have the pick.' However, she continued to purchase further horses of Ali Pasha breeding whenever the opportunity arose. Some of these horses were sent to the Blunts' stud at Crabbet Park, but others were kept at Sheykh Obeyd.

Lady Anne's purchases over the years from Ali Pasha, together with her acquisitions at auction, resulted in her securing the larger part of what remained of Abbas Pasha's stud. At Sheykh Obeyd, Lady Anne now concentrated on maintaining a stud of the finest seglawiehs, nejibas and jellabiehs, all descendants of those original horses of the collection of Abbas Pasha. During the following years, care of Abbas Pasha's and Ali Pasha Sherif's extraordinary legacies rested in the hands of Lady Anne Blunt. Her

Lady Wentworth, daughter of Wilfrid and Lady Anne Blunt, photographed at the Blunts' Sheykh Obeyd stud near Cairo.

concern had been to save these rare strains for posterity, and she worked almost single-handedly. Those in any way involved with the Arab horse are indebted to her, and she was deservedly known as the 'Noble Lady of the Horses'.

Lady Anne Blunt had dealings with several other princes who owned studs. Prince Ahmed Pasha Kemal, a neighbour of the Blunts at Mataria, had been given some horses by Ali Pasha Sherif, and he also purchased desert horses to add to his stock. The Blunts often visited his stud and Lady Anne noted in 1889: 'We looked over the horses carefully and like best an old chestnut kehilet ajuz from the Roala and a little white seglawieh mare of the horses of Ali Pasha Sherif, very beautiful.' Prince Ahmed bred a number of horses that were to be important to the future of Arab horse breeding in Egypt, notably the stallions Dahman El-Azrak and Rabdan, and the mares Roda and Dalal. On the death of the Prince in 1907, the stud passed to his son Yussef, who held an auction the following year, although he had already sold six horses to his cousin, Prince Mohammed Ali. Lady Anne Blunt attended and she finally obtained Roda, a seglawieh tracing back to the horses of Ali Pasha Sherif, and Bint Noma, a bay nowakieh. Prince Yussef continued breeding on a much-reduced scale until 1914, when the stud was dispersed.

Khedive Abbas Hilmi, Prince Mohammed Ali's brother, had shown a keen interest in the horses of Ali Pasha Sherif in his youth. He was presented with two valuable mares, the desert-bred Al-Dahma and Yamama; Prince Ahmed gave him the old stallion Saklawi I, and he also obtained some mares from the desert. Emir Issa al-Khalifa (who ruled Bahrain from 1869 to 1925) presented two dahmehs to the Khedive in 1903. Lady Anne Blunt learnt from Prince Mohammed Ali that the Khedive was selling the two dahmehs, since he did not think that they had perfect Arab type: 'too long and the heads not good enough'. On 17 December 1907, Lady Anne visited the Khedive's stables to see the bay dahmeh, and on 22 December she wrote: 'Thinking it over, she is a fine mare and authentic.' She purchased the mare a few days later, and gave her the name Bint el-Bahreyn.

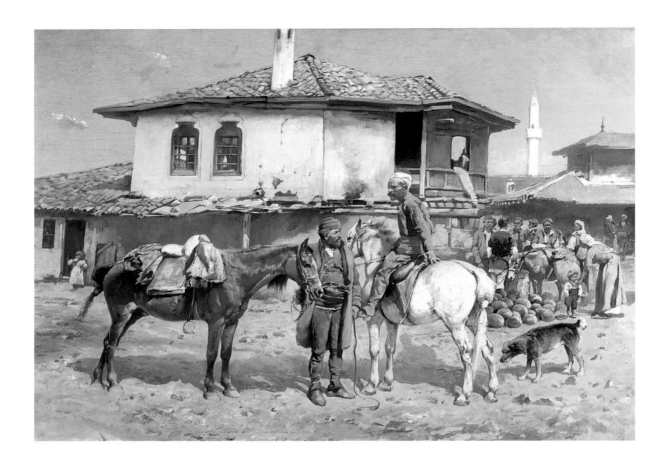

Tadeusz Ajdukiewicz, In an Eastern Market. *In 1877, Count Wladyslaw Branicki, a leading Polish Arab horse breeder, went travelling through the Near East, taking with him the painter Ajdukiewicz, who recorded scenes such as the above.*

Prince Mohammed Ali also established a stud which was to have considerable influence on breeding in Egypt, Germany and America. Lady Anne Blunt was a regular visitor to the Prince's magnificent stables situated at his Manial Palace on Roda Island, and they became good friends. She describes his horses, some of which were gifts from the Khedive, in glowing terms: 'We walked to the stables and saw the stallions first and then came back and sat by the palace wall.... The horses were led to and fro ... it was a brilliant show. There was first a flea-bitten mare ... they called her Roja [Bint Roja].... Second, the chestnut daughter of Bint Roja ... then a chestnut Kehileh Mimrieh.... [Prince Mohammed] had spent altogether one thousand, two hundred pounds for the Yusef Bey horses [actually eight hundred pounds] and Rabdan was a gift. There was a handsome white horse from the Khedive, a Dahman which headed the list of horses.... I also saw the famous black horse of Ahmed Pasha's ... then I was shown the Sultan's gift the horse from the Roala which is really black.... Altogether the beginning of the stud is promising.' After World War I, Prince Mohammed Ali reduced his stud: ten horses went to the Royal Agricultural Society of Egypt, including the old stallion Rabdan, and others were presented as gifts to his uncle, King Fuad. The Prince now concentrated his breeding programme on the kehileh jellabieh strain. Sadly, Prince Mohammed Ali's stud was ultimately dispersed, but all was not lost.

There is a puzzle concerning the origin of the jellabieh mare named Bint Yamama, an outstanding brood mare in Mohammed Ali's stud. Lady Anne, who visited the Prince's stud on numerous occasions, makes no mention of this mare; however, she did see there the old white Yamama [Bint Yamama], half-sister to Mesaoud: but this Yamama was of the seglawieh jedranieh strain. It seems there may have been two or more mares named Bint Yamama – Lady Anne had a mare of the jellabieh strain named Yamama at Sheykh Obeyd. Negma, the daughter of Mohammed Ali's Bint Yamama by the old Dahman El-Azrak, was the dam of Jasir (who went to Weil in Germany) and the mares Roda and Aziza (who went to America) and Mahroussa (who

stayed at the Manial Palace on Roda Island). Mahroussa's offspring Fadl and Maaroufa were purchased by Henry Babson as foundation stock for his stud in the USA.

Shortly before her death in 1917, Lady Anne presented three of her Arab horses to the Royal Agricultural Society of Egypt: a stallion called Jamil (a twenty-one-year-old seglawi jedran who had been one of the last horses bred by Ali Pasha Sherif) and two mares, Ghadia and her half-sister Jemla, both bred at Sheykh Obeyd. Other foundation mares and stallions were later given or sold to the Royal Agricultural Society by princes of the Egyptian Royal family. Prince Kemal el-Din – a nephew of King Fuad, who shunned the demands of state in favour of his horses and hunting with hawks – was president of the Royal Agricultural Society at that time, and in this capacity had visited Sheykh Obeyd to thank Lady Anne for her gift of horses.

Following Lady Anne's death, the horses remaining at Sheykh Obeyd were sold by the executors of her will. There were in all two stallions, six mares, four fillies and three colts. They were not all of unmixed Abbas Pasha descent, as Lady Anne had imported a last group of desert-bred horses to Sheykh Obeyd in 1911. At the auction, Prince Kemal el-Din purchased the important mares Feyda, Dalal, Zarifa and Serra, and Zarifa's colt by Jamil; a Greek dealer named Kasdughli purchased a filly named Durra, daughter of the desert stallion Saadun. The fate of the other horses, including the stallions Sahab and Krush, is not known.

Prince Kemal's stud was to form a vital link in the preservation of the bloodline of the Abbas Pasha horses. Several of his horses, including four mares and five stallions (one of which, Rashid, had been bred

Alberto Pasini, The Palace Guard, *c. 1874. The Ottoman Turks, during their long rule over the Near East, collected the best mares and stallions from the desert, partly as tribute, partly by purchase and partly by skulduggery.*

at Sheykh Obeyd), joined the stud of the Prince's uncle, King Fuad, at Inshass; Bint Serra went to the USA in 1932 and founded a dynasty there; and Mr Thomas Trouncer, a Scotsman living in Egypt, purchased an old mare with two of her daughters from the Prince shortly before his death. These valuable brood mares were selected as the foundation stock for Mr Trouncer's stud at Sidi Salem, where he gathered together a number of mares of a rare perfection and beauty. Two years after Mr Trouncer's death in 1955, an auction of his horses took place. One really beautiful grey filly, Mahasin, by Kasbana and out of Serra (the latter bred at Sheykh Obeyd by Lady Anne Blunt), was purchased by Ahmed Hamza as a foundation mare for his new stud. He had earlier procured three mares from Abdul Hamid of the Tahawi tribe, but was not to acquire his first stallion, the handsome white Hamdan, until later.

The Royal Agricultural Society of Egypt had been founded in 1898, and in 1908 opened a horse-breeding department, which started its programme with British Thoroughbreds. Later, the Society decided to turn to the Arab horse, with which Egypt had long been associated. Khedive Abbas Hilmi had presented a number of his best mares to the Society in 1914 as foundation stock for the stud at Bahtim, near Heliopolis; another expatriate Scotsman, Dr Branch, became the stud's manager. Over the following years, further horses were added to the stud, many being gifts from the Egyptian princes and from Lady Anne; some mares and three important stallions were obtained from Prince Mohammed Ali, and the mare Durra was bought from Kasdughli in 1924.

Bint Gamila, one of the mares that had come from the Khedive's stud, had a foal in 1917 by Rabdan, the old grey horse of Prince Mohammed Ali. Ibn Rabdan, as the colt was called, became the head sire at the stud. Two of his outstanding male offspring were Shahloul and Hamdan, both out of Bint Radia, the daughter of Ghadia (one of the mares of Abbas Pasha bloodlines given to the Society by Lady Anne Blunt).

January Suchodolski, Purchasing an Arabian Horse, *c. 1850. The Arab horse has always been considered as a gift of kings, but today many in all walks of life purchase a piece of equine magic by buying an Arab.*

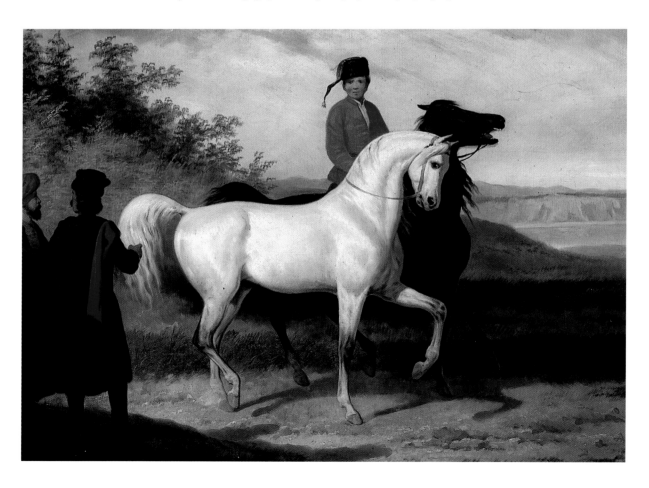

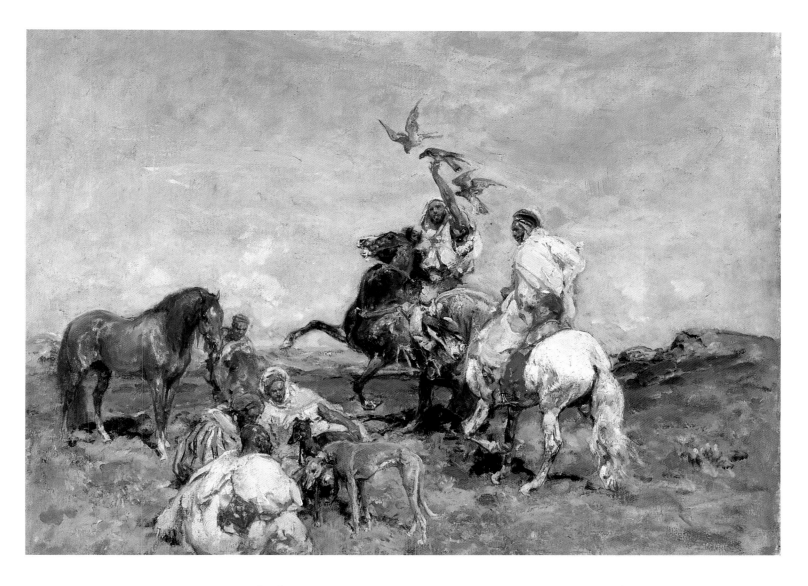

Henri Emilien Rousseau, An Arab Falconer, c. 1890. The Bedouin were renowned huntsmen, both with lance and rifle and also with falcons, which they trained as a means of supplementing their meagre meat diet with prey such as the desert hare and the houbara *bustard.*

Although the Society had been both fortunate and successful in collecting together an outstanding group of foundation mares, there was still a shortage of stallions, particularly as they were needed at depots in the provinces. As a result, in 1919, the Society sent Dr Branch to Crabbet in England in order to secure a group of horses. He returned with eighteen stallions and two fillies, both of which were descended from the Blunts' old desert mare Rodania. Two of these Crabbet stallions went to Prince Kemal el-Din, but the outstanding import was Kasmeyn, descended in tail-female line from the original Jellabiet-Feysul mare of Abbas Pasha, while his sire line was that of Mesaoud. Having established such a strong foundation, the Society was quick to achieve real success and many outstanding horses were bred during the following years. Through his female offspring Bint Samiha and Bint Sabah, Kasmeyn's lineage includes three of the most important stallions of the 1930s and 1940s: Sheikh el-Arab, Sid Abouhom and the legendary Nazeer.

As the stud developed and outgrew its original stables, the Society decided in 1930 to move it to Ein Shams, not far from Sheykh Obeyd in the desert just outside Cairo. The stud's name was changed to Kafr Farouk. In 1932, shortly after the move, Dr Ahmed Mabrouk took over the running of the stud. According to a report written by Dr Mabrouk, the Society strongly opposed introducing any more outside blood into their pure-bred Arab stock, but finally it was agreed as follows: 'If the pure-bred horse is continually inbred a position

would be created where there would be "all pedigree and no horse". Experience has shown that "continual inbreeding produces a deterioration of quality, and that the introduction of new pure blood is essential".'

In 1936, Dr Mabrouk travelled to Arabia in order to find pure Arab horses, hoping to purchase some for the Society. Peace in Saudi, he observed, meant that it was no longer profitable or necessary to keep horses. King Abdul Aziz al-Saud recalled that, twenty years previously, when raids were carried on between the Bedouin, horses had been absolutely essential: 'In the past, a good mare was a means of gain or safety. Fighting was carried on at close quarters with sword, lance or short-range gun, but now with long-range rifles neither the mare's nor her master's life is safe.' The King remembered that he had once counted 450 dead mares after one battle; because of the change in warfare with the introduction of firearms, the Bedouin were anxious to dispose of their horses – usually to the King. Dr Mabrouk reported that the King had about one thousand mares scattered throughout the desert, two hundred of which, being judged to deserve special attention, were kept at Kharg Oasis. Dr Mabrouk visited Kharg Oasis, where he particularly liked a bay stallion, Makhladi, who had been presented by Emir Fawaz al-Shaalan of the Roala. The King recommended that Dr Mabrouk see the pedigree stock of Emir Saud ibn-Galawi at Al-Ehsa, and that of the Emir of Bahrain.

Mabrouk ended his report on the trip, which had little success, with a reminder that the breeding of pure-bred Arab horses had been 'confined to a few who have spent lavishly in their endeavours to preserve and improve the breed. Were it not for the efforts of the Royal Agricultural Society in Egypt, Lady Wentworth in England, the Kellogg Institute in America, the Hungarian Government and Count Dzieduszycki in Poland, we should not have the few fine specimens of Arab horses we have today.'

Dr Ashoub, who had taken over the organization of the stud from Dr Mabrouk in the 1930s, compiled the first official Egyptian Arab horse stud book in 1948. In it the horses are listed in sections under their strains. In 1949, General von Szandtner took over at Kafr Farouk. He selected the very best of the horses and concentrated his breeding programme on these lines. His favourite mare was the exquisitely beautiful Moniet el-Nefous and his first choice of stallion Nazeer.

Nazeer will go down in history as one of the greatest Arab stallions of all time. It is perhaps fitting that on the female side he traced from Venus, and his sire line is that of the fine white seglawi which Ali Pasha Sherif obtained from the Roala. Nazeer's offspring have dominated Arab horse breeding throughout the world since the 1950s. In the USA, Nazeer's male offspring, Morafic and Ansata ibn Halima, and his female offspring, Bint Moniet el-Nefous, Ansata bint Bukra and Ansata bint Mabrouka (full sister to Morafic), have had remarkable success. In 1955, the Marbach stud in Germany imported Hadban Enzahi, whose sire was Nazeer, and who had a significant influence on Arab horse breeding in that country; Ghazal, another stallion by Nazeer, went to Marbach later. In 1963, the Russian state stud at Tersk was presented with Aswan. This son of Nazeer, although somewhat faulty, passed on his Arab type to his numerous progeny. Fortunately, not all Nazeer's Egyptian offspring were sold abroad. Possibly, too many of the best were allowed to go, but the influence of horses of which Nazeer was grand-sire or great-grand-sire is still a potent force.

In 1952, the revolution in Egypt swept the old guard away for ever. The new government seized Inshass, the King's stud, and the best of its horses were sent to Ein Shams; the Royal Agricultural Society became the Egyptian Agricultural Organization. Ein Shams is no longer out in the desert – Cairo's suburbs swallowed it up some years ago – and the Blunts' stud, Sheykh Obeyd, is now a housing estate. The majority of Egypt's private breeders have founded their studs with horses from the Egyptian Agricultural Organization. Notable private studs are those of Sayed Marei, Wegdan al-Barbari, Al-Badeia and Hamdan. This last took its name from a famous stallion. When the Inshass stud came up for auction in 1952, Hamdan was among the horses to be sold. Despite being twenty years old, the stallion was bought by Ahmed Pasha Hamza for his stud.

The Arabians are, above all nations, attached to their Horses, and the most scrupulous, both with regard to their pedigrees, and their care and precaution in breeding. The names, marks, colours, age and qualifications of all the superior stallions and mares, are generally known among the breeders of that country.

(J. LAWRENCE, THE HISTORY AND DELINEATION OF THE HORSE)

IN THE LANDS OF THEIR FOREBEARS

The vagaries of war had earlier affected the power and fortunes of the Arab princes during the 19th and early 20th centuries, but by early 1879, when the Blunts arrived in Hail, the ibn-Rashids were in the ascendancy. They visited the stud of Emir Mohammed ibn-Rashid, which Lady Anne describes as 'the most celebrated in Arabia', and which had surpassed in importance the stud of Feysul ibn-Turki al-Saud, which Mr Palgrave had seen and described some sixteen years before. The Emir was the richest and most powerful man in Arabia, and as such had better means than anyone of acquiring the best horses of the Nejd. The major part of his stud was sent out into the desert for the summer months, where the horses were left with the tribes; each spring, one hundred yearlings, mostly colts, would be sent down to the Gulf to be sold in Bombay. Charles Doughty visited ibn-Rashid's stud in 1892, two years after the Emir had defeated Abdul Rahman al-Saud in battle. He noted particularly 'a very perfect young and startling chestnut mare – shapely as there are few among them, and another mare led through the town [Hail] of perfect beauty; the Emir sent her, his yearly present, with the Haj to the Sherif of Mecca.'

In the early 1900s, the Arabian peninsula was still a land of tribes that fought amongst themselves for control of land and resources. Horses were trusted companions in life and battle and possession of horses

Carl Vernet, Arabian Horse, c. 1820. Horsemanship in the Near East developed over thousands of years. An 8000 BC rock carving in southern Turkey, showing a long-maned and long-tailed horse at the gallop, is reputedly the earliest evidence of the characteristics of the Arab breed.

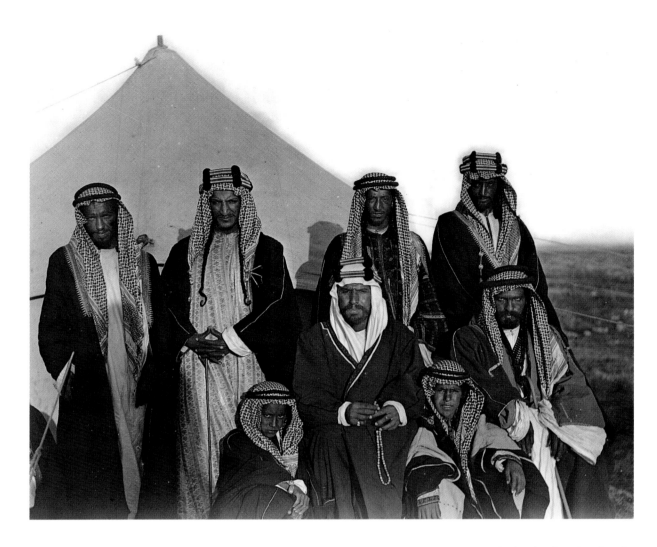

King Abdul Aziz al-Saud (seated second from right), photographed by Col. W. I. Shakespear at Thaj in 1911. The founder of Saudi Arabia, the King was a great horseman-warrior whose stables at Kharg Oasis were the last great desert collection in the history of Arabia.

was considered a sign of wealth. They were often presented as gifts between leaders and families. In 1913, Sherif Hussein of Mecca gave two black Arab stallions to the King of England. Soueidan, foaled in 1912, was the issue of the pure-bred mare Saada by the Sherif's kehilan ajuz stallion. The mare's lineage traced back to the horses of Hussein's great-uncle Abdullah, and they in turn traced in tail-female line to a mare from the stud of Emir Mohammed ibn-Rashid. The lineage of the second stallion, Soueidan el-Saghir ('Soueidan the Younger') traced on the female side to a mare presented to Abdullah by ibn-Saud. Some years later, ibn-Rashid sent Lalla Rookh, a flea-bitten grey saadeh togan foaled in 1913, as his gift to the Sherif; this mare was eventually exported to England.

In 1924, Sherif Hussein went to live in Cyprus and took two mares and two stallions with him. Sir Ronald Storrs, then British High Commissioner in Cyprus, relates how Zahra 'the gentlest and most graceful would step delicately up the flight of marble stairs from the garden and walk without shyness into the Salamlik to be greeted by cries of "Ahlan, Ma Sha Allah. Allahu Akbar" or "Qurribu, ya bint ammi." The king would call her "Qurrat al-Ain" ("cooling of the eye-lids") and offer her dates which she would eat slowly, never failing to leave the stones on the plate.' A groom, having been dismissed, took revenge by fatally injuring two of the horses, including Zahra, so the Emir sadly sold the remaining mare and stallion. This mare, a kehileh named Hegazieh, was eventually acquired by Mr Thomas Trouncer, the Egyptian-based Scotsman. She was described as being of 'beautiful proportions, her head typical of the type so often heard of, but rarely seen'.

By 1921, the ibn-Sauds finally gained the upper hand against the ibn-Rashids; King Abdul Aziz al-Saud took to his own stud the ibn-Rashids' famous white krushieh. By the late 1920s, lasting peace had been secured in Saudi Arabia, which virtually put an end to the constant raiding which had so devastated the Bedouin tribes. In the new status quo, war mares were no longer as valued as they had been in the past. As a result, many of these desert mares were presented to the King, who had a reputation as a great horseman, and the best of them were kept at the Royal Stud at Kharg Oasis. The King also gave away a large number of horses as gifts: a grey mare, Dafina, left the stud for England in 1927; she was of the rare kehilet el-krushieh strain, again bred in the Nejd by the Muteyr. A group of four horses were sent to King George VI of Great Britain in 1937, and two of these, the stallion Manak and the mare Turfa, appear in modern pedigrees in Britain and America. Of those horses presented to Kings Fuad and Farouk of Egypt, El-Kahila, Hind and El-Obeya Om Grees were all to establish important lines, which were transferred in the 1950s to the Egyptian state stud.

Today, the body concerned with Arab horse affairs in Saudi Arabia is the Dirab Horse Centre (Dirab), the registration authority for Arab horses. Established in 1964, the Dirab has become known as a modern, successful breeding facility whose director is keenly aware of the role of the Arab horse to his country and of its significance in the historical and religious traditions of the people. In November 1996, the Dirab organized and hosted the first national Arab horse show in Saudi Arabia; it has also worked closely with the Saudi Arabian Equestrian Federation (SAEF) organizing endurance racing throughout the kingdom. The Centre is situated near Riyadh, and currently houses more than two hundred pure-bred Arab horses; several of the brood mares are descended from the horses of King Abdul Aziz al-Saud.

Many of the Saudi princes also maintain large studs of Arab horses of their own, notably Crown Prince Abdullah bin-Abdul Aziz (who keeps a number of desert mares at Kharg Oasis), Prince Khaled and Prince Sultan bin-Abdul Aziz (who has a very old but magnificent flea-bitten grey desert stallion, El-Hamdany). Several studs, including that of Abdullah ibn-Farhad al-Swailem, now import horses from Egypt, England and the USA.

The emirs of Bahrain have, in the manner of their ancestors, carefully preserved the pure-bred Arab horse. The al-Khalifas came originally from the Banu Utuba of the southern Nejd. Then, in about 1670, the group migrated to the Gulf region, and in the early 18th century the families settled and founded the city of Kuwait. In the 1750s, Sheikh Mohammed bin-Khalifa left his cousins, the Al-Sabeh, and went southwards and established Zubara on the northwest coast of Qatar. The city was attacked in 1783 by the Governor of Bahrain, Sheikh Nasser ibn-Mathcoor. Sheikh Mohammed's second son, Sheikh Ahmed al-Khalifa, repulsed the invading army and then seized Bahrain, thus becoming its ruler.

The al-Khalifas have been breeding Arab horses for centuries and their stud was the source of some of the best horses obtained by Abbas Pasha for his famous collection. Following the Arab tradition, the al-Khalifa emirs also gave away many of their rare horses as gifts to honoured guests and foreign dignitaries. In the 19th century, Sheikh Mohammed al-Khalifa sent horses to Feysul ibn-Turki al-Saud. One was the important Jellabiet-Feysul already mentioned, and another a dahmeh usually known as Faras Nakadan ('the mare of Nakadan'). Both of these mares went to the collection of Abbas Pasha. Sheikh Mohammed also sent gifts of horses to Egypt and to the Sultan of Turkey.

Emir Hamed bin-Issa succeeded his father in 1925, and it was during his reign that two horses left his stud: Nuhra, a mare of the wadnah strain who was to have a great influence on Arab horse breeding in England, and Kuhailan Afas. This bay yearling colt went to Poland in 1931 and stood at stud at Gumniska until 1939, although sadly many of his offspring were lost during World War II. In the 1930s, the Sheikh received some seglawiehs and hamdaniehs from Abdul Aziz al-Saud, and two hadfehs from Abdullah ibn-Jasim al-Thani of Qatar.

Unfortunately, the wadnah strain has all but died out in Bahrain, but the kehileh jellabieh line flourishes. Many other family strains are still preserved by the emirs of Bahrain: the dahmeh, hamdanieh, kehileh, managieh, abeyeh, seglawieh, shuemah and rabdah. Important stallions in Bahrain in the 1940s and 1950s were Speckled Jellabi and Krushan (by Speckled Jellabi and out of Krush el Araibi, a krush mare presented to Sheikh Sulman al-Khalifa in 1948 by Sheikh Mohammed el-Araibi of Amara). The al-Khalifas are the only ones to have preserved some extremely rare strains – the suwaitieh, tuwaisah and the kray – and to have maintained a stud whose foundation mares and horses are all Bedouin-bred. They have never allowed the import of horses from outside Arabia to taint the purity of their horses: Sheikh Issa bin-Sulman (the present Emir), Crown Prince Sheikh Hamed and Sheikh Mohammed bin-Sulman zealously preserve their 'pearls of the Gulf'.

The Hashemites, descendants of the Prophet Mohammed, claim a long association with the Arab horse, for Rabiah 'al-Faras', who had owned the horses of his ancestors, was their ancestor. At Mecca, the Sherifs had long maintained a stud of Arab horses, and from there some went to Abbas Pasha's famed collection. Following the great Arab Revolt in 1916, which led to the end of Turkish rule and the creation of the Hashemite Kingdom of Jordan, Emir Abdullah founded the Royal Stud. During the revolt, horses from Mecca and the Hejaz had been ridden into battle and used for the great march north and the harrying of the Turkish army. The tribes gathered under the banner of the Sherif of Mecca and rode north to Damascus. Sheikh Jweibar, standard bearer to Emir Abdullah when in his ninety-second year, recounted which of the horses came from the Hejaz: 'There were many of them and they were pure-bred Arab horses. One was Freiha whom al-Sherif rode in the battle of Turba, another a kehilet el-krush (Safra), and a kehilan.' Seven mares and five stallions were chosen from among the desert horses to become the foundation of Emir Abdullah's stud.

Emir Abdullah took a personal interest in the horses and in the breeding programme, which concentrated on female lines. Other mares came as gifts from the sheikhs of the Aduan, Daaja and Majali. The seven

Juliusz Kossak, Wawrzyniec Fredro Entering Constantinople in 1500, *1883. The scene depicts the entry of the Polish envoy to the Sublime Porte as ambassador to Sultan Bajazet I.*

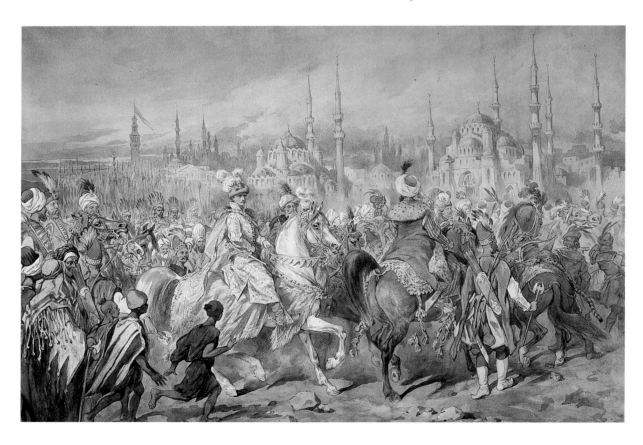

foundation mares were of the kehilet ajuz, kehilet el-krush, um argub, kubeysha, hamdanieh simrieh, abeyeh abu jeres, and managieh strains; all these families are still represented in the stud. In 1940, the stallion Selman, a gift from King Farouk of Egypt, joined the nucleus of superbly bred old desert mares. Selman had a profound influence as the sire of outstanding brood mares, including Emira I, out of the krushieh Jamila (one of the war mares), and Farha, whose grand-dam Freiha was ridden in the battle of Turba. Two Spanish stallions were presented to the Emir by Generalissimo Franco in 1948. One of them, Ushaahe, made a further contribution to the stud's development in siring stock out of mares by Selman, notably Gazella out of Emira I, and Samiha out of Farha. Ushaahe also sired the magnificent flea-bitten grey Bahar, who for many years served as the stud's senior stallion.

In 1951, the assassination of Emir Abdullah stunned the country. The succession passed to his grandson, King Hussein, but during the following years more pressing matters required the King's attention and the stud was nearly lost. Fortunately, the precious old mares were saved: Gazella, the white krushieh, was found pulling a plough and descendants of the original war horses were once again stabled at the Royal Stud. King Hussein had always regarded the Arab horse as a part of Jordan's heritage, not least because some of the greatest of the horse-breeding tribes lived within Jordan's borders. The future appeared secure with the stud in the hands of the Gibraltarian Santiago Lopez. However, it found itself in grave danger on 5 June 1967, during the Six Day War. The horses were down at Shuna, by the River Jordan, and the swiftness of the advance of the Israeli forces put the stud in jeopardy. Urgent action was needed and, as soon as night had fallen, Santiago Lopez and the Bedouin grooms, each riding a horse and leading others with the remainder following loose, slipped quietly away. They reached Amman and safety after a hazardous twelve-hour journey.

The stud, now the Royal Jordanian State Stud, is situated in the country northwest of Amman, the stables built around a series of arched courtyards housing some two hundred Arab horses. The stud is now supervised by Princess Alia, King Hussein's eldest daughter, admired throughout the equestrian world for her knowledge of, and devotion to, the Arab horse. Although the stud still preserves the families of the seven original mares, new blood has been introduced when necessary through imports from abroad. In 1988, the first 'Arab Horse at Home' was held at the Royal stables and eight Arab countries brought horses to the event. Its success led to the annual show now held in Amman, and the Middle Eastern Championships.

For many years, Syria was considered to be first among the Arab countries as a source of pure-bred horses. The great horse-breeding tribes of the Anazeh pastured their camels and mares in the desert to the east and north of Damascus, and it was from these tribes that Europeans and Americans were to buy many of the horses which became the foundation stock of the great studs of Europe and the New World. Dr Mabrouk recalled proceeding during his 1936 expedition 'on a trip to the Shammiah [Syrian] desert. I found on the way that the horses were nearer the desert type, because most of the owners are Bedouin.' He tried to buy some mares, but was unsuccessful.

Over the ensuing years, the Bedouin sheikhs and others in Syria, such as Dr Iskander Kassis, continued to maintain pure-bred Arabians, but it was not until the 1980s that a group of Syrians dedicated to the cause of the breed began the painstaking task of recording details of their horses. In the first Syrian Arab horse stud book there are six hundred foundation Arabs of fifty-two different strains, a treasure house of new bloodlines, for the most part unrelated to other strains around the world. Basil Jadaan and Hisham Ghrayeb are among the breeders near Damascus, while one of the largest studs is that of Sheikh Mustafa al-Jabri at Aleppo. Both the Tai and Shammar tribes still breed and preserve the 'horses of their forefathers'.

Oman has long been associated with the Arab horse. During the 19th century, the Imam of Muscat gave numerous high-caste Arabs as presents to the crowned heads of Europe. Queen Victoria wrote in her diary in 1852: 'We went to the stable, where we saw two fine horses, which Albert has received from the Imaum of Muscat … the second one is the greatest little beauty I ever saw, a perfect little animal … such a head

and crest, carrying his tail so beautifully, and when he steps he seems hardly to touch the ground.' Given the name Imaum, he was subsequently acquired by the celebrated horse-painter J. F. Herring, and appears on many of Herring's canvases. Old records exist in Oman which list hundreds of Arab horses in the Royal stables. More recently, Sultan Qaboos bin-Said has established a Royal Stud with imported stock. The stud is today home to several breeds of horse, including Arab horses of French, Polish, Russian, British and American bloodlines.

The United Arab Emirates is a federation of seven separate sheikhdoms, each with an independent ruling family. The growth of interest in the Arab horse here in the late 20th century has been largely due to the President of the Emirates and Ruler of Abu Dhabi, Sheikh Zayed bin-Sultan al-Nahyan, in whose view horse-owning and horse-breeding are a valued part of Islamic culture.

Camel and horse racing are traditional in this part of the world. Early races were impromptu affairs in celebration of a grand wedding, a visiting dignitary or similar occasion. It therefore comes as no surprise that, with oil wealth and the rise of popularity of Arab horse racing in Europe and the USA, the ruling families of the UAE should become heavily involved in the 'sport of kings'.

The Royal stables of Sheikh Zayed of Abu Dhabi are home to some two hundred Arab horses. One of the foundation stallions, Aboud, an English-bred horse of Crabbet bloodlines, was personally selected by the Sheikh. Magrabi (Lahrir), presented to Sheikh Zayed in the early 1970s by King Hassan II of Morocco, was a stallion of French bloodlines. His last foals were born in 1987, and mares by Magrabi form an important part of the breeding programme. Another stallion of interest was Dahman Al Asfar, a hamdani simri bred

The mount of Sultan Abdul Hamid II, Constantinople, c. 1885.

Stanislaw Chlebowski, The Austrian War Episode, *c. 1870. Stanislaw Chlebowski (1835–1884) was a pupil of Jean-Léon Gérome and lived for a long time in Constantinople, where he painted for Sultan Abdul Aziz.*

at the Dirab, a gift from King Faisal bin-Abdul Aziz. An excellent racehorse, the stallion's offspring include the mare Dahma Romaniya and the stallion Turefi Dahman, a senior stallion at the Royal stables in the 1990s. The stables are currently home to both modern imports (Arab racehorses from France and the USA, including the French-bred Chaikh Man) and Russian and English horses of the classic type.

The Zabeel stables in Dubai concentrate on racehorses for the ruling Maktoum family, who have an international interest and involvement in the game. Their horses are mostly of French and American bloodlines, and they have some of the finest and most advanced equestrian facilities in the world. Victoria's Secret is the jewel in the Dubai Crown Prince's Arab racehorse breeding programme, centred at his farm at Hatta near the Omani border. Although Sheikh Mohammed bin-Rashid al-Maktoum is better known in racing circles as perhaps the world's largest and most important Thoroughbred owner and breeder, his love for the Arab horse has come to the fore in recent years, making him also the biggest breeder of Arab racehorses, with stud farms in France, England and the United States.

The Ruler of Sharjah, Sheikh Sultan al-Qasimi, has a small but elite stud of Arab horses. The Sheikh and his daughter, Sheikha Noor, are personally involved in the stud, and aim to produce horses that retain the true characteristics of the breed.

The al-Thani family, the Royal family of Qatar, has a long history of association with the Arab horse. In the early years of the 20th century, they presented horses to the al-Khalifas of Bahrain, and to the

ibn-Sauds. More recently, many of the Qatari sheikhs have searched the world for the very best horses available with which to establish their studs. Today, some of the most sought-after of all Arab horses are in the studs of Sheikh Hamad bin-Khalifa al-Thani (the Emir of Qatar), Sheikh Abdulaziz bin-Khaled al-Thani and Sheikh Nawaf bin-Nasser al-Thani.

The Emir's Al Shaqab stud was founded in 1993 and now houses some 220 Arab horses, mainly of Egyptian bloodlines. Their most outstanding stallion of recent years was possibly Ansata Halim Shah (imported from the USA). The Umm Qarn stud (which has a branch in England), owned by Sheikh Abdullah bin-Khalifa al-Thani, and the Al Shahaniah stud, owned by Sheikh Mohammed bin-Khalifa al-Thani. were founded on a wide base of bloodlines, with the emphasis mainly on racing and performance sports. Two studs with strong links to the show-ring, and with mainly Egyptian bloodlines, are the Al Rayyan stud, owned by Sheikh Abdulaziz bin-Khaled al-Thani, and the Al Nasser stud, owned by Sheikh Nawaf bin-Nasser al-Thani. The Al Naif stud of Sheikh Abdullah bin-Nasser al-Ahmed al-Thani, where the emphasis is equally on showing and racing, is one of the most recently founded in Qatar.

Many in Qatar take a keen interest in Arab horses; several are prominent in the Qatari Racing and Equestrian Club. The first Qatari international Arab horse show took place in 1992, and today combines with the Qatar International Desert Marathon and the main race meeting in an event known as the Festival of the Horse. Racing is extremely popular in Qatar and interest in the sport is growing. The season runs from November to May, and includes the Emir's Sword Race; some Qatari owners also take their horses to Europe for the summer racing season there.

Some of the Bedouin horse-breeding tribes pastured their flocks in the land between the Tigris and Euphrates in what is now Iraq. The Shammar and their allies the Zoba were further to the north, while southwards could be found the powerful Muntifik and the Dhafir. Many desert horses imported to Europe and Egypt during the nineteenth and early twentieth centuries came from these tribes.

Later, King Faisal of Iraq kept a Royal Stud, based on similar foundation stock to that owned by his brother, Emir Abdullah of Jordan. All this was swept away in the bloody Iraqi coup of 1958, and the horses in the Royal Stud were lost or killed. That is, except for one grey colt named Mehrez, bred by the King's friend Daoud Pasha al-Daghestani. A groom slipped the horse quietly out of the country and into Jordan, where he was finally presented to the King. Mehrez became one of the most famous and influential stallions at the Royal Jordanian Stud.

Evidence for the horse in Iran stretches back some 5,000 years to the Elamite civilization of southern Iran, which was contemporaneous with the Assyrian civilization. Wilfrid and Lady Anne Blunt met Ali Gholi Khan at Hail in 1879, who promised them an introduction to his father, the chief of the Bakhtiari tribe of southern Iran. He had, they were told, a very fine stud of Arab horses. Unfortunately, the visit did not take place, for it would have been fascinating to have had a detailed record of these *asil* horses of Persia. One Bakhtiari horse named Zil was exported to Britain in 1900, it having been given to Sir M. Durand by one of the Persian princes, who got it from the Bakhtiari tribe.

Earlier records exist which express the importance of pure-bred horses. Kasravi in *Five Hundred Years' History of Khuzestan* mentions how 'Every other year [Mobarek would send to the King] ... a present of fifteen pure-bred horses', and in the 19th century, the Kaab tribes paid taxes in cash and *tazi* (*asil*) horses. It is not possible to leave the *asil* horses of Iran without mention of Mary Gharagozlou, for she is 'the lady of the *asil* horse of Iran'. Almost single-handedly, she has saved the Arab horse there, including those of the Bakhtiari tribe.

The Ottoman Sultans had for centuries received gifts of Arab horses from the countries over which they ruled. In 1861, Sultan Abdul Aziz, wishing to form a new stud of oriental horses, sent a purchasing commission to Bialocerkiew, Count Branicki's stud in Poland, which had gained a reputation for breeding such horses. One

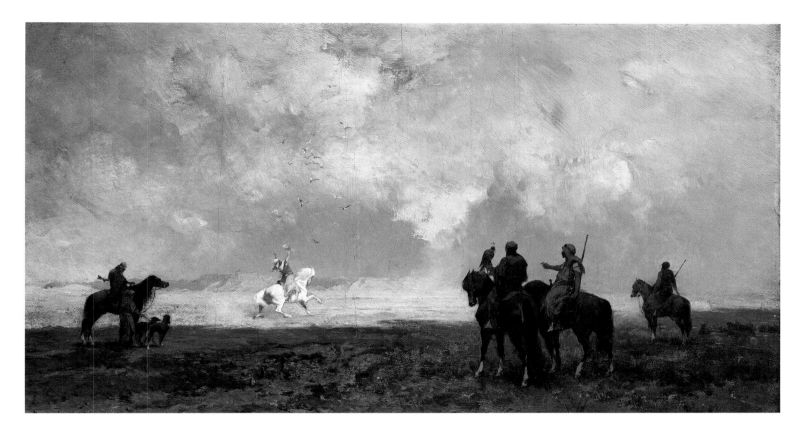

Alberto Pasini, An Arab Hawking Party, *c. 1867. Traditional desert hawking companions are man, horse, falcon and saluki.*
The passion of the Bedouin of Arabia for falconry is unbounded even today.

of these, imported from England in 1855, was the stallion Indjanin, and some of his male offspring were among the ninety-two horses purchased by the commission. In 1879, Sultan Abdul Hamid II sent two stallions from the stables, Leopard and Linden Tree, as gifts to President Grant of the USA.

When the Blunts visited the Imperial stables in 1893, about 1,700 horses were being kept there. Lady Anne noted a 'first class Arab mare' from ibn-Rashid and a 'white Seglawi called Asshab.... A perfectly magnificent one that is as lovely as a gazelle' from Ali Pasha Sherif. Homer Davenport, an American who had become interested in Arab horses after seeing some Syrian specimens at the Chicago World's Columbian Exposition in 1893, visited the Imperial stables in Constantinople in 1906. He thought the horses of good blood, though perhaps not all would please the Bedouin. They were badly kept, and a large number of finely bred stallions were going to waste.

With the establishment of the Republic of Turkey in 1923, new national studs were founded, including Karacabey, Anadolu and Sultansuyu, originally Sultan Ahmet's stud. The foundation horses for these national studs included a small number from Abdul Hamid II's stables, and horses purchased in 1925 and 1936 from the Urfa region of eastern Turkey, as well as from the Arab countries. Since the establishment of the national studs, all horse breeding in Turkey has been well documented. Today, breeding is also carried out by many private studs, which also buy, principally for racing, which is very popular in Turkey.

Fleet-limbed and beautiful! Farewell! Thou'rt sold, my steed, thou'rt sold!

(The Hon. Mrs Norton, *The Arab's Farewell to His Steed*)

THE ARAB HORSE IN EUROPE

The 19th-century desert travellers seeking the Arab horse had a great influence on the history of the breed. Their imports to Europe marked the start of Arab horse breeding in non-Arab countries, and it is to these imports, and the studs which grew from them, that we now turn.

Continually forced to wage wars with predatory neighbours and to keep a cavalry force under arms, the Poles early discovered the superb qualities of stamina, endurance and speedy regeneration of strength possessed by the Arab horse. As early as the reign of King Sigismund Augustus (1548–1572), there was a Royal Stud in Knyszyn, whose task was 'the breeding of pure-bred Arabian horses without any mixture'.

In the 17th century, Polish noblemen sent emissaries to search out the noblest desert horses from the Middle East with which to establish studs which were to play a decisive role in the history of Arab horse breeding in Poland. Of particular importance were those of Prince Sanguszko at Slawuta, Count Branicki at Bialocerkiew, Count Dzieduszycki at Jarczowce and Count Potocki at Antoniny. The studs at Gumniska and Antoniny were founded with mares from Slawuta.

Throughout Europe in the 19th century, Arab horses from Poland contributed greatly to the breeding of pure-breds and half-breeds. A few, in particular, deserve mention: the silver-grey Obejan Srebrny, born in 1851, whose line descends through the foals he sired at Strelets to the Russian stud later known as Tersk; the stallion Bagdady, who distinguished himself at Hungary's Babolna stud; Ban Azel who was sold to Emperor Franz Josef for the stud at Lipizza; and the grey Skowronek, from the Antoniny stud, whose story is told later. Between 1908 and 1912, the government studs of Spain acquired a group of Arab horses from Slawuta and other Polish studs, among them the stallions Ursus and Van Dyck, whose lines are active in Spain to this day.

World War I wreaked havoc on Poland, and Slawuta, Bialocerkiew and Antoniny were destroyed in the aftermath of the Russian Revolution. The story of Count Josef Potocki is typical of these tragedies. Count Josef owned the stud at Antoniny; he had inherited some Slawuta horses through his mother Maria, the daughter of the first Prince Roman Sanguszko, and had imported others. The desert stallion Pharaoh was purchased from Crabbet in 1882 at a cost of 500 guineas, and other mares and stallions came from Egypt, Turkey, India and Arabia. Count Potocki died in 1918 defending his stud from the Bolsheviks. His brood mares were burnt alive, and the stallions hanged or beheaded.

Théodore Géricault, George IV as Prince of Wales. *The Prince Regent in the uniform of a General of the Hussars, painted from an engraving after G. H. Harlow during Géricault's London visit of 1820–1821.*

January Suchodolski, Sobieski's Squire, *c. 1850. John III Sobieski, King of Poland, achieved his greatest glory when he relieved the Turkish siege of Vienna in 1683 and drove the Turks from the Imperial capital.*

The Dzieduszycki family had long maintained a stud of horses at Jarczowce, and most of the horses from the stud were also lost, stolen or killed during World War I. Over the years, the family had procured many from the Middle East. In 1840, Count Juliusz bought the wonderful desert stallion Bagdad, though he had to pay Gliocho, a Greek dealer, an enormous price. His interest awakened, Count Juliusz then travelled to the desert, staying there for two years before returning in 1845 with seven stallions, including Abu Hejl, and three mares. This trio of grey kehilehs, Sahara, Mlecha and Gazella, were to found the most important female lines in Poland.

Out of five hundred broodmares at the Polish studs, only forty-six survived to be entered in the new Polish stud book in 1926. However, the state stud at Janow Podlaski, re-established in 1918, collected the most valuable of the remaining stock, including four mares tracing to the trio of grey kehilehs at Jarczowce. A Polish Arab horse breeding society was established in 1926, and Arab horse racing became popular at about the same time.

Prince Roman Sanguszko was killed in 1917 during the Russian Revolution, and his great stud dispersed. At Gumniska, Prince Roman III slowly gathered together what horses remained, and out of the ashes the stud was established once more.

Like his ancestors, Prince Roman III was forever seeking fresh bloodlines. His thoughts turned to the desert, and in 1930 he sent his stud manager, Bogdan von Zietarski, accompanied by the German Carl Schmidt (who later took the name of Raswan, for reasons that will be explained), on what was to be the last great expedition to the desert in search of Arab horses. They travelled far into the desert, then south to Bahrain, where von Zietarski bought a bay yearling colt of the kehilan afas strain from Emir Hamed ibn-Issa al-Khalifa. Hearing of a kehileh known among the Bedouin as the Pearl of Arabia, they sought her out with the help of the British consul, and were able to acquire her too. Von Zietarski met the great Roala tribe near Jauf, and was fortunate to get an eight-year-old bay stallion of the kehilan haifi strain, bred by Khalif al-Auad of the Al-Majali; von Zietarski later wrote in his report of the mission: 'It is just the horse I am seeking.'

In 1931, von Zietarski returned to Gumniska with five stallions and four mares, including the Pearl of Arabia. Kuhailan Zaid, one of the stallions from the Wuld-Ali, had been purchased specially for Babolna, the Hungarian state stud. The other stallions included Kuhailan Haifi and Kuhailan Afas, founders of important lines in the world today. Kuhailan Afas (from the stud of Emir Hamed ibn-Issa) gave the world the marvellous Comet, but perhaps the strongest Polish sire line today is that of Kuhailan Haifi. Von Zietarski recalled the excitement he felt when he first saw this stallion in the Roala camp near Jauf. It was the same tribe from which Abbas Pasha had obtained his seglawieh sudaniehs in the 1850s, and Ali Pasha Sherif the famous old

white Saklawi. Among the first foals born to Kuhailan Haifi was Ofir, one of the greatest sires in Polish breeding and known as 'the regenerator of the race'. He stood at Janow Podlaski from 1937 until 1939, when he was among the horses taken by the Russians (see below). Although few of his stock were saved, just four male and four female offspring, most achieved world fame: the most celebrated were Witraz, Wielki Szlem and Witez II. Witraz was the most eminent sire; his son Bask became the leading sire of champions in the USA, and a founder of dynasties in his own right. Witraz's female offspring were equally outstanding. Bandola, the 'Legend of Janow', was queen of them all. This flea-bitten grey mare of uncommon beauty and dignity provided Poland with Bandos and Banat, two stallions that became the chief progenitors of their own sire lines. Kuhailan Haifi also sired Czort, perhaps the most prominent sire ever of race-winners, including Sambor and El Paso.

Poland was invaded once again in 1939, and in September the Soviets took the horses of the Janow Podlaski stud away, including the incomparable Ofir; they never came home. Finally, they were moved to the stud at Tersk and made an invaluable contribution to Russian Arab horse breeding. Re-established under German management, Janow Podlaski was evacuated once again in 1944 to Germany. Thanks to the devotion of the Poles who accompanied the horses, the stud survived and returned to Poland in 1946, bringing two sons of Ofir (Witraz and Wielki Szlem) and Amurath Sahib, stallions who were to play key roles in post-war Polish Arab horse breeding. In that year, fifty-two mares were registered in the Polish Arab horse stud book.

Reconstruction of Janow Podlaski was completed in 1961, and by 1973 three more studs, at Michalow, Kurozweki and Bialka, had been established. Today they boast around three hundred broodmares, a genetic pool representing seven sire lines and fifteen dam lines, the oldest reaching back more than twenty generations to 1790 and the Slawuta stud of Prince Sanguszko. All three-year-old horses must undergo a racing and endurance test, which ensures that only the best will be used for breeding.

Polish Arab horses have been sought by breeders all over the world, not only for their beauty, correct conformation and movement, but above all for extremely high performance abilities, proved in racing and endurance competition: Banat, Bandos, Etruria, Penitent, Pilarka, Dornaba, Aramus, Wizja, Gwalior, Elkana and Erros are but some of the Polish high achievers. The huge success of the state studs of Poland has also depended on the knowledge and skill of the directors: Dr Skorkowski laid the foundations for the success of the Polish studs and, more recently, under the long directorship of Dr Ignacy Jaworowsky, Michalow has received great acclaim.

The history of Hungary is marked by long periods of occupation by foreign powers. For

Juliusz Kossak, Adam Potocki, c. 1870. Count Potocki, a descendant who founded the Antoniny Stud in Poland, was murdered in 1918 defending his stud from the Bolsheviks. The mares were burnt alive and the stallions hanged or beheaded.

173 years Hungary was ruled by the Turks, then in 1699 it became part of the Austro-Hungarian Empire. The Turks had brought with them their interest in the Arab horse, the Ottoman sultans having long appreciated the special qualities of the breed, and since they also controlled Arabia, they had a ready source of horses from the desert. Their passion was taken up by members of the Hungarian aristocracy.

In 1811, Tajar, a white Arab stallion of exceptional beauty, arrived in Hungary, destined for the stud of Count Josef Hunyadi. Tajar had been the mount of one of the Mamelukes massacred by Mohammed Ali, and Count Rzewuski, being in Cairo at the time, had been able to purchase the horse. In that same year, Baron von Fechtig had also imported four Arab stallions, who were quickly sold. Using agents in the Middle East, he started importing Arab horses regularly for the European market. Bairactar and Murana I, two of his 1816 consignment, went to the stud at Weil in Germany. In 1821, the Baron started breeding his own Arab horses, and had great success for the next twenty-nine years.

The Babolna stud in Hungary, founded in 1789, is housed in magnificent classical buildings surrounded by open and pleasant landscape. In 1816, it was decided that only oriental stallions would be used in an effort to effect an improvement in the stock. Stallions were obtained through Baron von Fechtig and the dealer Gliocho. Sadly, Babolna was to have its share of disasters and epidemics, which badly affected the

Juliusz Kossak, Mohort Presenting the Stud Farm, *1858. Juliusz Kossak was famous in the nineteenth century for his magnificent horse studies. An able horseman and hunter, Kossak was a frequent guest at aristocratic estates in Europe. This painting depicts the mythical knight Simon Mohort presenting his beautiful Arab horses grazing on the vast Ukrainian Steppes.*

development of the stud. In order to obtain new breeding stock, Major von Herbert was sent to Syria and returned with stallions and mares. Shagya, one of the stallions, a grey bred by the Banu Sakr tribe, was to found a breed of his own, which is named after him. Von Herbert made a successful visit to Egypt in 1843, bringing back a further nine stallions. Horse numbers at the stud were then over six hundred and all seemed well for Babolna's future. Following the Austro-Hungarian wars in 1848, Colonel von Brudermann, head of the Babolna stud, led a most successful journey to the desert in 1856, returning a year later with sixteen stallions, fifty mares and a Bedouin boy who had been unwilling to leave the horse of his father. Two of these stallions were selected by the Emperor Franz Josef for the stud at Lipizza.

Babolna was firmly established, and during the following years the Bedouin boy, Fadlallah el-Hedad, grew up to become an army officer. In 1885, he led a further expedition to Arabia in search of horses. O'Bajan, a black managhi stallion, was to become the most famous of the four stallions and five mares purchased on his journey. O'Bajan's remains lie at Babolna and on his gravestone is written: 'O'Bajan. Sire O'Bajan. Dam Manechie. Born in 1880 at Tell-El-Keladi, Syria. Bought for 6,000 Francs in 1885; for 25 years he covered mares here. He sired 312 foals

Albrecht Adam, King Wilhelm I of Württemberg, *1830. King Wilhelm I of Württemberg founded the famous German stud at Weil in 1816 with Arab horse imports from the deserts of Arabia.*

of whom 112 became premium stallions and 56 brood mares. Died 1910.' Colonel Fadlallah made two more journeys to the desert, in 1897 and 1901. Finding good, pure-bred Arab horses was becoming more and more difficult, and Fadlallah began to think that his last mission would fail. A year later, he arrived back at Babolna with four mares, including Semrie of the umm argub strain, and the important stallions Mersuch and Siglavy Bagdady.

The stud suffered at the end of World War I, when the Romanians seized more than a hundred horses in 1919. Babolna was badly in need of a good stallion after this major loss, but it had to wait some years before it found one. In 1931, the desert stallion Kuhaylan Zaid, specially chosen for them by Bogdan von Zietarski, arrived at Babolna. The stallion proved an extremely successful sire, and once again Babolna became firmly established among the greatest studs of Arab horses in the world.

Like the studs of Poland, Babolna also fared badly during World War II. In 1944, many horses were lost or sold in the chaos. Fortunately, after the war, the authorities, realizing the value of Babolna, gave it support to continue with the breeding of Arabs. In 1968, it was decided to import some stallions and mares from Egypt, including Ibn Galal and Farag, both grandsons of Nazeer. During its long history, Babolna has not only managed to survive, but has preserved a precious collection of Arabians.

Historically, there are many links between the Arab horses of Poland, Hungary and Germany; at an early stage, all three countries adopted a similar breeding principle, based on regular infusions of new blood, by importing new sires from the deserts of Arabia. The home of the breed in Germany is the stud founded in 1816 at Weil in Württemberg. Before this date, many Arab horses had been imported, but efforts to establish studs of pure-bred Arabs, notably by Emil von Nitzschwitz (among others), had met with limited success. However, through the services of Baron von Fechtig, who had imported a consignment of Arabs to Europe in 1816, the King of Württemberg acquired the legendary Bairactar, one of the best stallions ever to come out of Arabia. The stallion became the foundation sire of the stud at Weil. Bairactar was a silver-white seglawi jedran, imported in 1817; his influence in the history of the Arab breed has been enormous. In the same year, the stud also received the mare Murana I. The Queen, sister to Tsar Alexander I, took a great interest in the Arab horses, and requested that Count Rzewuski, whom she knew to be respected in the deserts of Arabia, procure some Bedouin horses for Weil. The result of this commission was eight stallions and twelve mares.

Few years passed without further additions of desert horses to the stud. In 1836, the veterinary surgeon Dambly obtained four stallions from the Lebanon, and in the following year the celebrated black stallion Sultan was purchased at the sale of the Hampton Court stud in England, Sultan had been presented to King William IV by the Imam of Muscat. He was described by one who saw him at the Hampton Court stud as being 'of the highest class being rarely if ever met with…. Here I had before me one, selected by a Prince whose subjects have ever been celebrated for trafficking in the purest blood of the Desert. I could not doubt his claim for legitimacy.' King Wilhelm of Württemberg paid 580 guineas for Sultan, but the horse proved a disappointment at stud. In 1838, another Arab stallion was purchased in England, the twelve-year-old grey desert-bred Padischah, who had been a gift from the Sultan of Turkey. Padischah was a great success at Weil, and his blood can be traced in Arab horses in Germany, Poland and Russia.

Baron Julius von Hügel also procured a number of valuable horses for the stud. He obtained the white stallion Djelaby, once the property of the Pasha of Medina; another white stallion, Jemscheed, who had been a gift from India to Queen Victoria; and from Prince Albert he bought Said, who had been yet another gift from the Imam of Muscat. We saw that von Hügel travelled to Cairo in 1856 and in 1860 for the auction of Abbas Pasha's horses. Accompanying von Hügel in 1860 was von Nitzschwitz, who also had a keen interest in the auction; he bought two mares for his stud at Königsfeld. Later, a mare descended from the Arab horses at Königsfeld was chosen by Captain Gerhardt von Schmidt for his stud at Roblingen. Von Schmidt also purchased the two desert stallions Hassan and Ali, of whose pedigree there was written record: 'In the name of Allah, the Merciful! Peace be with the Prophet who said, "Weal is bound to the forehead of the noble horses" – also peace be with the companions of the Prophet who are far from any evil. This is the pedigree of the brown and blessed stallion which has been transferred into the possession of our Master and Lord His Highness Izzet Pasha, General and Commander, Allah preserve him and his grandeur. This stallion descends from the famous strain "Dahman Shahwan" as we Arabs know from experience. It is the brown one, son of Faras and of Zeid el-Saad, daughter of Masuda, daughter of Suahda, daughter of El-Nur [Light], daughter of Salama Shahwan, which has been mentioned already and descends from the noble Arabian horses. Date: Shahwal 5th, 1330. Witnesses [14 seals of Sherifs and 7 seals of Sheikhs].'

Within the space of forty-five years, thirty-eight Arab stallions and thirty-six mares were acquired for Weil, and when King Wilhelm I died in 1864, there were well over three hundred horses in the Royal Stud, but Wilhelm II took little interest in them. Princess Pauline, grand-daughter of Wilhelm I, shared his enthusiasm for the 'little Arabians' and she asked Carl Schmidt to be her agent in Cairo. He purchased the white horse Jasir from the stud of Prince Mohammed Ali and in this way the blood of the horses of Abbas Pasha was reintroduced to the Royal Stud. Shortly afterwards, Weil was transferred to the state, and in

1932 some of the horses – nine pure-bred Arab mares and four stallions, including Jasir – were moved to Marbach. The mares were all of the family of Murana I, and also traced back to Tajar and the stallion Bairactar.

Following World War II, two Polish stallions, one by Ofir, were used at the stud, but the need for a new stallion became increasingly urgent. Marbach found him in a stallion by Nazeer, renamed Hadban Enzahi, who, with his half-brother Ghazal, was to dominate Arab horse breeding in Germany for the next two decades. At the closing of the 20th century, there were about twenty-five brood mares at Marbach, some tracing right back to the desert imports of the early 19th century, making them part of the oldest continuous recorded line of pure-bred Arab horses anywhere in the world.

The number of private breeders in Germany increased enormously over the last two decades of the 20th century, and since the reunification of the country, Germany now has the biggest registry of Arab horses in Europe, as well as the strongest group of breeders of Egyptian Arab horses, for it was Marbach's policy always to use an Egyptian stallion as chief sire.

After the final expulsion of the Moors from the Iberian peninsula in 1492, Spanish grandees, like other European princes, eagerly sought out Eastern stallions to use for the improvement of their own horses. The Andalusian, one of the most famous breeds of the 16th and 18th centuries, owes its ancestry to the Arabian.

As elsewhere, the 19th century in Spain witnessed a renewed interest in the Arab horse. Gliocho, the Greek dealer who had supplied Arabians to both Poland and Germany, was commissioned by Queen Isabella II to purchase horses for Spain. These desert horses, twenty-six stallions and twelve mares, arrived at the Royal Stud in Aranjuez in 1850. In 1893, the Yeguada Militar was founded in order to establish a stud of the Spanish and Arab breeds. Today, the stud is situated at Cortijo de Vicos, east of Jerez de la Frontera, with nearly five hundred horses, of which just under one-third are Arabians. In its early years, the Yeguada Militar had very few Arab horses, but in 1905 a delegation was sent to Syria which returned with ten stallions and thirteen mares.

The Duke of Veragua, a descendant of Christopher Columbus, had been a breeder of the famous fighting bulls of Spain, but in his later years he concentrated on breeding Arab horses, establishing a stud in 1926 near Toledo. He was supposed to have said that the breeding of these horses 'was a task apt to fill a man's life'. The Duke scoured the world for the best foundation stock, and imported horses from England, Argentina, France and Poland. The three stallions and thirteen English mares were mostly of Crabbet breeding, the exception being Razada, whose sire was by the desert horse Mootrub and traced to Kesia, Major Upton's import of 1875. Ten mares purchased from Señor Hernan Ayerza, an Argentinian breeder, also traced to Crabbet stock, and were imported in 1914.

The success of the Veragua stud was interrupted by the Spanish Civil War. The Duke was murdered in 1936 by a discontented former servant, who forced his master to sign a will handing over his estate to him. By good fortune, many of the horses were saved, taken by the state and sent to the Yeguada Militar. In all, thirteen stallions and forty-six mares were found, and because the Veragua horses were branded, as is the normal practice in Spain, there were no doubts as to their authenticity. These mares, therefore, were all given names beginning with 'Ver...' and are so entered in the Spanish stud book. Razada was among the fifty horses that disappeared during the Civil War, but male offspring by him were saved, including Nana Sahib and Ifni.

The Yeguada Militar is still the major influence in Arab horse breeding in Spain. Probably their leading stallion of recent years has been Garbo, who traces on the male side from the desert stallion Seanderich, through Eco, Barquillo and Orive. There are also several important private studs, particularly in the south of the country. The best known are those of Don Luis de Ybarra, Don Miguel Osuna, Diego Mendez Moreno, and Princesa Teresa de Borbón, Marquesa de Laula, whose stud is just north of Madrid. She has concentrated on the sire line of Zacateco, a dark-chestnut stallion owned by the Yeguada Militar. Until recently, Spanish

John Frederick Herring, Sr, Tajar and Hammon, *1845. J. F. Herring, Sr, a great Arab horse lover himself, bought the stallion Imaum, who had been presented to Queen Victoria by the Imam of Muscat. Imaum also appears in some of Herring's paintings.*

breeders have preferred to concentrate on Arab horses of Spanish descent, but in recent years some outside blood has been introduced.

The Nederlandse Arabieren Club, the Dutch Arab horse society, was founded in 1935. Unlike many other European countries, which imported their horses directly from the original source, the first pure-bred Arabs came to the Netherlands from Great Britain, their principal purpose being to infuse some 'hot' blood into the heavier breeds. During the 1970s, this all changed: the Arab became popular in its own right and the number of Arab horse shows increased dramatically, not only in the Netherlands but across the whole of Europe.

Until its move to Great Britain in 1969, the most prominent Dutch stud was that of Dr H. C. E. M. Houtappel, an astute breeder with an eye for beauty. In the 1970s, the Kossack stud, which was founded with breeding stock brought exclusively from the Tersk stud in Russia, became the most prominent. Many important Russian horses have found new homes all over the world via the Kossack stud. In the true spirit of a nation of traders, the Netherlands has always exported a disproportionately large number of horses for its size: to redress the balance, the number of horses imported has also always been high. For many years, Arab horses in the Netherlands, as elsewhere, were considered an unusual, expensive and exclusive commodity; their main use was perceived to be for the show-ring. However, after the breeding boom of the 1980s, horses which would have had careers at stud twenty years before became affordable as riding horses, and the increase in popularity of Arab racing created a welcome new demand. During the 1990s, the world market for Arab horses became saturated, and these days most Dutch

breeding is done for the national market. A significant number of Dutch owners take their horses to international shows such as those organized each year under the auspices of the European Commission of Arab Horse Organizations.

Sweden, with a population of eight million, has more than eight thousand pure-bred Arab horses registered with the Swedish Arab Horse Society. In 1998, the society had about 1,200 members, many of them owners of just one riding horse; when the society was formed in 1964, there were only about twenty pure-breds in the country. The first president and registrar of the society was Count Claes Lewenhaupt, whose wife Penelope was born in Scotland. She brought with her in 1959 the Arab stallion Kariba and the mare Farissla. At that time, the Arab horse was virtually unknown in Sweden, apart from those imported by former president of the Swedish warm-blood society, Dr Arvid Aaby Ericson, whose stallion Jäger, bred at the Marbach stud in Germany, was used in a warm-blood breeding programme in his final years.

In 1964, Erik Philip Sorensen founded the Blommeröd stud with Polish bloodlines obtained from Erik Erlandsson, another pioneer breeder. Erlandsson was to become known throughout the Arab horse world as the breeder of US National Champion Stallion Aladdinn. How this magnificent legendary stallion came into being is worth recounting.

Aladdinn was foaled in 1975, in the small Swedish community of Tomolillo. Aladdinn's grand-dam, Lafirynda, had been found in Poland by an Englishwoman, Patricia Lindsay (whose search for the ideal stallion will be described later), in a pitiful state, pulling a harrow for a poor farmer. Rescued by Miss Lindsay, Lafirynda went to England and duly produced Lalage to the stallion Gerwazy. Lalage was purchased by Erlandsson, who took the mare home to Tomolillo. There he bred Lalage to Nureddin, a stallion by Witraz, who had once earned his keep performing in a circus. In the autumn of 1974, a young couple from Norway visited Erlandsson's farm, hoping to buy a mare. They were offered two in-foal mares, the good-looking bay Estramadura and the rather insignificant, and definitely tiny, grey Lalage; the visitors bought Estramadura. Erlandsson was fortunate in keeping Lalage and her foal, as that foal was Aladdinn, subsequently syndicated for the enormous sum of $1,800,000, and a sire of magnificent Arab horses.

The 1980s saw an export boom for Swedish Arab horses, and those such as Exelsjor, Essaul, Edjora, Batann and Probat, all of Polish bloodlines, left Sweden for the USA. Since then, Swedish breeders have expanded their programmes to include Egyptian, Russian and English Arabs. Today, the largest Swedish stud is still Blommeröd, with about eighty horses. Countess Penelope Lewenhaupt still runs the very successful Claestorp stud, which has about thirty Arabs. Other well-known breeders are Cecilia and Hans Borghardt of Aspenäs stud and Bertil Uhlen, whose stud is now run by his daughter Baroness Inge Gyllenkrok.

As early as 1779, eight stallions arrived from Syria at the national stud of France at Pompadour in order to improve local breeds. A second expedition returned in 1790 with twenty-four stallions. In 1798, Napoleon's army defeated Murad Bey at the Battle of the Pyramids. So impressed was Napoleon by the beauty and bravery of the Mameluke horses that he sent many back to France, declaring the Arab to be the best horse in the world. Many paintings of Napoleon, who was a small man, show him mounted on one of his several Arab stallions, Vizier, Wagram or the white Anglo-Arab, Marengo. Despite the Emperor's enthusiasm for the Arab horse and the large numbers of desert imports to France, there was little interest in the breeding of pure-bred Arabians. Among those subsequently procured were thirty-nine stallions, which arrived in a shipment in 1820. One of them, Massaoud, a desert stallion of the Fedaan, may be considered the foundation stallion of pure-Arab breeding in France. Although the majority of his foals were out of thoroughbred mares, Massaoud did sire some pure-breds out of the desert mares Warda and Nichab.

Nichab had been foaled in 1818 out of an Arab mare owned by Lady Hester Stanhope, an English-woman (niece of the prime minister William Pitt) who had earlier settled in her villa at Djoun on Mount Lebanon to await the coming of the Messiah. The mare was brought to France in the 1820 shipment by

M. de Portes. Since Nichab would permit no-one to ride her, she was sent to stud, spending her last years at Pompadour.

During the early 20th century, the only breeder of real importance in France was the remarkable Robert Mauvy. His interest in the pure-bred Arab horse was sparked off by a visit to the Universal Exhibition in Paris in 1900. Although only eight years old, he never forgot the horses he had seen there: Obejan, Melpomena and Dehman. Years later, he began breeding his own Arab horses, starting with the Tunisian mare Fadda and an Egyptian stallion Dahman.

The Italian Arab Horse Society, the Associazione Nazionale Italiana del Cavallo Arabo (ANICA) has been recognized since 1982 by the World Arab Horse Organization as keeper of the Italian Arab horse stud book. ANICA organizes Italy's major shows, and in 1997 ran the European Championships. Besides halter shows, it conducts ridden events. Arab horses are used in many equestrian sports in Italy, including racing, endurance and Western and English ridden competitions. Carriage driving is popular, and in 1997 an Arab mare, the only Arab horse entered, won the national trophy for carriage driving.

The first official recorded data about Arab horses in Russia come from the beginning of the 17th century, with further imports recorded in the 18th and 19th centuries. By the 1840s, Russia had more than forty studs, all of which used Arab stallions. The best known of these was Strelets, where the Polish stallion Cyprian stood. However, no Arab horses in Russia are known to have survived World War I or the Russian Revolution.

Tersk stud was founded on 11 February 1921, on the estate of S. A. Stroganov, a famous breeder of horses in the north Caucasus, originally part of Poland, and the surviving horses from the Strelets and Stroganov studs were moved there. In 1930, Tersk purchased six mares and a stallion from France; in 1936 twenty-five horses came from Crabbet, and in 1939 fifty were confiscated from Poland. Further purchases and some gifts from Germany, Poland and Egypt followed. In the preface to the Russian Arab horse stud book, it is written that the stud directors considered 104 pure-bred horses as foundation stock. All, with the exception of those from Crabbet Park, were from state studs.

The selection process in Russia has always been extremely strict – for example, today only one stallion and six mares are descended from the horses imported from Crabbet Park. The evaluation process, done by a committee, measures height of withers, length of body, girth of chest and cannon bone, and gives scores for parentage, measurements, conformation, performance and quality of descendants. Horses are evaluated as foals at weaning, and then every year following. Once a mare has been denoted a broodmare, she is given four chances to produce a foal better than herself; if she does not produce such a foal, she is then culled. All horses are raced as two-year-olds: the best continue on as three- and four-year-olds and the marks for performance are then included in the evaluation of the horse.

Tersk stud concentrated on breeding only Arab horses from 1944, and the present stock is descended from English, French, Polish and Egyptian lines, although in 1984 a colt of Spanish bloodlines was purchased from England. The Russians, with a tradition of horse breeding handed down from father to son through generations, have shown a remarkable ability to blend lines and breed excellent horses.

Naseem (by Skowronek out of Nasra) was purchased from Crabbet Park in 1936 at the age of fourteen and used at stud at Tersk for sixteen years. From a total of eighty-six foals, six colts and sixteen fillies were retained for breeding – a high number, bearing in mind the strict selection process. Naseem was first used on the French and Crabbet mares and then on the confiscated Polish mares. Undoubtedly, his best male offspring was Negatiw, out of Taraszcza, one of the mares from Poland. After eleven seasons at Tersk, Negatiw was sold to Poland in 1962, where his son Nabor had been used. (Nabor was later sold to the USA, after siring the famous stallions Aramus and Gwalior and the mare Dornaba.) Negatiw's Polish fillies became much sought-after by breeders of Arab horses around the world, and the Naseem line continues

Juliusz Kossak, Cossacks Riding through a Village, c. *1885. Cossack horsemanship has been renowned through time, and the choice mount was an Arab horse.*

to this day in Poland with the stallions Bandos, Eukaliptus and Pepton. In Russia, the Naseem fillies Nitochka, Negrada and Naturaliska have founded dynasties in their own right.

Priboj, by the Polish stallion Piolun out of the Crabbet mare Rissalma, was born in 1944. His line was continued through his sons Pomeranets, Sport and Topol, and this line includes such horses as Kapella, Kanitel, Kumir, Karta, Neposeda and the five fillies of Malpia, as well as Muscat (US National Champion Stallion).

In 1963, the five-year-old Aswan, originally known as Rafaat, was presented to Russia by Egypt to celebrate the completion of the Aswan Dam, and by the time of Aswan's death in 1985, the stallion had sired 287 foals. It is worth noting that, even though bred in Egypt, Aswan traced through his dam to the Crabbet-bred Rustem, and Aswan's sire, Nazeer, was out of Bint Samiha by the Crabbet-bred Kasmeyn. Aswan's best progeny were out of fillies by Arax, Priboj and Salon, a stallion by Naseem. Poland purchased Palas, a colt by Aswan that has left fillies of exceedingly high quality, while other Aswan offspring went to the USA and Europe and have left their mark on international breeding.

Two very important mares in the Russian breeding programme were Mammona, an Ofir daughter known as 'the Pearl of Tersk', and Taktika, who traces to Sobha, a Crabbet mare of Abbas Pasha bloodlines. Mammona had a foal every year for eighteen years: two of the best offspring were Pomeranets and Magnolia. Menes, whose grand-dam was Mammona, when put to the Aswan filly Panagia produced Balaton, now a very successful stallion.

First let us obtain the pure bred and perfect horse, then let us take
care to keep his future generations perfect.

(ROGER UPTON, *NEWMARKET AND ARABIA*)

THEY CONQUER THE WORLD

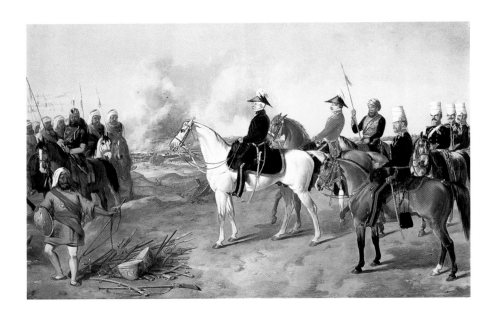

The story of the Arab horse reaches from the desert to the West and the New World, to Asia and the Antipodes. The Arab is now bred in every part of the world.

The trade in horses between the Arabian peninsula and India was noted by the Venetian traveller Marco Polo in the 12th century. For hundreds of years, there was a market for colts bred by the Bedouin tribes, and this trade intensified after the arrival of British troops in the subcontinent. In Bombay, British officers would visit the stables of Abdul Rahman Minnie or one of the other dealers who shipped the horses in from Arabia, in order to find a horse which would serve them not only in a military capacity, but as a mount for racing, pig-sticking, hunting and polo. One such horse was Kismet, bred by the Muntifik and sent as a five-year-old to Bombay, where he was purchased by Lieutenant Broadwood and put into racing in 1883. Kismet did not lose a single race in two seasons in India, and his winnings amounted to £30,000. In 1884, his owner took Kismet back to England and immediately ran him at Newmarket in a race which had

John Alfred Wheeler, The Army of the Sutlej, *c. 1870. Thousands of Arab horses, mainly stallions, exported from the Arabian desert to India were used for racing, polo, pig-sticking or as officers' chargers.*

been arranged for Arab horses over the two-mile July course. Although Admiral Tryon's three-year-old colt Asil won, Kismet was to get his revenge when he beat Asil over two miles at Sandown.

Another horse that deserves mention is Maidan, purchased out of the same Bombay stable as Kismet by a Colonel Brownlow in 1871. This officer rode the horse in campaigns through India and Afghanistan, including the famous forced march of 300 miles (480 kilometres) from Kabul to Kandahar. Here, Brownlow was killed while commanding his troops and the horse eventually became the property of Captain Fisher. For the next three years, Maidan was highly successful on the race-course and was winner of the Kadir Cup, the blue ribbon of pig-sticking in India. He was eventually sold to the Hon. Eustace Vesey, who set off back to England with Maidan on board the troop ship Jumna. All went well until they reached Suez, where the ship was commandeered to ferry troops back down the Red Sea for the relief of Suakim, at the time of the Sudanese campaign. After one hundred days at sea, the ship finally docked at Marseilles. When Vesey died in 1889, the horse was purchased by the Hon. Miss Dillon, another breeder of Arab horses, who for the next two seasons rode him regularly out hunting in Suffolk, and steeplechased him with success when he was twenty-two years old. Descendants of Maidan and Kismet survive to this day.

The first group of desert horses purchased by the Blunts had been imported to England in 1878, and with these the Crabbet Park stud was founded. One mare, Dajania, their very first purchase, established a

Sir Edwin Landseer, The Arab Tent, *1866. Omar, the Prophet's Companion, has said: 'Love horses and look after them, for they deserve your tenderness; treat them as you do your children.'*

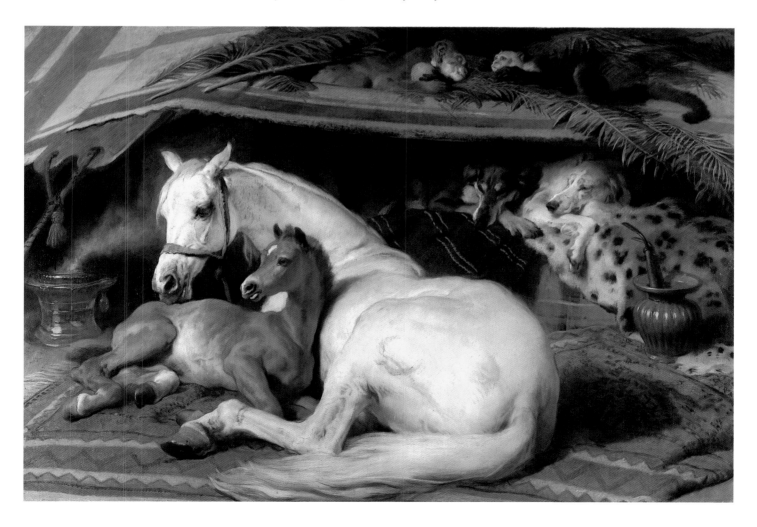

most successful line through just one filly, Nefisa. In the following year, Pharaoh and the Queen of Sheba arrived at Crabbet, and in 1881, a last large group of desert mares was imported. Amongst these was the old chestnut Rodania, who had been bought from the Roala, and was of somewhat uncertain temper. She, through her daughter Rose of Sharon, was to found the most influential female line at Crabbet Park. Through exports, Rodania's descendants have instituted further dominant lines in the USA, Russia and Egypt.

The importation of twelve mares and seven stallions of Abbas Pasha bloodlines proved an invaluable addition to the stud's foundation stock. The white mare Bint Helwa, a seglawieh jedranieh of ibn-Sudan's precious strain, was described by Lady Anne as 'rather old, but a beautiful mare in spite of a rather weak back – fine head and style'. Soon after her arrival in England in 1897, Bint Helwa met with a terrible accident, breaking her off foreleg in two places. Although badly disfigured and lame, she continued to breed until 1906. Bint Helwa left at Sheykh Obeyd Ghazala, a filly that Lady Anne sold to America in 1909. Ghazala's line is still pre-eminent there, while Ghadia (Radia), a filly out of Ghazala, founded one of the Egyptian stud's most valuable seglawieh families.

The most important of the Blunts' purchases from the stud of Ali Pasha Sherif was Mesaoud. Lady Anne notes: '… the pick is of course, the Seglawi Soudani son of Aziz', and Wilfrid Blunt was to write later, 'nearly all our best mares are descended from him. Indeed he may be considered as the foundation in the male line of our stud, for neither Kars nor Pharaoh nor Azrek were at all to be compared to him as a sire.' In the opinion of some, Mesaoud is possibly the premier sire of all time, though it may be argued that Skowronek and Nazeer are his equals. He was a handsome bright chestnut with a beautiful head, very fine shoulder and great depth through the girth. His tail was set very high and carried magnificently. Mesaoud's influence proved wholly beneficial and to this day remains a powerful force: the stallion's offspring and their descendants dominated Arab horse breeding for half a century.

The Blunts' daughter, the brilliant and mercurial Lady Wentworth, eventually took over the horses of the Crabbet Park stud, but not without a strange dispute which ended in a court case. Wilfrid Blunt had kept a portion of the stud at his old home, Newbuildings Place. Following Lady Anne's death in Egypt in 1917, Lady Wentworth took the horses at Crabbet, which had really been left in trust by Lady Anne to her grand-daughters Anne and Winifrid Lytton, and, not content with them, also demanded the horses her father had kept at Newbuildings Place. He refused to part with them and she instituted proceedings against him. Eventually, his daughter took the remaining horses off to Crabbet in triumph. The reputation of the stud reached its zenith during the time that Lady Wentworth was in charge. Visitors came to admire and to purchase from all over the world.

At the London Show in 1920, Lady Wentworth saw an exquisite white stallion and knew that she must have him. The stallion's name was Skowronek (The Lark), a truly great horse who founded a new dynasty at Crabbet. In Lady Wentworth's words, Skowronek was: '… snow white and of perfect conformation and beauty. Style wonderful. Exquisite head and neck. Large black eyes "painted" all round. Enormous strength of back and quarter, which is quite level and extra long. Tail set high and carried like a feather. This horse is of perfect type and could not be surpassed for beauty. He is like the dream horse of a fairy tale and dances on air.' Skowronek had been bred in 1909 by Count Potocki at his Antoniny stud, and the story of his purchase as a young grey colt and subsequent importation to England is worth recalling.

Walter Winans, an American, had visited Antoniny in 1912 and, before leaving, paid £150 for the colt, and brought him to England. Within six years, the Antoniny stud had been destroyed by the Bolsheviks, and Ibrahim, Skowronek's desert sire, and his dam Yaskoulka were both killed; two stallions by the same sire and out of the same dam as Skowronek were taken by the Cossacks. At first, Skowronek was used as a riding horse, his value as a sire as yet unrecognized. Then in 1919, Mr Musgrave Clark, an Arab horse breeder whose stud was later to achieve a fame almost equal to that of Crabbet, bought the

King Fuad of Egypt (seated wearing a fez) with Lady Wentworth at Crabbet Park in 1929.

horse from the pig-farmer who then owned him. Clark used him at stud and exhibited the horse in 1919 and 1920. It was while Skowronek was at the London Show that Lady Wentworth saw him for the first time and there and then determined to buy him. Aware that Clark would be unlikely to sell to her, Lady Wentworth used a young American intermediary named C. Hayden to arrange to buy the horse for her.

Skowronek's worth at last appreciated, the stallion was used extensively at Crabbet from 1920 to 1927, siring forty-seven pure-bred foals. Through these colts and fillies, and their descendants, this extraordinary white horse stamped his mark on the Arab breed. Two sons of his, Raseyn and Raffles, took America by storm. Naseem, another celebrated stallion by Skowronek, was described by Lady Wentworth as 'a very fine type with perfect legs and the most perfect gazelle head I ever saw'. The sire of numerous first-class mares and champion stallions at Crabbet, including the immortals Silver Fire, Irex, Raktha and Rissam, Naseem was later sold to the Russian government. At Tersk he established important sire lines, particularly through Negatiw, and sons such as Bandos and Nabor became leading sires in Poland and America. The Hungarian state stud at Babolna bought Ajeeb, a colt by Skowronek, in 1930. The Duke of Veragua purchased five fillies by Skowronek for his stud in Spain, and other offspring, including Raffles' dam Rifala, were imported to the USA. The legend of Skowronek was thus created, and it is no wonder that he is still considered by some to be the most influential Arab stallion in the world.

Following the death of Lady Wentworth, the Crabbet stud carried on for some years, albeit on a much reduced scale. Lady Wentworth's daughter, Lady Anne Lytton, who remembered with affection her grandparents and their Arab horses, continued to keep a small stud of her own at Newbuildings Place, the old family home left to her by Wilfrid Blunt. Many of the original studs which had started with Crabbet stock, notably Hanstead and Courthouse, were dispersed. The oldest stud now in England is the Harwood stud, which was founded in 1896 by Miss Lyon, with Howa, a filly she had bought at Crabbet.

*Lady Wentworth (left) with the legendary Skowronek and (right) with the Crown Prince of Saudi Arabia (to her right)
on his visit to Crabbet Park in 1935.*

When Princess Alice, accompanied by her husband, the Earl of Athlone, visited Arabia in 1938, they were welcomed in Jeddah by Emir Feysul and later met King ibn-Saud, who in 1937 had given two stallions, Manak and Kasim, and two mares, Turfa and Faras, as presents to King George VI of Great Britain. The Crown Prince presented Princess Alice and the Earl with a mare and a stallion of pure Arab blood and took them gazelle hunting and hawking. From Riyadh the Princess and the Earl travelled to Bahrain, where Emir Hamed bin-Issa presented them with a mare of the rare wadnah khursanieh strain and the mare's half brother, a kehilan al-muson. The mare, Nuhra, was at first put to Manak, the desert stallion. Later, home-bred stallions were used and, through six fillies out of her, Nuhra established one of the most dominant and successful Arab horse dynasties in England. Other presentations have followed: Habis el-Majali, head of the Majali tribe in Jordan, presented a number of horses to Saudi Arabia and to Queen Elizabeth, the Queen Mother. One of these, Shams, may be considered the last real desert import to the United Kingdom.

An invasion of Britain by Polish Arab horses was triggered by the English lady, Patricia Lindsay, who had visited Poland in her quest for the perfect Arab stallion. Her first trip in 1958 resulted only in the purchase of five mares, one of which went to Miss Lyon's stud, while a bay half-sister to Bask, Celina, went to Mr Musgrave Clark, whose last Polish horse had been Skowronek. Celina was an outstanding mare who became British National Champion. The remaining three mares had been carefully selected by Miss Lindsay for her own stud. Of these, the real treasure was the deeply flea-bitten grey Karramba, a filly by the famous sire Witraz, and one of the greatest mares to come out of Poland. Patricia Lindsay was eventually to find the stallion she had been seeking in Gerwazy. Many English breeders continue to share the Blunts' great enthusiasm for the Arab horse, and today there are some 250 studs in the United Kingdom. The Arab Horse Society of Great Britain registers about one thousand foals a year, and there are now some fifteen thousand Arab horses in Britain.

The country with the largest population of Arab horses in the world is the United States of America, where the total number is greater than the sum of Arab horses in the rest of the world. The first known Arab imported to the North American continent was the stallion Ranger, brought to Connecticut in 1765. He was described as 'of a fine dapple grey colour, rising 15 hands high and allowed by competent judges to be the compleatest horse ever brought to America'.

One of the earliest Americans to import a group of horses from Arabia was A. Keene Richards. To judge by portraits painted by the artist Edward Troye, some excellent horses were acquired as a result of Keene's

visits to Arabia, which arrived in America in 1853 and 1856. Leopard and Linden Tree, two stallions which had been gifts from Abdul Hamid II, the Ottoman Sultan, to President Grant, were imported in 1879. Both were used extensively at stud. Leopard was the first foundation sire registered with the Arabian Horse Club, but Anazeh, a stallion by Leopard, was his only pure-bred offspring to be registered. Huntington, the owner of Naomi, the dam of Anazeh, described Leopard as 'a beautiful dappled grey 14.3 hands high … his symmetry and perfectness making him appear taller'. Kismet, a desert stallion that had been leased to Huntington, was shipped to the USA in 1891, but sadly died of pneumonia only one hour after completing the voyage.

A large group of Arab horses was sent to the Chicago World's Columbian Exposition in 1893 by the Hamidie Society of Syria. One of these, the mare Nejdme, figures as number one in the American stud book. Shortly after this time, the first Crabbet horses began arriving in America. In 1895, the perfect white stallion Shahwan, purchased at Crabbet, was shipped to the USA. Shahwan was to sire only three foals, and was followed by the mare Ghazala, who, like the stallion, was of Abbas Pasha bloodlines. Ghazala had been bought by Colonel Spencer Borden from Lady Anne Blunt's Sheikh Obeyd stud in 1909 and, through her fillies Gulnare and Guemura, she founded a very influential line.

Homer Davenport, by profession a cartoonist, saw the Hamidie exhibition at the Chicago fair, and for him this marked the start of a love affair with the Arab horse. He could not rest until he too had travelled to the desert to seek out the breed. His party set out in 1906, and first had to go to Constantinople to confirm that official permission had been granted by the Sultan to export horses from Arabia. The Turkish authorities were loath to give permission, but with the help of a letter from President Theodore Roosevelt, and Davenport's persistence, permission was finally granted. Luck continued to accompany Davenport, and in Aleppo he was fortunate to meet Sheikh Achmet Haffez, the ruler of the Anazeh and a respected man among the tribes. Davenport wrote: ' … having been made his brother, I was treated like a brother by him, and the mares and horses in my importation, he was proud to have said were of his own choice.' Sheikh Achmet had just received as a gift from Sheikh Hashim ibn-Mehed of the Fedaan the greatest mare in the desert, and a servant was sent to fetch her. Wadduda (Love) was her name, and she was of the seglawieh El Abd strain. To Davenport's joy and surprise, Achmet Haffez presented the mare to him. A further gift of Haleb, a brown managi stallion, was presented by the Governor of Aleppo. With such a propitious start, Davenport's quest was assured of success.

In the desert, Davenport met with Sheikh Hashim ibn-Mehed himself, and purchased more horses. When the time came to leave the tribe, hundreds of Anazeh horsemen waited to bid goodbye to the famous stallion Haleb and they tied blue beads in his mane and tail to ward off the evil eye. Davenport failed to buy a bay seglawieh named Urfah, considered one of the finest horses possessed by the Anazeh, but he did manage to purchase two colts out of her. The party had left Aleppo and started for the coast when, one evening, the son of Sheikh Achmet came in, bringing Urfah with him. Homer Davenport arrived home on 7 October 1906 with twenty-seven horses: seventeen stallions and ten mares. These horses, together with those purchased by Wilfrid and Lady Anne Blunt, are arguably the best-authenticated group of Arabians imported from the desert to the West.

An influential stud in the USA was that of Roger Selby in Ohio. One of Selby's earliest purchases was the dazzling white seglawi stallion Mirage, who was to be a potent force in Arab horse breeding in the United States. Mirage had been bred by the Sebaa tribe before being purchased by King Faisal of Iraq, who subsequently gave the horse to Signor di Martino, the then Italian ambassador to France. Lady Wentworth purchased Mirage in 1923, just before the stallion was due to be auctioned at Tattersall's in London, 'immensely to the indignation of Messrs. Clark and Hough and others who followed the horse in motor cars and stopped my man in the street to find out who had got him'. Lady Wentworth used Mirage at stud, but since the horse could not be registered with the *General Stud Book* in England – Arab horses were not included after the volume for 1925, unless they could be traced to lines already included – Mirage was sold on in

1931 to Roger Selby in the USA. In a pamphlet produced by the Selby stud in 1937, Mirage is described as 'Mr Selby's wonderful twenty-five year old white stallion. Famous in his native Arabia, Champion at the Richmond Royal Show, England 1926, and now rated by many experts as the most perfect specimen of the ancient elite or classic type in America, added to himself the title of Champion Arabian Stallion of the United States for 1934.... He stands a scant 14.2, a sturdy model with the characteristic refinements of the best of his breed. His head is a glory and his great eyes express high but gentle spirit, and gracious personality.'

Other important Selby horses were Nureddin II, one of the tallest Arab horses on record, given to Selby by Lady Wentworth, and Raffles, a little horse with a great personality. By Skowronek and out of Rifala (a filly by Skowronek), Raffles can claim a great number of champions among his many descendants. Raffles arrived in Ohio in 1933, joining other Crabbet horses, among which were some valuable mares, including Rifala, his dam.

In 1932, W. R. Brown, author of *The Horse of the Desert* and owner of the Maynesboro stud in New Hampshire, imported some Egyptian Arab horses, the first since the arrival of Ghazala. More horses from the stud of Prince Mohammed Ali were purchased by Henry Babson, who imported Bint Serra, a filly out of Sit Serra (bred by Lady Anne Blunt at Sheykh Obeyd), and the stallion Fadl. This stallion, usually recorded as a kehilan jellabi, established a most successful dynasty, and Bint Serra produced two outstanding colts by him, the grey Fay el-Dine and the black Fa Serr. Probably the most successful stallion by Fadl in championship terms was Fadheilan, an outcross stallion and the sire of 'the Fabulous Fadjur'. These horses are today usually referred to as the 'Old Egyptians', to distinguish them from importations from Egypt which took place after the mid-1950s.

In 1941, Henry Babson was able to buy the desert mare Turfa; she had been bred by King ibn-Saud in 1933 and presented by him as a coronation gift to King George VI in 1937, along with three other horses. At the outbreak of World War II, Turfa was sent to Canada and there seen by Henry Babson. Once at his stud, Turfa was bred exclusively to the Old Egyptian stallion Fadl, and created a dynasty of her own.

One of the most important studs founded in America was that of W. K. Kellogg at Pomona, California. Like Brown and Winthrop Ames of Boston, who had imported the stallion Astraled, Kellogg looked to Crabbet for his horses, and in 1926, a large group of stallions and mares arrived at his ranch. The shipment of fourteen horses included the important stallion by Skowronek, Raseyn. Many of the American champion Arab horses of the 1940s and 1950s are of Raseyn's sire line: Ferseyn, Ferneyn, Ferzon, Amerigo and Khemosabi, one of the greatest stallions of recent years. Other horses in the shipment were Nasik, full brother to Nureddin II, and Raswan, another stallion by Skowronek whom Lady Wentworth had loaned to Carl Schmidt, Kellogg's agent. Sadly, Raswan was killed during a fight for his possession at Pomona. Carl Schmidt thereafter took 'Raswan' as his surname.

The studs of Kellogg and Selby had an immense influence on the growth of Arab horse breeding in the USA, an influence which is still felt today. In the years following the importation of Raffles and Raseyn, a quarter of all pure-bred foals registered in the USA were of direct male descent from them.

The first Polish Arab horses started arriving in America during the 1930s, the major importer being General Dickinson of Travellers Rest Farm. In 1945, the US army imported from Europe horses captured during World War II from the German Wehrmacht. The Polish stud at Janow Podlaski had been overrun by the Russians, who took many of the horses to the state stud at Tersk, and those saved by the Poles were then taken by the Germans. However, General Patton and his troops captured eighteen Arab horses, which were donated to the US government and sent to Kellogg, for the provision of remounts. Although this Polish invasion created quite a stir in America, the arrival of Nabor and Bask from Poland in 1963 was even more sensational. Nabor, a great-grandson of Skowronek, had been bred at Tersk, then imported to Poland in 1956. At Albigowa and Michalow, Nabor sired Espartero (Swedish and European Champion), Gwalior

(Champion of Canada) and Aramus (United States and Canadian National Champion Stallion). Fillies by Nabor were of equal merit, and include twenty-five excellent broodmares. At the age of nineteen, Nabor was sold and the buyers, Tom Chauncey and Wayne Newton, paid $150,000, a record for the time. Bask, a spectacular dark bay stallion imported by Dr La Croix as a seven-year-old, also became one of the stars of the breed in America. Probably the most famous son of an equally famous sire, Witraz, Bask was National Champion of the USA and a leading sire of champions.

From 1931 right through to 1966, small groups of horses were imported to the USA, most of them from the stud of ibn-Saud. One such import was made by John Rogers, who had spent many years in Saudi Arabia. He purchased three mares: Subaiha and Bakhaitah (both Saudi), and Thorayyah of the tuwaisah strain from Bahrain. Rogers wrote: 'In 1944 we were the first privileged to visit the royal stables in the oasis at Hofuf. The featured mare was Hamdaniya, a

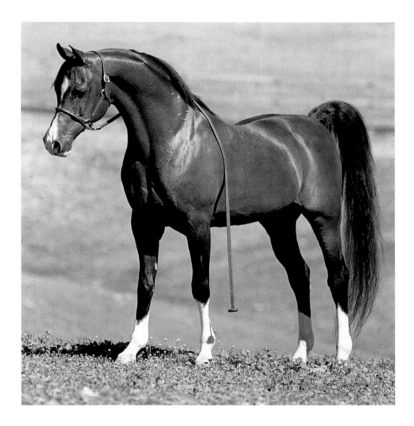

Khemosabi, famed product of contemporary American Arab horse breeding.

twenty-seven-year old Mashusha (rose-speckled grey, not flea-bitten). The attendants proudly told us that the great King Ibn Saoud had ridden this mare in the last wars in the 1920s. Next, the four-year-old Subaiha was brought out to show how the old mare had looked in her youth. Both horses, although quite thin, made a life-time impression because of their spirit, conformation, obvious intelligence and overall balance. Three years later the writer was indeed fortunate to be requested to name what he considered one of the best mares in the Royal Stables. It took only a moment to recall a few of the best, and settle on Subaiha.'

The 'New Egyptians' started arriving in America in 1958. The first, imported by Richard Pritzlaff, included the exquisite Bint Moniet el-Nefous and the first male offspring of Nazeer, Rashad Ibn Nazeer. A year later, three more of Nazeer's offspring crossed the Atlantic, imported by Judith Forbis for her Ansata stud, which has achieved international acclaim and has exported New Egyptians to every corner of the world. Douglas Marshall of Gleannloch also visited Cairo, was similarly impressed and imported many Egyptians to Texas; of these, the stallion Morafic, acquired in 1965, was almost as influential as his sire Nazeer. The white Crabbet-bred stallion Silver Vanity arrived in the USA in 1963, a horse as elegant and refined as any New Egyptian. Silver Vanity made his mark at Al-Marah, the stud which Bazy Tankersley had established with earlier imports from Crabbet following the death of Lady Wentworth.

Enthusiasm for Crabbet, Egyptian and Polish Arab horses continues unabated in the USA, even though fashions come and go; more recently, Russian and Spanish imports have become popular. The Arab horse in the USA is a major industry and Arab horse shows have become a world of their own. However, big business can create demands which may or may not be in the best interests of the breed – a justified concern that may be directed to other parts of the world as well.

The Arab horse was a comparative latecomer to Canada, where its importation followed its establishment in the USA. The early Arabians imported to the country included several of Crabbet breeding, such as the

stallion Rajafan and the mare Namilla. The stallion Osolette, of Davenport breeding, produced high-class part-bred saddle stock in the Canadian west, but the first registered Arab horse in the western provinces was Aldebaran, bred by the Prince of Wales and shipped to Canada in 1929. There was a great expansion there in the late 1970s and the 1980s in activities relating to breeding and showing Arab horses. Today, Canada has representatives of most world breeding programmes, including Polish, Egyptian, Crabbet, Russian, Spanish and, of course, American and domestic bloodlines.

No horses existed on the Australian continent prior to the arrival in 1788 of the first fleet from England, carrying marines, soldiers and convicts. However, by 1802 there were three hundred horses in the colony of New South Wales, including stallions recorded as being 'of Arabic and Persian blood'. In 1803, Governor King of New South Wales made enquiries about acquiring suitable Arab horses, after hearing that the merchant Robert Campbell had imported one from Calcutta, at a cost of 500 rupees. The stallions Shark and White William arrived in Tasmania from Bengal in 1804 and to White William fell the honour of siring the first pure-bred Arab foal to be born in Australia, out of Captain Sladdin's Arab mare. This was the colt Derwent, who stood at Parramatta at a fee of seven guineas (plus half a guinea to the stud groom). Other high-caste Arab stallions brought to Australia included Hector (who had belonged to the Duke of Wellington), Model and Satellite. Satellite arrived in 1822 from Madras and, although barely fourteen hands in height, sired offspring noted as 'tremendous weight carriers and could scarcely be over-ridden'.

Juliusz Kossak, An Amazon, *c. 1860.*

'A good jewel cannot be made except from gold.' Arab saying.

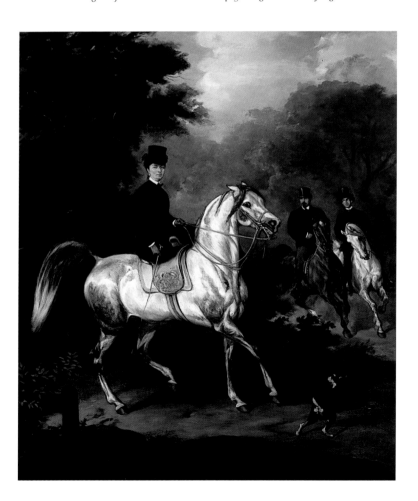

For much of the 19th century, Arab horses were counted as Thoroughbreds in Australia. They were particularly favoured as racehorses, since the numerous heats demanded extra stamina from a horse which was to survive to the final contest. Elegant Arab hacks were ridden by ladies and gentlemen in city parks; sturdy Arab horses carried explorers into the desert; tough Arab stockhorses worked on sheep and cattle stations; and Arab horses served as police troopers' mounts and were used for fast getaways by the bushrangers who held up travellers after the gold rushes of the 1850s. Sadly, these early Arabians do not appear in today's Australian Arab horse stud book, despite the fact that many were of undoubted pedigree. For example, the horses procured by Major Upton at the request of W. J. and A. A. Dangar do not feature in the stud book, even though the stallion Alif, who arrived in the colony after many trials, was described as 'the beau ideal of a perfect horse'.

Throughout the 19th century, many Arab horses were imported to Australia, some directly from the desert or India and others from the Crabbet stud. Indeed, through these imports, some lines which were lost in Britain still continue to exist in Australia, particularly among the importations made by Judge James Boucaut to

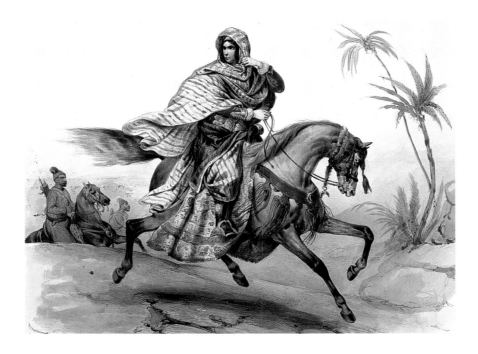

Victor Adam, Lady of the Harem, c. *1824. 'Her longing is the far-extended desert, plain giving unto plain.' Yazid, poet and warrior.*

South Australia in 1888. They were the stallion Rafyk and the mares Dahna and Rose of Jericho, all from Crabbet. The oldest line of pedigrees in the stud book traces to Dahna, out of the Blunts' desert mare Dahma.

Notable Australian breeders during the first half of the 20th century included the Hon. Samuel Winter-Cooke and Messrs J. F. Jelbart and A. J. Macdonald. In 1925, Mr A. E. Grace imported the famous endurance-test winner Shahzada, by Mootrub out of Ruth Kesia. In the same year, Mrs A. D. D. Maclean established the Fenwick Arab horse stud, importing horses from Crabbet Park as well as from other British sources and at first mating them with horses tracing to the Boucaut mares. The influence of Crabbet lines is still strong in Australia today.

Arab horses were to follow from many parts of the world. Polish bloodlines arrived from 1966, Egyptian lines from 1970; they were joined by horses registered in the stud books of Spain, Russia, Germany, the USA and other countries. Australia's registry is second only to that of the USA in size: so far, the Australian stud books contain the names of nearly 42,000 pure-bred Arab horses, with around 1,100 new registrations each year.

The tendency amongst Australia's breeders has always been to choose the best possible matings rather than breed straight programmes. The exceptions to this are the small group of breeders of 'straight' Egyptian Arab horses, led by Marion Richmond of the Simeon stud. Her senior stallion is Asfour, bred by Dr Hans Nagel in Germany.

Until 1970, when the New Zealand Arab Horse Breeders Society was formed, that country's Arabians were registered with the Australian stud book. Today, the breed is flourishing, and New Zealand produces Arab horses of world class. Being distant from other centres of Arab horse breeding except for Australia, and because of historic links to the British Isles, New Zealand's foundation stock was biased towards bloodlines from England, sometimes imported via Australia. Traditionally, New Zealand's Arab horse studs are run alongside other interests, such as dairying or sheep farming.

South African breeders of Arabians started with imports from Britain, especially from Crabbet and Hanstead. The first registered pure-bred Arabian horse arrived in South Africa in 1891. This was the desert stallion Azrek, imported by the mining magnate Cecil John Rhodes from the Crabbet stud. Some years later, Claude Orpen imported the pure-bred stallion Jiddan from England, and in 1945, five Egyptian Arab horses arrived. These were two mares, Baraka and Nabilah, which came from the Royal Agricultural Society

of Egypt's stud, and three stallions, which had been bred at King Farouk's stud at Inshass. The stallion Zaher and the two mares left descendants that are still an important part of South Africa's Egyptian programmes.

The oldest South African stud farm existing today was founded in 1951 by Betty Arnold of Bedford with three pure Crabbet mares from England. Shortly afterwards, John and Margaret Kettlewell founded Jericho Arabians. Most of the other studs that started up in the 1950s no longer exist, but their legacy is felt today: the late Petrus van der Merwe, who founded Vlinkfontein stud in 1951, was the first to import Arab horses from the United States.

Argentina pioneered the breeding of Arabians in South America. A group of horses was imported in 1894 by Hernan Ayerza, who dedicated his life to the study and breeding of the desert horse. His first visit to Turkey, Syria, Lebanon and Egypt, where he selected Arab horses for importation, was made in 1892 with his wife Maria Moreya. The following year, he founded the El Aduar stud with horses he had purchased in Constantinople and Damascus. He returned to Syria in 1898 and was successful in buying Haydee (the future dam of the famous stallion Haurram II) and Gelve (both kehilehs), the seglawieh Kariban, and five stallions: Marum, Saekat, Richam, Hadi and Dayman. In 1910, he imported from Germany the stallion Y-O'Bajan, changing this horse's name to Kurdo III. By that time, Ayerza's brother Alfonso had also started a stud farm, and imported from Babolna the stallions O'Bajan V6 and Hamdani Semri; later he imported Semri 1–9, O'Bajan 7 and Hadban 1–4.

The year 1914 saw Hernan Ayerza import Risfan from Crabbet Park. In that year also, Felix Burxareo Oribe, from Uruguay, imported the stallion Ajman (by Feysal out of Ajramieh) from Crabbet. The last group

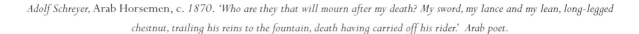

Adolf Schreyer, Arab Horsemen, *c. 1870. 'Who are they that will mourn after my death? My sword, my lance and my lean, long-legged chestnut, trailing his reins to the fountain, death having carried off his rider.' Arab poet.*

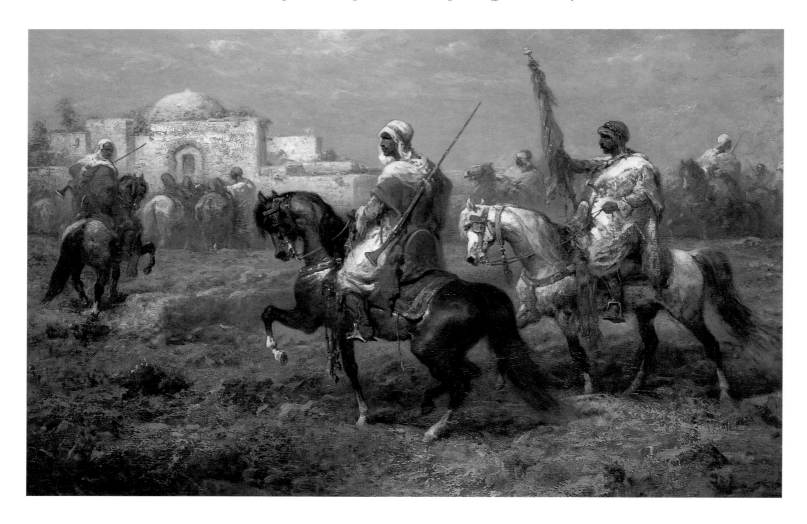

of desert horses imported by Hernan Ayerza, in 1931, all came from Sheikh Fawaz al-Shaalan of the Roala tribe. They had been purchased for him by Carl Schmidt (Raswan) in the year in which he had helped von Zietarski buy the last important group of horses to come out of the desert for Poland and Babolna. Importations from Europe continued and new stud farms, such as Los Toros, owned by Julio Mendez, were set up. Argentina began to export Arab horses, mainly to Brazil and Uruguay; ten mares and a stallion were exported to Spain, to the Duke of Veragua.

In 1936, Dr Bartolome Mitre began the Pavón stud in Argentina. During the years that followed, new enthusiasts incorporated first-quality bloodlines from around the world into a variety of breeding programmes. One of Argentina's greatest breeders, Count Federico Zichy-Thyssen, has imported new bloodlines and outstanding specimens from all over the world, and it is on account of him that Argentina became home to the renowned El Shaklan. El Shaklan was a horse who caught the imagination of everyone who saw him, and whose influence has been quite sensational. Foaled in Germany,

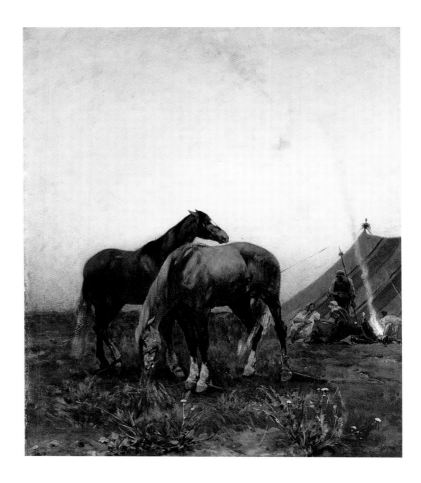

Alberto Pasini, An Arab Encampment, *1866. The Bedouin still maintain their custom of spending long nights around camp fires, recounting the deeds of valour of man and horse.*

the result of what some have called 'the golden cross', El Shaklan's sire and dam were the Egyptian stallion Shaker el-Masri and the Spanish mare Estopa. The stallion quickly came to international attention with successes in Britain (where he had been leased by Major Maxwell), both in foals produced and in the championships won. Following the death of Shaker el-Masri, El Shaklan returned to Germany, and the title of Reserve World Champion (at Paris in 1981) was added to the list of his successes. Next, he crossed the Atlantic to take the USA by storm, before travelling down to Brazil, where he became Grand Champion. El Shaklan's final journey was to the stud of Count Zichy-Thyssen in Argentina.

Arab horse breeding in Brazil started in 1930, but new impetus was created when Aloysio de Andrade Faria imported three stallions and six mares from England and the USA in 1965. At the same time, the Brazilian Arab horse breeders' association was founded. The quality of these horses and their offspring inspired new breeders and many importations were made during the 1970s, while much hard work was done to make the Arab known at horse events and agricultural fairs. Great expansion came in the early 1980s, when five thousand horses were registered by their owners, many of them companies, who found that breeding Arabians was a good investment as well as a relaxing hobby. Prices for mares were high and the Arab horse gained media attention for this fact rather than for its original qualities. Many people with no previous link with horses became attracted to the breed.

After 1987, when the US market was down, Brazilians purchased many excellent and important horses, including three US National Champions. Many horses were also exported, not only to countries in South America but to the USA, Germany, Italy, Australia, the Netherlands and Spain. A major exporter was Maria Helena Perroy, owner of the stallion Ali Jamaal, a horse that has been immensely influential worldwide.

THE PRIDE OF RACE

Today, Arab horses are to be found in almost every country from East to West: they have indeed conquered the world. Whereas the Bedouin relied on oral tradition in the past, the maintenance of accurate and comprehensive stud books is essential to the future of the breed. In some countries, this responsibility is in the hands of government departments, but in the majority of cases a breed society or registry is the official authority. The stud books of some countries were for long little more than registers of horses, though today the tendency is to record as many details about each individual as possible (a task made easier by efficient computer software). Blood-typing and DNA testing can also be used to corroborate the written parentage of any foal whose sire and dam were both blood-typed.

The history of stud books goes back many centuries. In AD 1330, abu-Bekr ibn-Bedr compiled what may rightly be called the first stud book, with details of the horses belonging to the Mameluke Sultan al-Naseri. The Sultan was passionate about Arab horses and received the finest specimens from Bahrain, Al-Hasa, Qatif, the Hejaz and Iraq. One horse, Nashuan, is reported to have died of the plague, a disease which was periodically to decimate the horse stock of Arabia and Egypt throughout the centuries (Ali Pasha Sherif is known to have lost the greater part of his collection in one epidemic).

In the 19th century, many of the early European breeders and travellers maintained their own records and personal stud books, and these have become invaluable sources for those who wish to study early pedigrees; the Abbas Pasha manuscripts also give some fascinating details. Accurate records may be found in the Crabbet Park and Sheykh Obeyd stud books, which are the main sources for all we now know about the horses of Ali Pasha Sherif, while the meticulousness of the Babolna stud books is an example to other countries.

A Spanish Arab horse stud book was published in 1885, but the oldest national record is the *General Stud Book* in Britain, which was first published in 1793, with a foundation of one hundred oriental stallions and forty-three mares. This became the stud book of what is now known as the British Thoroughbred. Volume XIII, published in 1877, included for the first time a separate Arab horse section. Major Upton's desert imports appear in this edition, and in the following volume are registered the first horses imported by Wilfrid Blunt. The *General Stud Book* continued with this Arab horse section until 1921 when Weatherby's, the keepers of the stud book, decided that no new entries of imported Arab horses, unless they could be traced to lines already accepted, would be included after the issue of Volume XXV in 1925.

Théodore Chassériau, The Caliph Constantine Ali Ben Hamet, Chief of the Harachas, Followed by His Escort, *1845.*

The Prophet Mohammed's favourite Arab steed was called Oskoub (The Torrent) because of his speed.

It was not as drastic a decision as it appeared, for in 1918 the Arab Horse Society of Great Britain had been 'founded to promote the breeding and importation of purebred Arabs, and to encourage the re-introduction of Arab blood into English Light Horse Breeding'. Its first president was Wilfrid Blunt, and the following year the Society published Volume I of *The Arab Horse Stud Book*. In it are registered a total of forty-six stallions and fifty mares, of which fourteen were imported from Arabia, Egypt, India, Bosnia, the Weil stud and Poland, this last being Skowronek.

In 1972, the World Arab Horse Organization (WAHO) was established with the purpose of verifying and unifying all Arab horse stud books. Although admirable in theory, the goal may be unattainable if standards are to be maintained. The great strength of WAHO is its ability to get people together: at its last conference, in Abu Dhabi in 1996, fifty-four nations were represented. It seems desirable that goodwill and a shared appreciation of the Arab horse should find ways to overcome problems which may arise from time to time between WAHO and certain national registries.

Although it was possible for buyers who travelled to Arabia to acquire stallions, the Bedouin were loath to sell their mares, which could be obtained only in exceptional circumstances. Traditionally, the prices paid for pure-bred Arab horses were substantial. Aswad ibn-Rifaah, so abu-Bekr records, paid ten thousand dirhams for 'the unborn foal of Khalifa's mare', which was given the name Bala. A similarly huge price of seven thousand Egyptian pounds is said to have been paid by Abbas Pasha for the Jellabiet-Feysul also bred by the al-Khalifas. (Interestingly, an Arab stallion, Simeon Sadik, was purchased from Australia in 1996 by a British breeder for a price in the region of US$740,000; the horse's pedigree could be traced through the Egyptian Nazeer and the Crabbet horse Kasmeyn back to the Jellabiet-Feysul purchased by Abbas Pasha.) The prices paid for Bala and the Jellabiet-Feysul pale into insignificance when compared to the £40,000 paid for one particular celebrated stallion by Sultan al-Naseri more than six and a half centuries ago.

Breeders today buy and sell Arab horses on an international market. So a horse bred at Russia's Tersk stud may race on the tracks of Britain, grace the show-ring of Qatar, sire endurance horses in Australia or compete in the national championships in the USA.

Showing Arabians today is big business. In 1920, the Arab Horse Society of Great Britain took over the organization of the Arab classes at the London Show. It still organizes a National Show (no longer in London), which is probably the oldest for the breed in the world. Most countries hold National Championship and International Arab horse shows, and often run a number of regional events. This enthusiasm for showing has also spread to the Middle East. The three main competitions in Europe are the World Championships in Paris, the European Championships and the Nations' Cup, which is a national team championship. Occasionally, an outstanding horse has taken the 'Triple Crown', winning at all three major European shows, as Essteem did in 1994. A Middle East championship is now held each year in Jordan, with shows in Qatar, Abu Dhabi and Saudi Arabia. In the USA, world-class Arab horses compete in regional championships, then at the national shows. Australia inaugurated its national Arab horse championships in 1982. Today, this event alternates between State capitals, each of which has its own major show. Winning carries enormous kudos, enhances the value of a horse and, if a stallion, brings it greater popularity as a sire.

With the growth in showing, and the introduction of international shows, some regulatory body was needed so that certain standards could be met regarding organization and judging methods. The European Conference of Arab Horse Organizations (ECAHO) is the European show authority, though its brief now also encompasses North Africa and the Arab countries. Judging is carried out by one of two systems: the comparative method, where it is usual for one judge to place the horses in their class in order of preference; and the points system, where a panel of judges scores each horse out of a total based on an ideal standard.

Horses at breed shows are usually shown in 'in-hand classes', known in the USA as halter classes. The handler's job is to present the horse before the judge in the most advantageous way and, if necessary, to

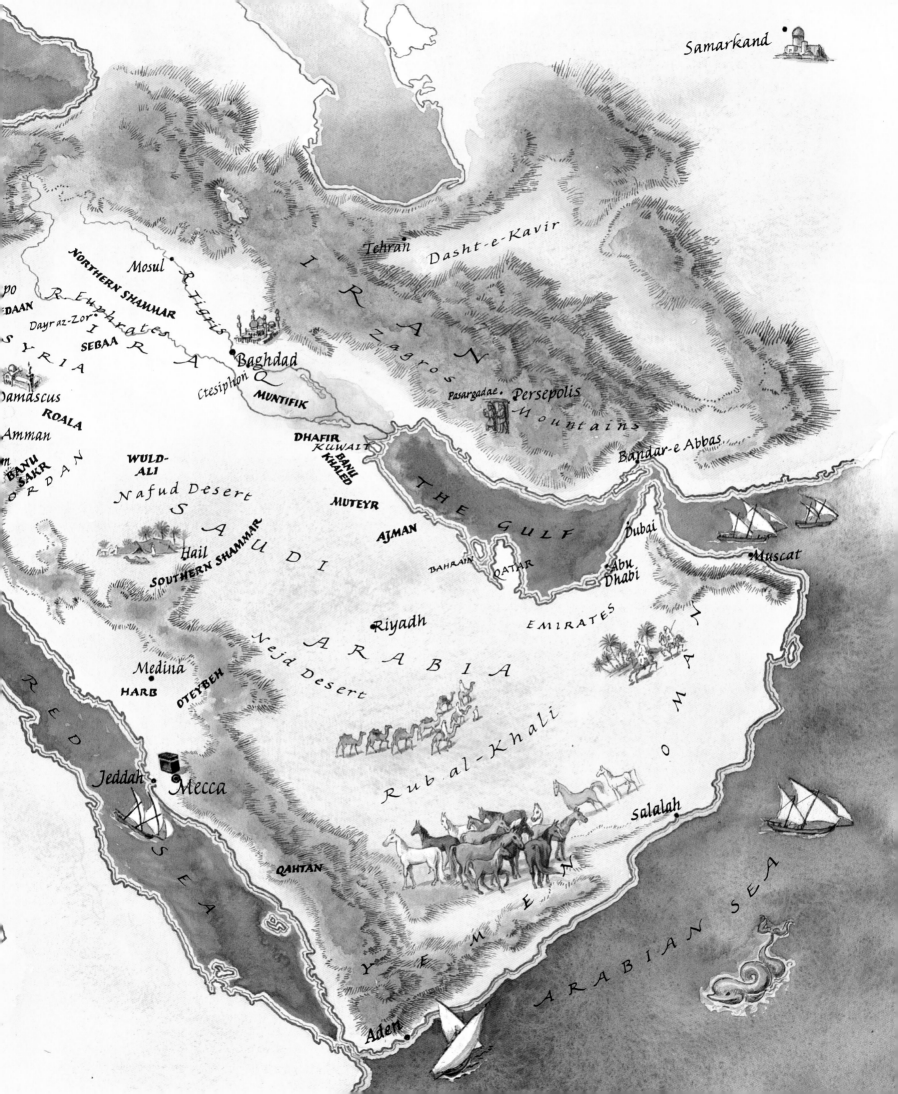

Samarkand

Mosul

R. Tigris

NORTHERN SHAMMAR

Tehran

Dasht-e-Kavir

IRAN

po

DAAN

R. Euphrates

Dayr az-Zor

SYRIA

SEBAA

I R A Q

Baghdad

Ctesiphon

MUNTIFIK

Damascus

ROALA

Amman

BANU SAKR

JORDAN

WULD-ALI

Nafud Desert

S A U D I

Hail

SOUTHERN SHAMMAR

Zagros

Pasargadae

Persepolis

Mountains

Bandar-e Abbas

DHAFIR

KUWAIT

BANU KHALED

MUTEYR

AJMAN

THE GULF

BAHRAIN

QATAR

Dubai

Abu Dhabi

Muscat

EMIRATES

O M A N

Riyadh

A R A B I A

Nejd Desert

Medina

HARB

OTEYBEH

Rub al-Khali

RED

SEA

Jeddah

Mecca

QAHTAN

Salalah

Y E M E N

ARABIAN SEA

Aden

YEMEN

Yemen, one of the oldest continuous civilizations in the world, has some of the most diverse landscape in the region. For this reason, horses were used from the earliest times to work in this often rugged terrain. In the past, Yemenis were famous because of their horses, but today such horses are rarely seen, although they are widely distributed across the country from as far afield as the Tihama on the Red Sea to the desert fringes.

In his book of travels, Marco Polo as early as the 13th century described the profitable export of these horses from Aden to India: 'From here [Aden] beautiful and valuable Arab horses are exported to the Indian islands, to the great profit of the merchants. A horse can be sold in India for more than 100 silver marks.' ABOVE: Baraqish, in the Al Jawf region, is one of the oldest preserved walled cities in the world. The region is even today known for its horses, although tribes are suspicious of strangers. RIGHT: Sana'a, the political capital of Yemen and one of the oldest inhabited cities in the world, is a living museum, one of the most astonishing Arab cities in the Middle East.

The tribes in the Mareb are well known for their horses, yet rarely is one seen. OPPOSITE ABOVE: Sadah, near the Saudi border, was once renowned for its horses and fiercely independent tribesmen. OPPOSITE BELOW: The Mareb dam, built in the 6th century BC, was one of the ancient world's great structures and a magnificent feat of early engineering. The dam's destruction in AD 120 led to the flooding which forced the migration of the horse-breeding tribes northwards and eastwards through Arabia.

OMAN

In ancient times, horse breeding on the coastal plains of Oman was important. Affonso de Albuquerque, the Portuguese who sacked the old port of Quriyat in the early 16th century, mentioned the export of horses. Arab horses were also exported from Al Balid, a thriving entrepot in Dhofar during the 13th and 14th centuries. The biggest stables today are owned by the ruler Sultan Qaboos bin-Said, who is passionately keen on reviving the breeding of Arab horses in Oman.

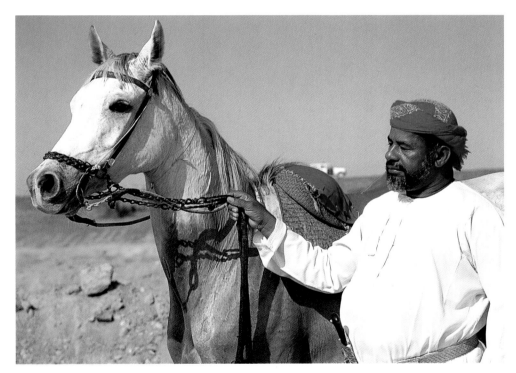

The steep road up to Wadi Auf in the foothills of the Jebel Akhdar to the remote hamlet of Zarmah, framed by the mountain backdrop. At this altitude, clouds build up suddenly to cause violent rainstorms and floods roar down the rocky wadis, sweeping away everything in their path. ABOVE: Sensitive and alert to the presence of other horses, a fine Arab in the Ibri region in the Omani interior.

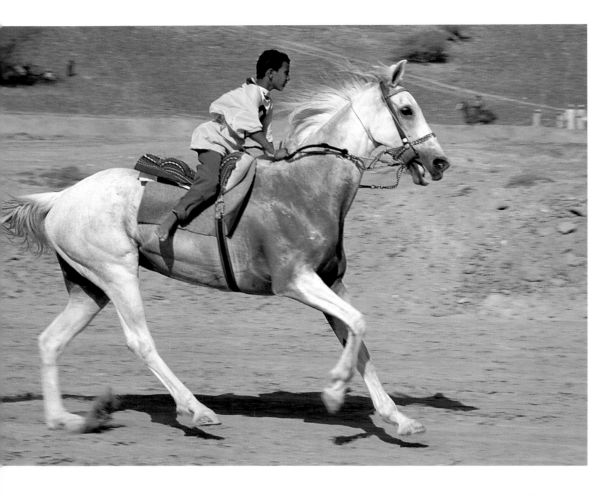

A young handler exercises his Arab horse before an impromptu race meeting held in the desert near Ibri. An Arab at full stretch is a composite of power and harmony. ABOVE: Sultan Qaboos bin-Said, the Ruler of Oman. LEFT: Omanis in the interior often refer to themselves as the 'People of the Palm', with the date palm covering 50 per cent of the total cultivated area. Dates are considered high in nutrients for horses. OPPOSITE: Stallion and groom.

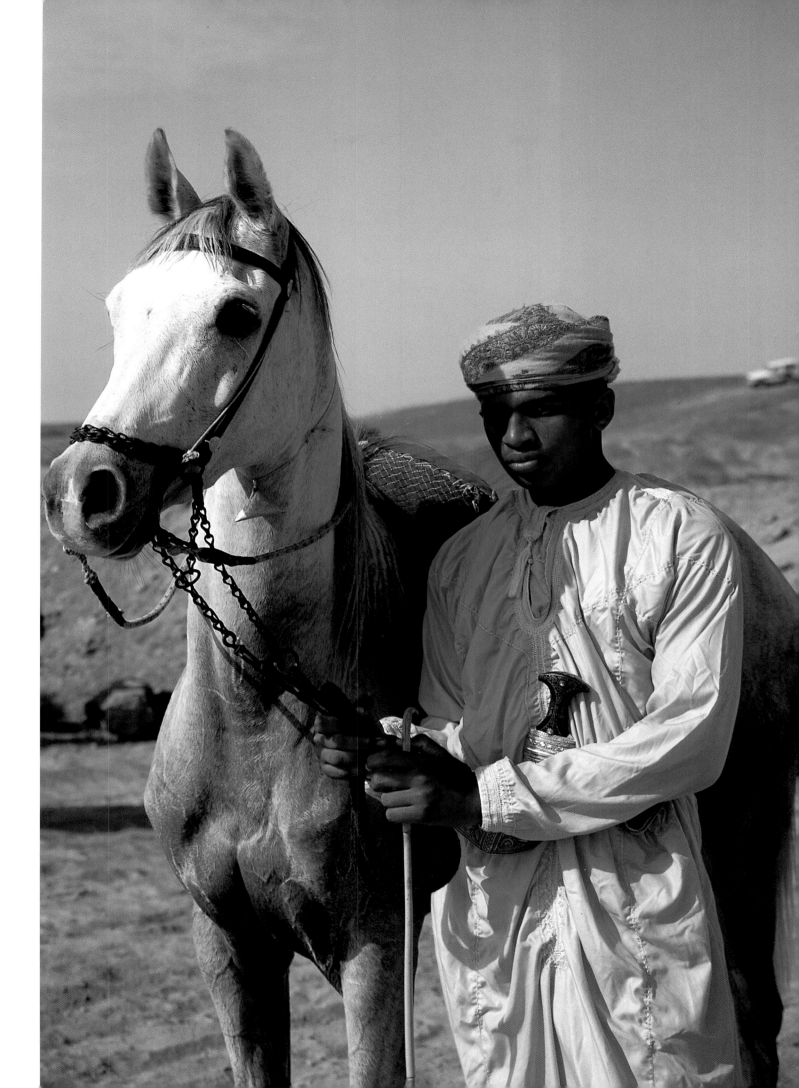

UNITED ARAB EMIRATES

ABU DHABI

THE UNITED ARAB EMIRATES AND ITS PRESIDENT SHEIKH ZAYED BIN-SULTAN AL-NAHYAN

HAVE BEEN IN THE VANGUARD OF REGIONAL STATES WORKING TO REINTRODUCE THE PURE-

BRED ARAB HORSE INTO ITS ORIGINAL HOMELAND.

According to the sayings of our forebears, we should judge the horse
more by his character than by his appearance.
THE EMIR ABD-EL-KADER

*F*alconer in Al Ain Oasis, Abu Dhabi, a tradition as old as the desert Bedu. Falconry, next to
the husbandry of horses and camels, continues to this day to hold the passionate devotion of
both sheikh and citizen in the UAE. RIGHT: Desertscape around Al Ain, a lush oasis town
surrounded by forbidding dunes.

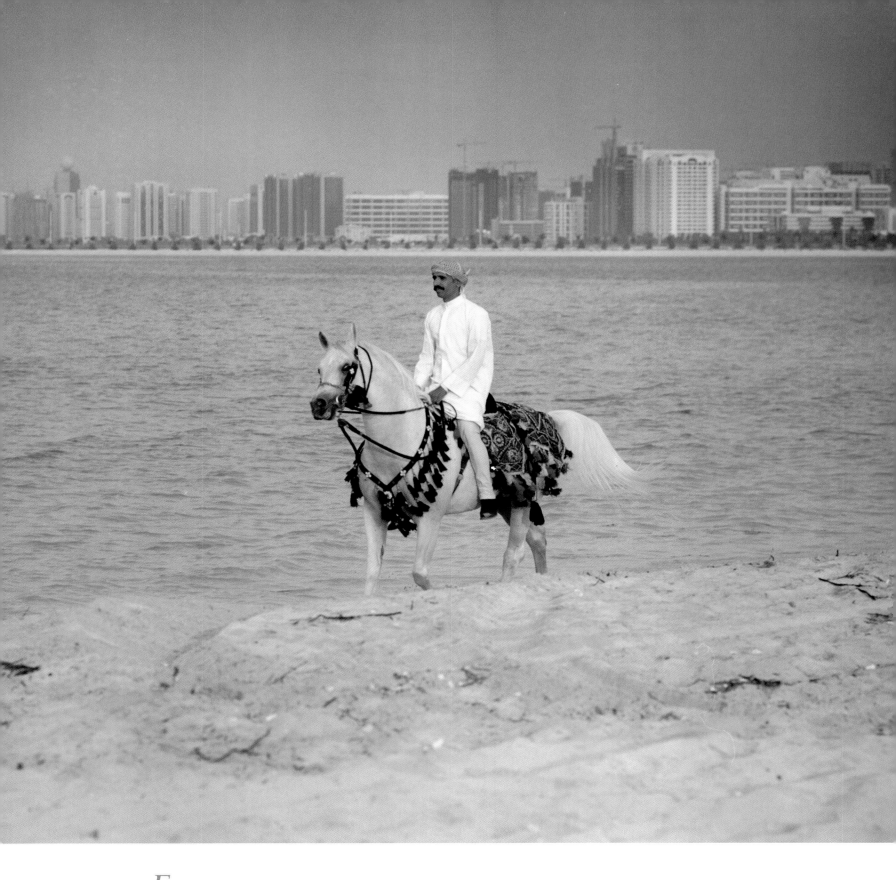

*F*ine specimens of the Arabian breed on display at the Ruler's Amiri Stables; from the top, the stallion Pakistan, the filly Karama and the stallion Aboud, the favourite of Sheikh Zayed. ABOVE: Abu Dhabi skyline – splendid horse, impressive city. Forty years ago, this was a sleepy desert hamlet with just a mud fort to its name. Today it is a bustling capital city with half a million inhabitants.

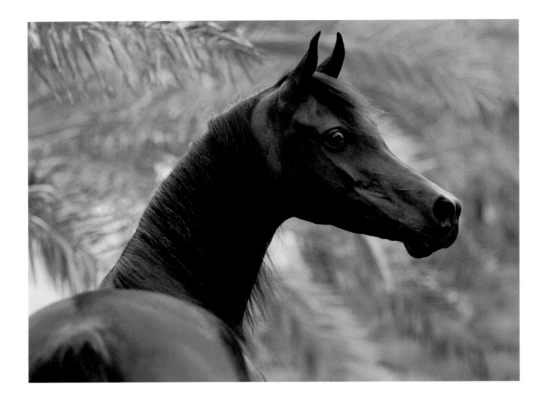

The mare VA Scoundrel, owned by Sheikh Mansour bin-Zayed al-Nahyan, a keen horseman himself and a leading proponent of the Arabian breed. Sheikh Mansour is the President of the Emirates Arabian Horse Society and Chairman of the Abu Dhabi Equestrian Club. BELOW: The mare FA Protea, owned by Sheikh Zayed. Islam has always held a special place for the horse. OPPOSITE ABOVE: The Amiri Stables' little mosque forms a backdrop for grooms and mares. OPPOSITE BELOW: Taking a late-afternoon stroll through the shade of the palm grove.

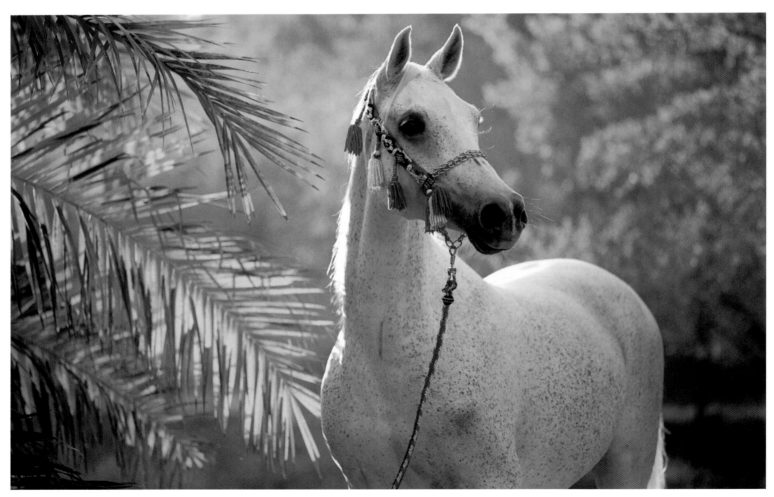

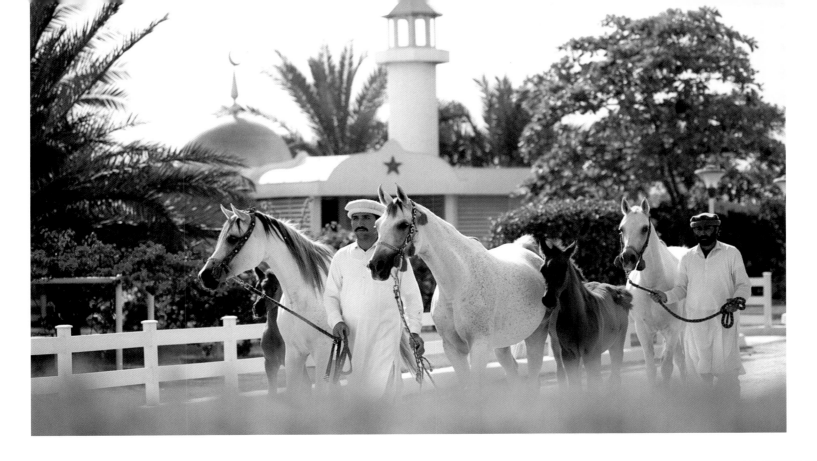

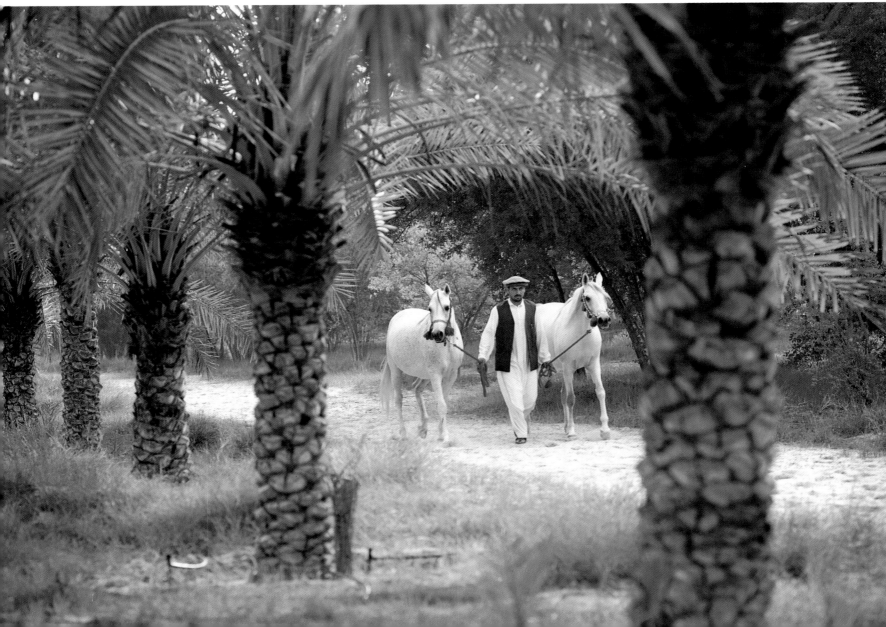

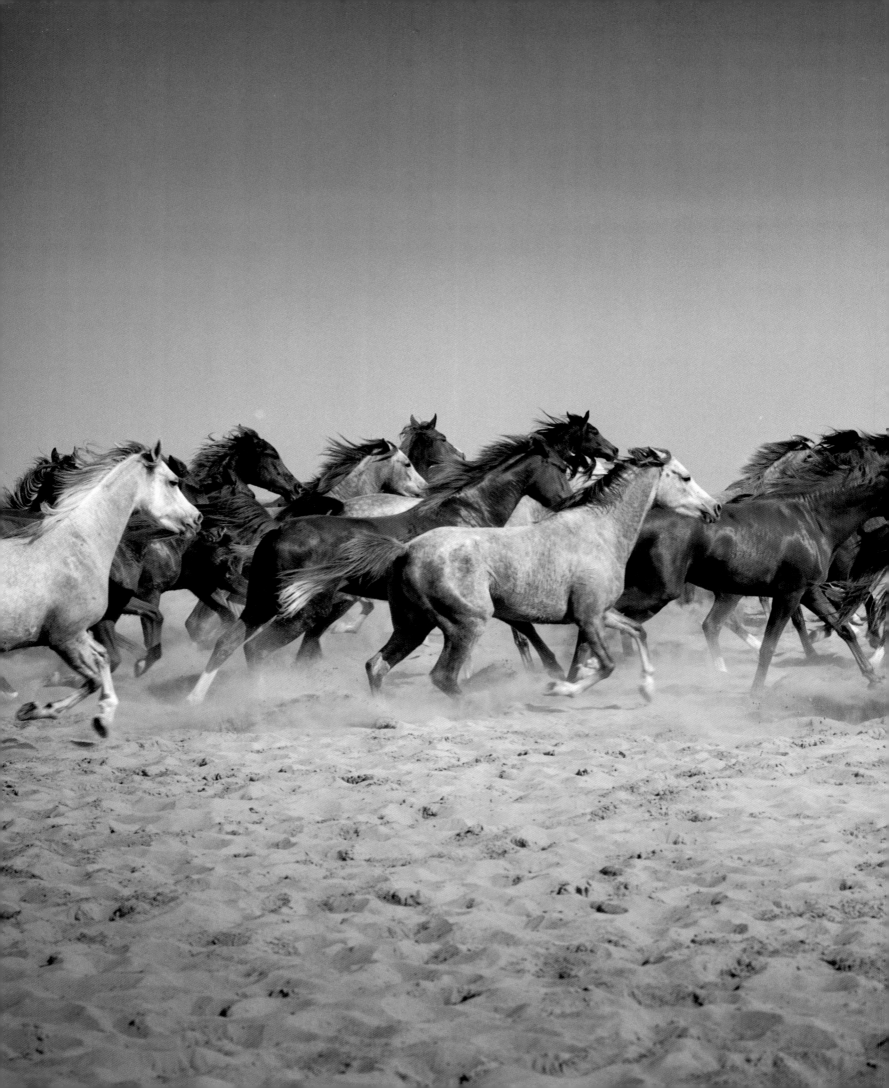

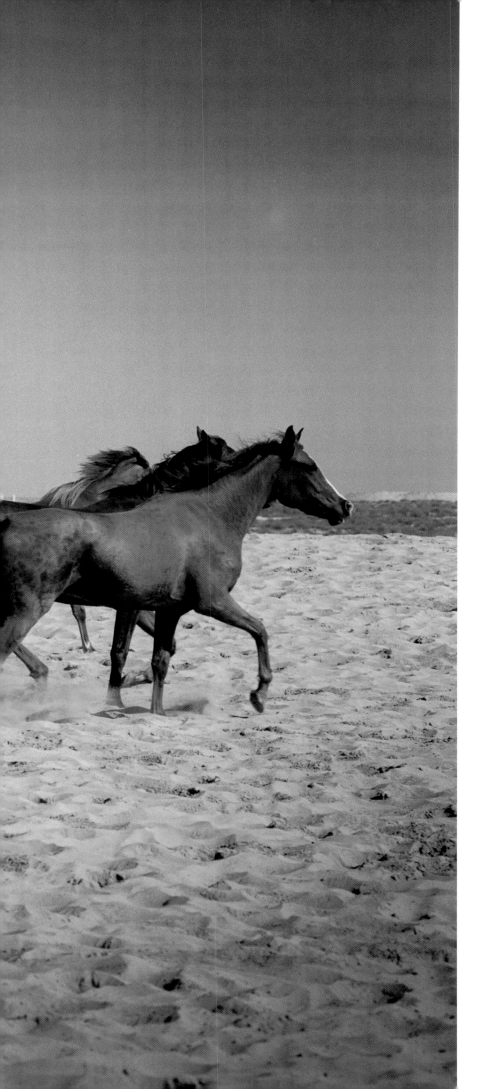

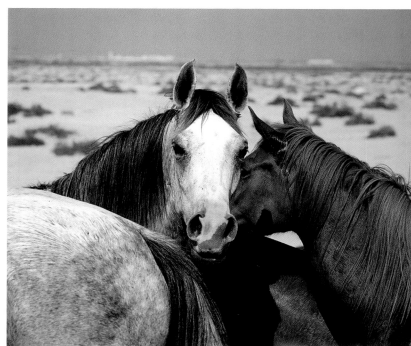

*T*he poet Salim bin-Abdullah Haj's words: 'Her nostrils flare when/
She gathers the wind to her. / Her chest is power. / The grace and
strength of / Her shoulders astonish the eye' are here brought to life out in
the Abu Dhabi desert at the Seih Sudeira breeding farm of the Presidential
Stables, where the horses of Sheikh Zayed and Sheikh Mansour are free to
roam the sands in large, fenced desert enclosures.

O noble company of Arabs! ye
My pride and boast, o'er every company, . . .
Ye are a folk whose chronicles abound
With noble deeds, since valour was renowned,
Yea, from when Qahtan found a hero's grave
Even to Shaiban's Qais, and Antar brave,
To that Quraishite orphan, who was lord . . .

(KHALIL MITRAN)

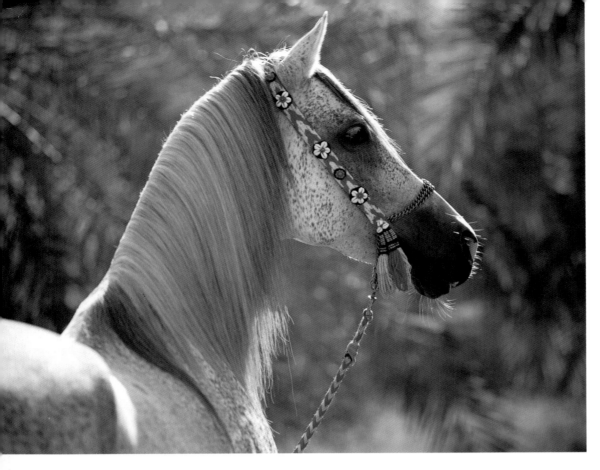

*T*urefi Dahman, one of the most striking horses of the region, bred by Sheikh Zayed. BELOW: Traditional saddle and finery at the Amiri Stables. OPPOSITE: Father and son at the races. Sheikh Zayed enjoys a light moment with Sheikh Mansour at the Abu Dhabi Equestrian Club's annual President's Cup.

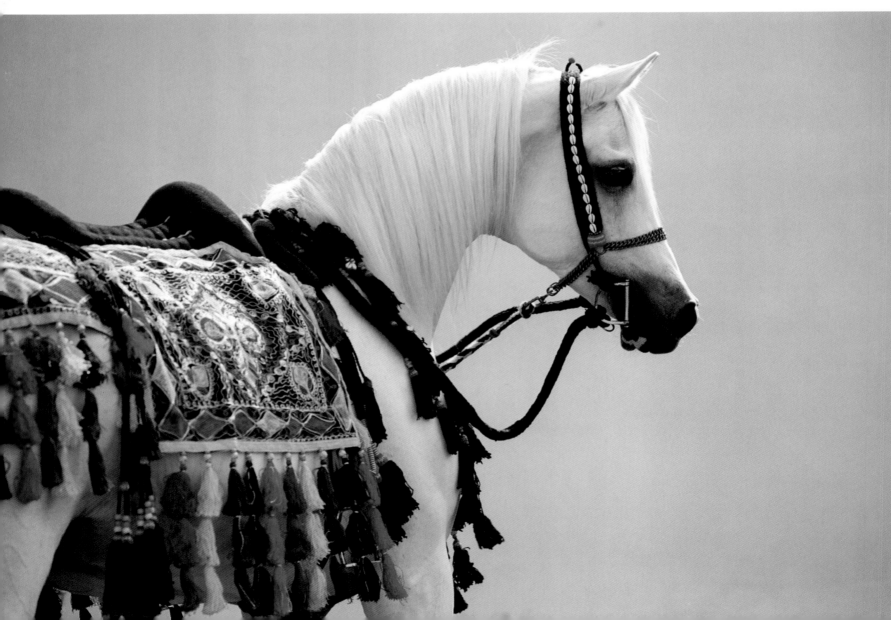

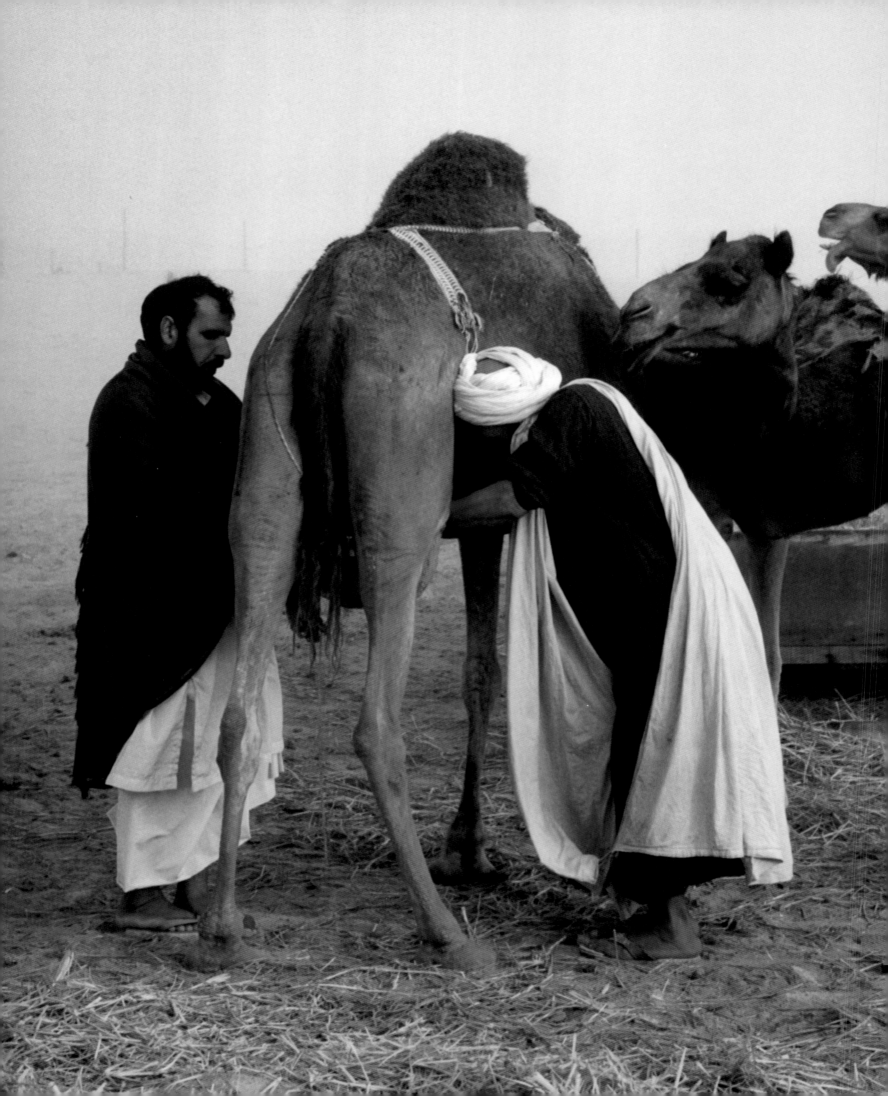

A firm believer in traditional methods of horse breeding, Sheikh Zayed keeps a herd of milking camels for his mares near his desert stud at Asha'ab, just outside Abu Dhabi city. ABOVE: At the stud, fresh camel's milk and dates are fed to the horses every sunset, while desert hospitality awaits the weary traveller.

UNITED ARAB EMIRATES

DUBAI

The Ruling Family of Dubai, the al-Maktoums, are better known in the racing world as leading owner-breeders of Thoroughbreds. But traditions have a strong hold over the Emirate, and some of the best Arab racehorses are owned by Sheikh Mohammed and Sheikh Hamdan, who also have studs in England, Ireland, France and the United States, as well as in Dubai itself.

Early-morning mist shrouds the Zabeel Stables' riders exercising some of the most valuable horses in the world against a glittering Dubai skyline. OPPOSITE: Midday, and endurance riders, led by the Crown Prince of Dubai, struggle through the United Arab Emirates' scorching desert heat in this 160-kilometre (100-mile) qualifier ride for the World Equestrian Games Endurance competition being held in the UAE for the first time in the Middle East.

A true Arab horseman, Sheikh Mohammed bin-Rashid al-Maktoum, the Crown Prince of Dubai, is not only the largest owner and breeder of Thoroughbred racehorses in the world, but is also a very keen exponent of the asil Arab horse. While his Godolphin Organization in Dubai manages to sweep most major European racing trophies, his love of the Arabian is personified by his attachment to such world-class Arab racehorses as (ABOVE) the mare Victoria's Secrett (Kahayla), who has an unbeaten track record. Soldier, poet, sportsman and tireless innovator, Sheikh Mohammed has dedicated his life to the horse.

لوحة بدوية

أحب أهلي والبدو والشوق قتّال
منهـم يميني للزّمَان وشَمَالي
البدو يا أصّل العَرَب قول وأفعَال
أهل المروة والكرم والـنّزالي
واحب أرضٍ تنبت اسيوف وابطال
أرض عزيزة عَن صروف اللّيَالي
واحب شيخٍ صَادق بفعل واقوال
الشّيخ زايد هوَ زعيم الرجَالي
زايد سجلّه بالمفَاخر ولفضَال
عند العرب معروف أوّل وتّالي
واهوى القنص والهجن واكون خيّال
واسهر عَلى فنجَان بنٌ وهَالي
واحب ظبيٍ أكحل العَين يفتّال
يشفيك شوفه من اريَام الرمَالي
واشقر طويل المعنّق يشرح البَال
له كل مَاحَان الهدد طَاب فَالي
في صحصح قنرا بهَا يلمع اللّال
وفي خَايع مَافيه غَير الغَزالي
هناك تتجدد معَاني وأمَال
وارد خَالي من همومي وسَال

الشّيخ محمد بن رَاشد آل مَكتوم

THE BEDOUIN

by Sheikh Mohammed bin-Rashid al-Maktoum

I love the realm, this land, the Bedu in their hue
from all sides, left and right, is my destiny renewed

O Bedu, the true Arab, by your deeds and actions
your generosity and hospitality are your attractions

I love the land that breeds heroes from the sword
This dear land, its gracious day, its embracing nights

I love the Sheikh, this Leader of Men
Sheikh Zayed, his honest word, his promise kept

Known by all, from near and far
all Arabs speak of his generosity, his pride and aspirations

I love hunting and riding, and the horse
the all night drinking of coffee, deep in discourse

I love the gazelle, eyes deep black in kohl
the sight healing the desert travellers so bold

Its long neck, its light hair comforting the weary, young and old
my soul soars like a bird, relaxing my being, alighting from the cold

In this dark desert of life that is lit by the stars
in a place where only deer wander the beyond

Over there are my hopes, the meaning and purpose of my life
renewal from the seasons, and from others' strife

Over there do I seek a truer life
and come back emptied of my troubles, and all my strife

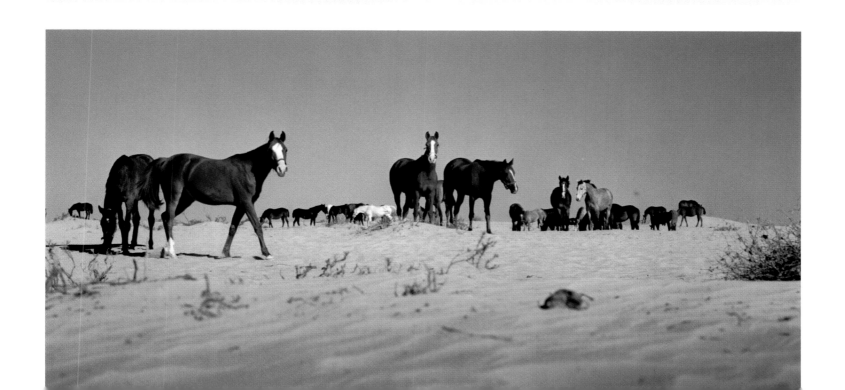

UNITED ARAB EMIRATES

SHARJAH

*T*radition-bound Bedu society does not encourage women to ride in public, but the exceptions make the rule as Sheikha Noor, the daughter of the Ruler of Sharjah, proves. ABOVE AND LEFT: *Doctor Sheikh Sultan bin-Mohammed al-Qasimi, Ruler of Sharjah, tends to new-born foals at the Al Qasimi Stables, which cherish such exquisite Arabians as Estashama* (OPPOSITE).

How exquisite her ears / Pointed as a date flower bud. / A comely blaze enhances her / Smooth cheeks / And generous mouth / And long black lashes.

BAHRAINI POET

SAUDI ARABIA

HERE STILL LIVE MANY OF THE HORSE-BREEDING TRIBES, THE AJMAN, MUTEYR AND OTEYBEH.

FROM THESE TRIBES AND THE STUDS OF THE IBN-SAUDS AND THE IBN-RASHIDS CAME MANY OF

THE FOUNDATION HORSES OF THE MODERN ARABIAN. SAUDI PRINCES TODAY CONTINUE TO

PRESERVE THE ARAB BREED OF THEIR FOREFATHERS.

*The Kingdom of Saudi Arabia consists of two-thirds rippling, waterless desert.
The Rub al-Khali, or Empty Quarter, covering around 250,000 square miles
(650,000 square kilometres), is one of the most hostile environments in the world. Still a
formidable obstacle to exploration, it was first crossed by Bertram Thomas in 1930.
From the flat, rippling expanse of sand in this picture near Tabuk, it rears up into great
crescent-shaped dunes along the border shared with Abu Dhabi.*

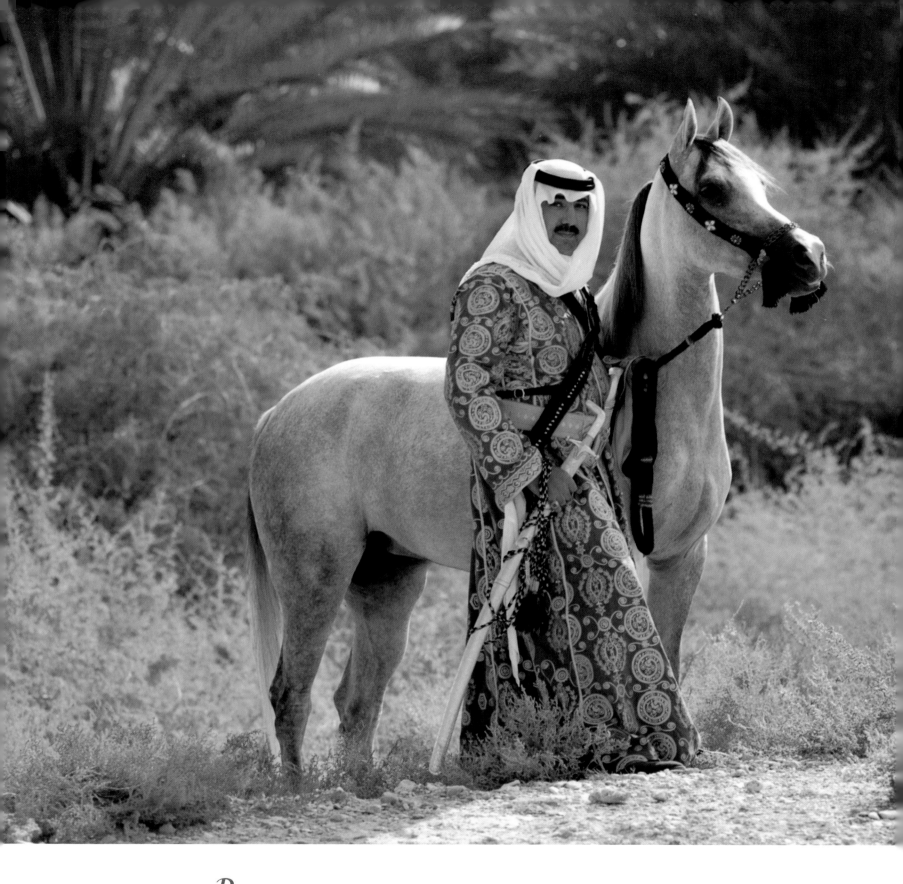

*P*rince Faisal bin-Abdullah bin-Mohammed, President of the Saudi Arabian Equestrian Federation, at home with his horse near Riyadh. OPPOSITE ABOVE: *Arab stallion at Al Jandariyah stud, owned by the Saudi Crown Prince.* OPPOSITE BELOW: *An example of a fine cultural heritage at the Dirab Arabian Horse Centre, the Kingdom's national breeding organization.*

And [God has created] horses ... for you to ride and as an adornment.
KORAN 516 A8

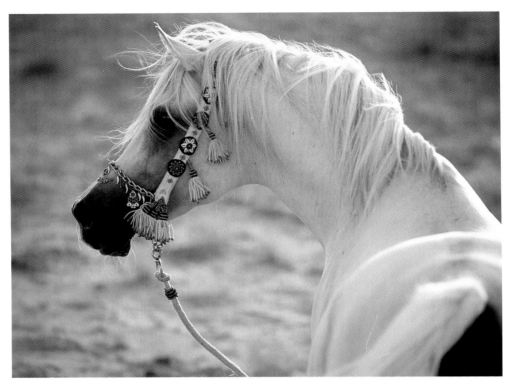

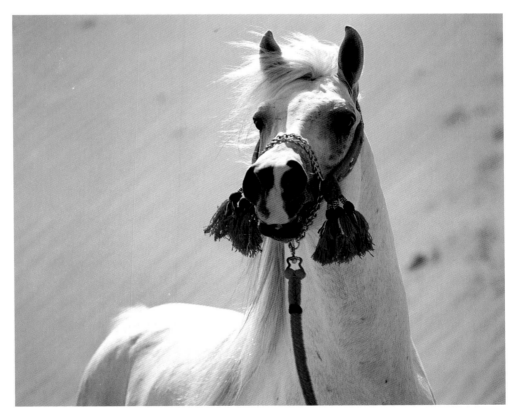

The Nejd region of the Arabian Peninsula has been known throughout the centuries as a source of fine Arabian horses like these specimens, reminding one of the poetic description in The Stealing of the Mare, *one of abu-Zeyd's cycle of romances of a Bedouin mare: 'Spare is her head and lean, her ears pricked close together; / Her forelock is a net, her forehead a lamp lighted / Illumining the tribe; her neck curved like a palm branch …'*

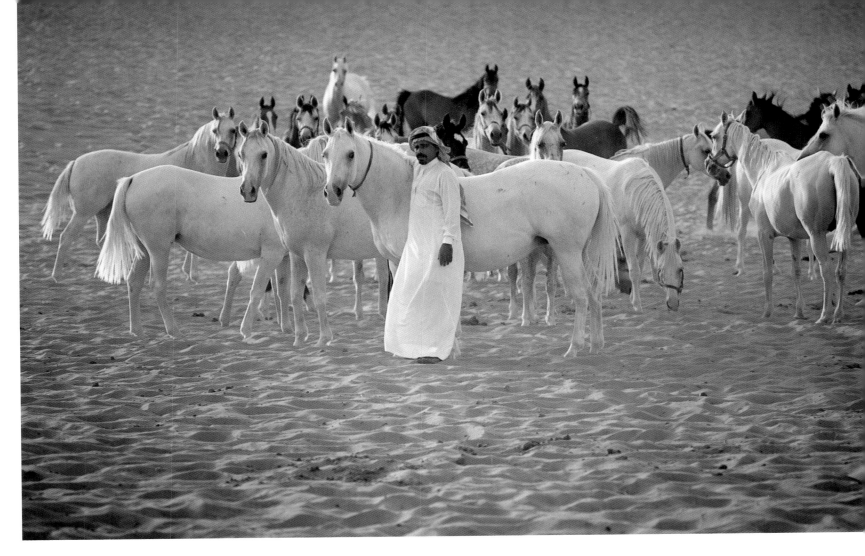

*A*bdullah al-Swailem, a leading Saudi breeder, designed his remarkable stud farm, Marbat Al Jawad Al Arabi, close to the historic town of Diryyah, the ancestral seat of the ibn-Sauds. ABOVE: Mares in the desert stud of Crown Prince Abdullah at Al Jandariyah. RIGHT: The Crown Prince of Saudi Arabia and Deputy Premier and Commander of the National Guard, Sheikh Abdullah bin-Abdul Aziz, handing out prizes at the Kingdom's first National Arabian Horse Show in 1996. The Crown Prince is the leading Saudi force in the regeneration of the asil breed in its traditional homeland.

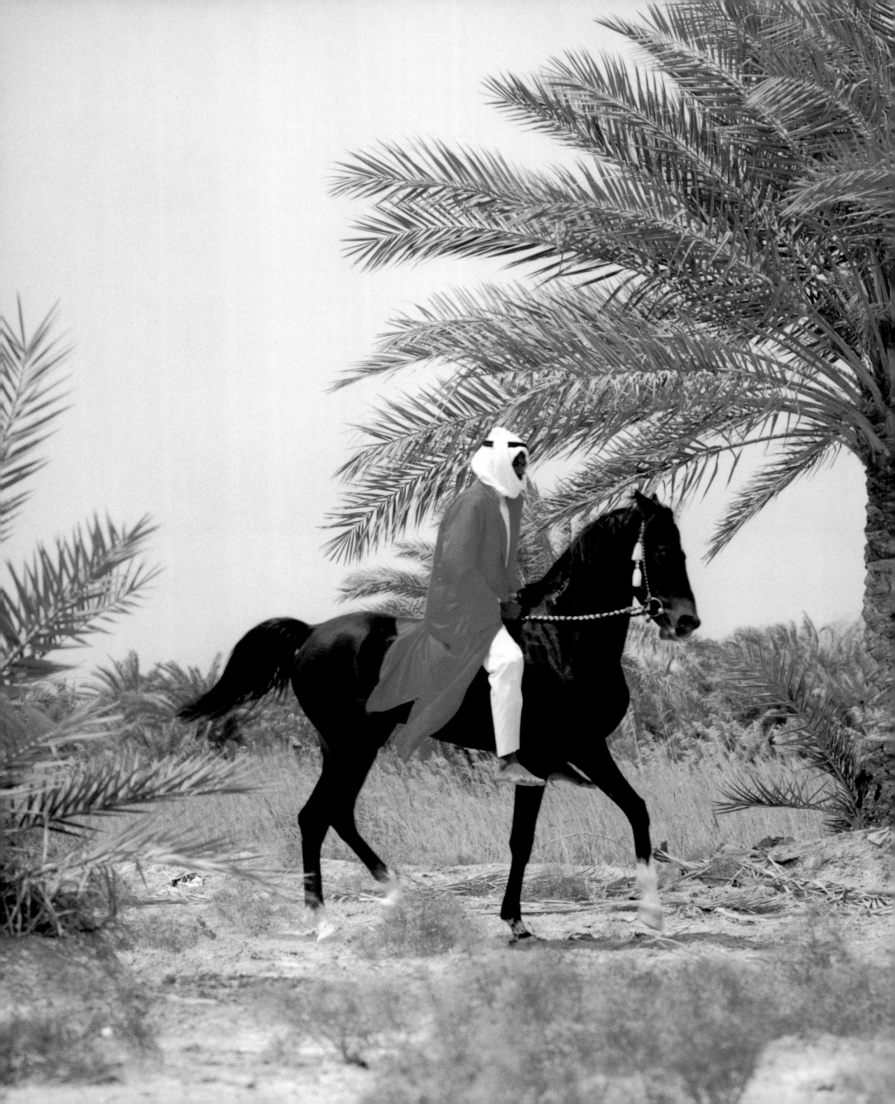

BAHRAIN

The Emirs of Bahrain have maintained a stud of Arab horses for hundreds of years, and they have preserved such rare strains as the Kray and Jellabieh. Horses at the Amiri and the Crown Prince's studs are unique in that they carry no imported blood, other than directly from the desert.

Allah has blessed Bahrain
In abundance
And clothed her in finest raiment....
She exemplifies that
Which is called beautiful,
This daughter
Born in Awal.
Praise be to Allah!
The Sheikh's ancestors
Have bestowed upon him
The Treasure of Ages.
Bahraini poet Salim bin-Abdullah Haj

121

The island of Bahrain was prosperous well before the discovery of oil in Arabia, due to its strategic position, its 3,000-year-old pearling industry, its fresh-water springs and shipbuilding craft. The al-Khalifa family, who have been rulers here uninterrupted since 1782, had originally come from the Nejd. OPPOSITE: Sindbad's magic reflected on this Arabian isle. ABOVE: A stallion at the Amiri Stud drinks from a well. RIGHT: The late Emir of Bahrain, Sheikh Issa bin-Sulman al-Khalifa.

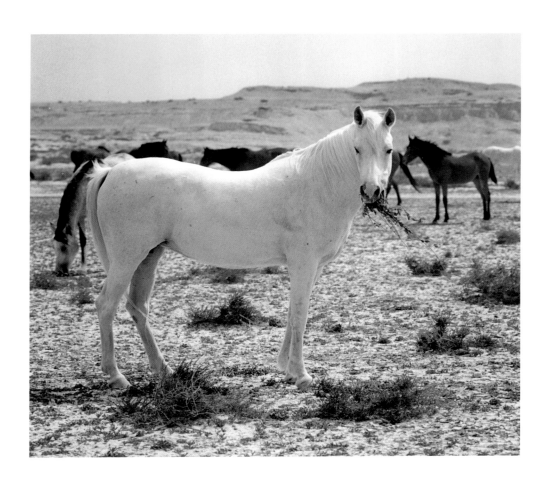

From one generation to another, the al-Khalifas have preserved the purity and maintained the incomparable and unique qualities of their 'Daughters of the Wind'. Exemplars of this noble tradition are the Ruler's Stud and Crown Prince Sheikh Hamad's Amiri Stud. ABOVE: Horses in their desert homeland at the Amiri Stud. RIGHT: Raising the dust at the Crown Prince's desert breeding farm.

The legendary North African ruler of the last century, the Emir Abd-el-Kader, at the height of his power, punished mercilessly with the death penalty every true believer convicted of having sold a horse to the Christians.
FROM J. FORBIS, *THE CLASSIC ARABIAN HORSE*

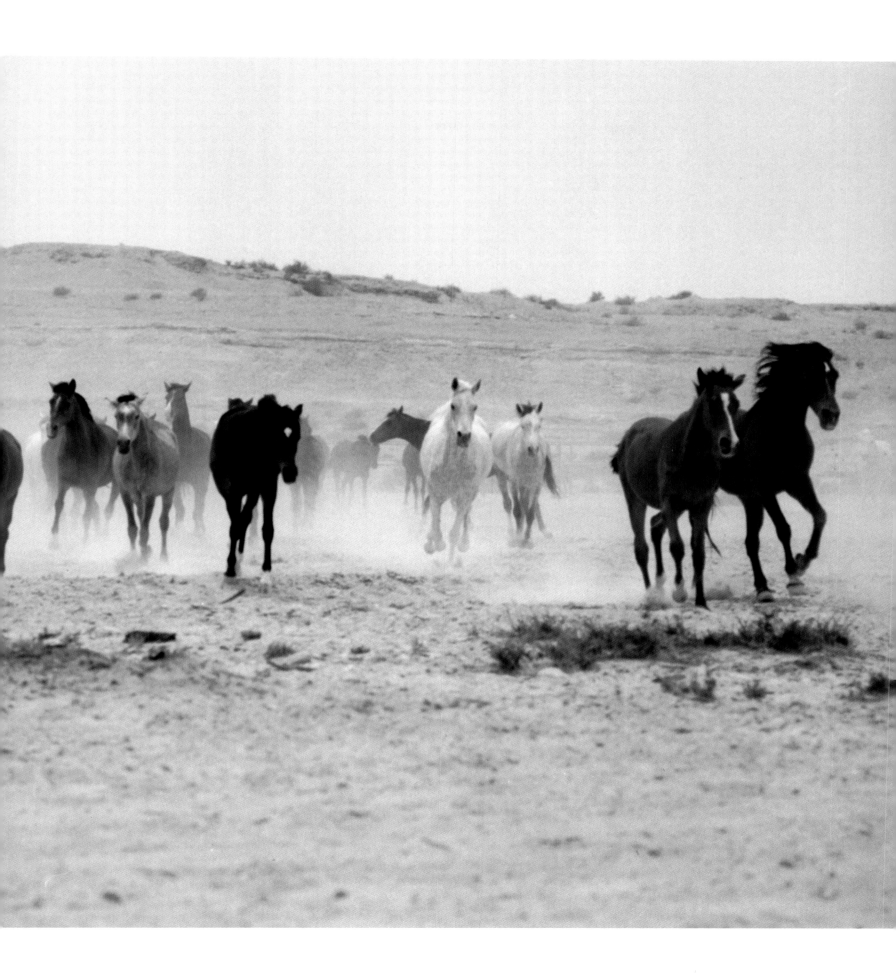

QATAR

In the past, the al-Thani Sheikhs of Qatar kept a stud of Arab horses and sent many as gifts to the Emirs of Bahrain and Saudi Arabia. The present Ruler and other Qatari sheikhs have collected some of the finest Arab horses from around the world.

The stallion Ibn Nazeema at the Al Shaqab stud owned by the Emir. RIGHT: *Walking home at sunset to the Al Shahania stud of Sheikh Mohammed bin-Khalifa al-Thani.*

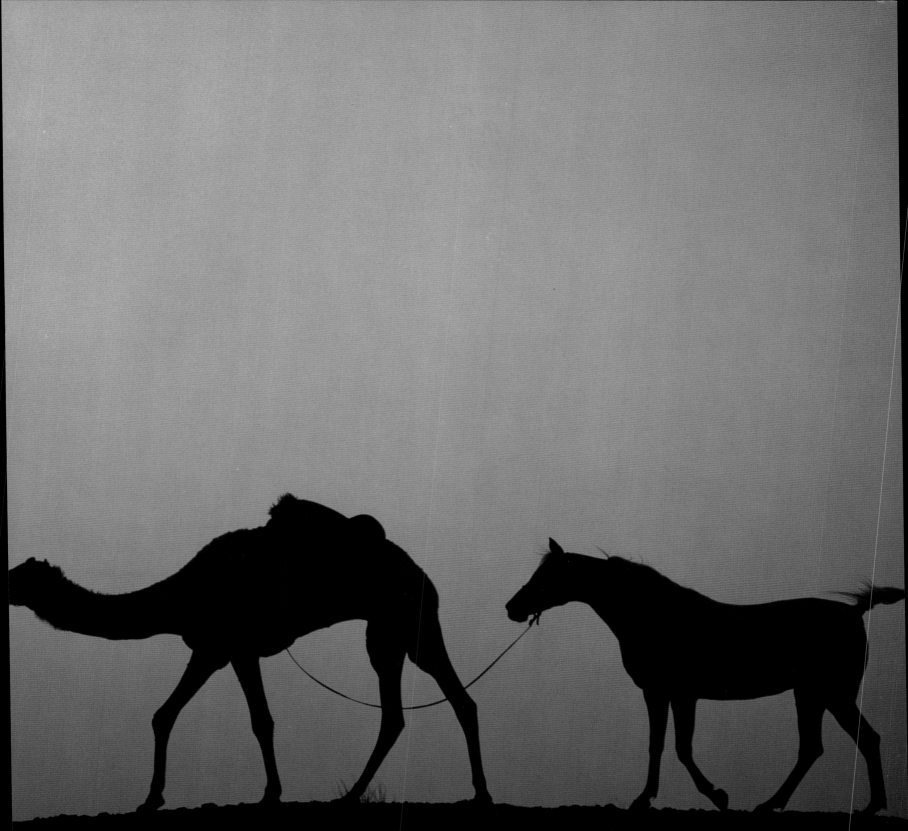

A green oasis in the middle of a desert city, the Al Shaqab stud farm has become a leading force in the region because of their champion horses and asil *breeding programmes.* OPPOSITE ABOVE: *The loneliness of the long-distance runner, competing in the marathon at Al Khor.* OPPOSITE BELOW: *The Emir, Sheikh Hamad bin-Khalifa al-Thani, with his son Khalifa and a favourite mare.*

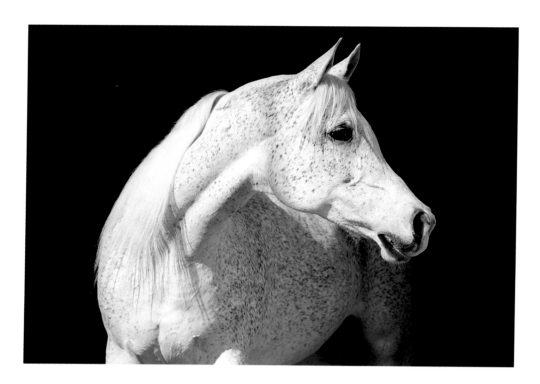

Phanelah, the Emir's World Champion mare.
BELOW: *The mare Imperial Shaharah testing the waters.*
OPPOSITE: *The old* majlis *at the Al Shaqab Stud.*

Her shapeliness bears testimony
To Allah's enduring blessing,
For her master attends her
Even before he meets his own needs.
SALIM BIN-ABDULLAH HAJ

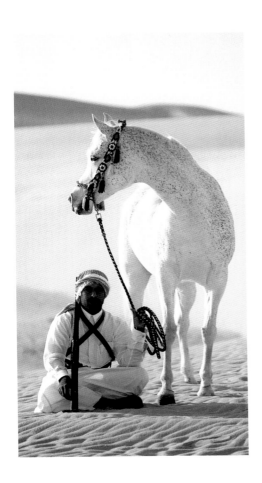

*O*nce a Bedu, always a Bedu.
OPPOSITE ABOVE: *Abdulrahman, his horse, falcon and saluki in the dunes of Khor Al Adeed.*
OPPOSITE BELOW: *From the stables of Sheikh Nawaf bin-Nasser al-Thani.* ABOVE: *Sheikh Hamad bin-Ali al-Thani, the manager at the Ruler's Al Shaqab stud.* RIGHT: *The lovely Ikhnatoon son Safir from the stables of Sheikh Abdulaziz bin-Khaled al-Thani.*

Indeed Allah has fashioned
Her forelimbs
In His perfect way.
SALIM BIN-ABDULLAH HAJ

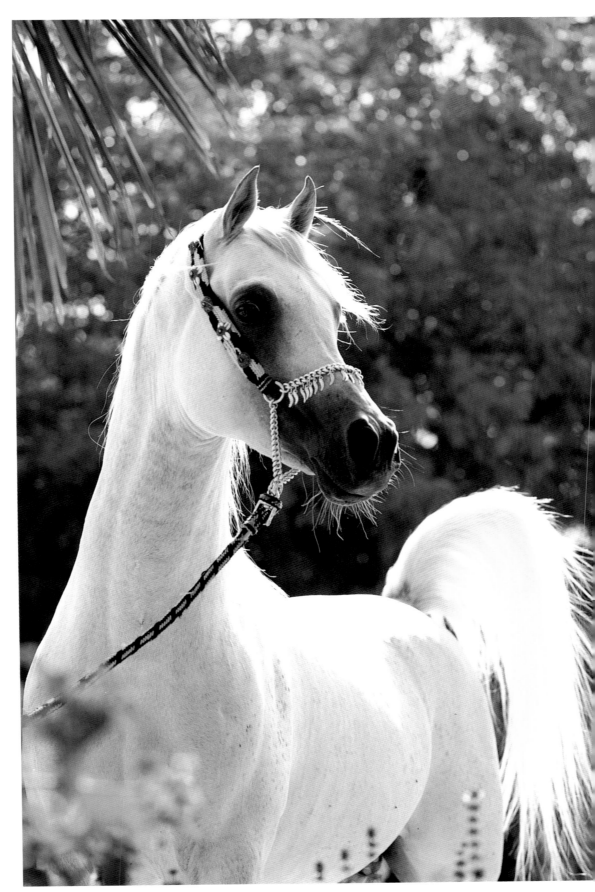

133

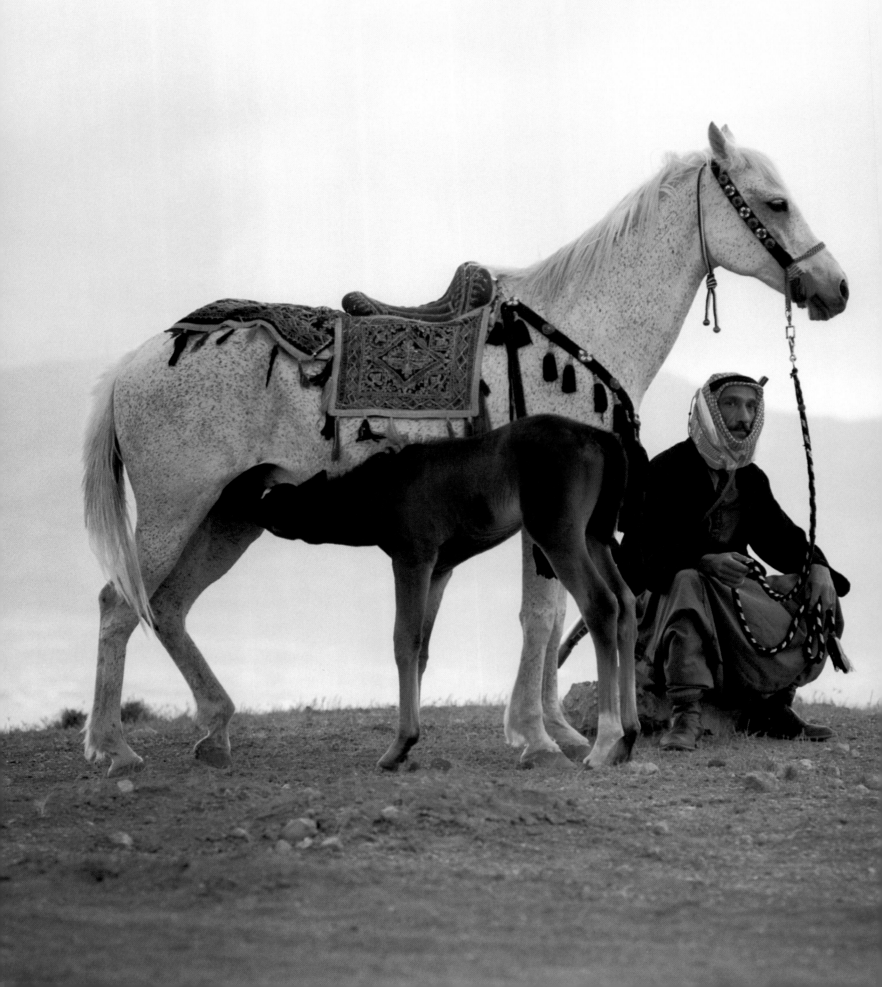

SYRIA

MANY OF THE GREAT TRIBES OF THE ANAZEH, THE FEDAAN AND GOMUSSA ARE STILL TO BE

FOUND IN SYRIA. IT WAS TO THESE TRIBES THAT MANY OF THE DESERT TRAVELLERS IN SEARCH

OF THE PURE-BRED ARAB HORSE WENT IN THE 19TH AND EARLY 20TH CENTURIES. TODAY,

THESE SAME TRIBES AND OTHER DEDICATED BREEDERS STILL PRESERVE THE TRUE DESERT HORSE.

Syrian tribesman with his horse in the Golan Heights. ABOVE: The Aleppo souq, dating back to the 15th century, is a labyrinth of shops and workshops extending over 10 kilometres (more than 6 miles).

Najim Alhimmari of the Bajjara tribe with his mare Marwah. Tribal traditions remain strong in Syria. RIGHT: A traditional wedding ceremony in Palmyra (Tadmor). In ancient times, Palmyra was the capital of an ancient empire and the seat of the legendary Queen Zenobia who, after being vanquished by the Romans, was paraded through Rome laden with her jewels as punishment for her resistance to the Roman Empire.

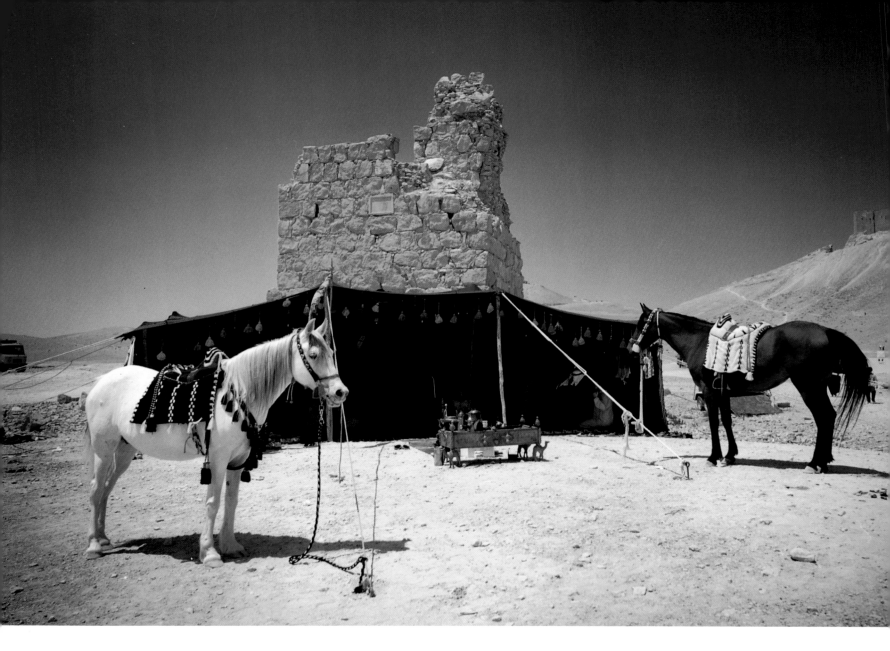

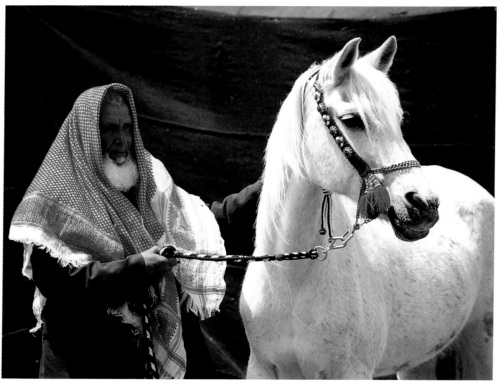

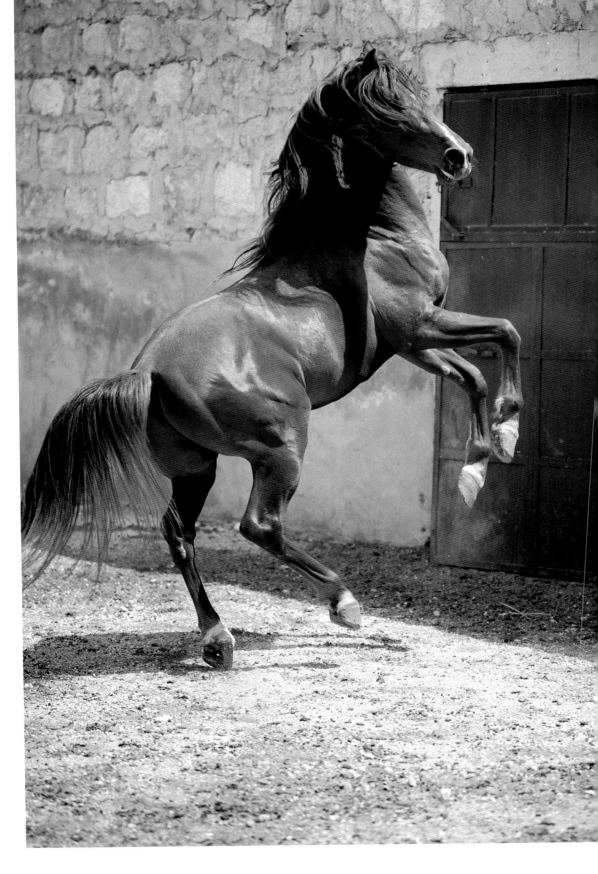

*I*n the heart of the Syrian desert, a Bedu's tent
pitched against the ruins of long-lost empires,
offering the weary traveller hospitality and rest.
OPPOSITE BELOW: Mohammed al-Khider with his horse
Adeelah. The Arab considers the horse to be a true
companion, faithful in travel and loyal in war.
ABOVE: A Bedu woman with traditional markings
on her face. RIGHT: Aleppo was an important cross-
roads for the export of pure-bred horses from
Arabia to the rest of the world. Mahrous, a chestnut
stallion, shows off his true colours.

139

JORDAN

The Arab horse is an integral part of the heritage of Jordan and its people, who include the great horse-breeding Bedouin tribes of the Roala, Banu Sakr and Howeitat. The Royal Stud founded by King Abdullah still maintains a fine collection of pure-bred Arab horses.

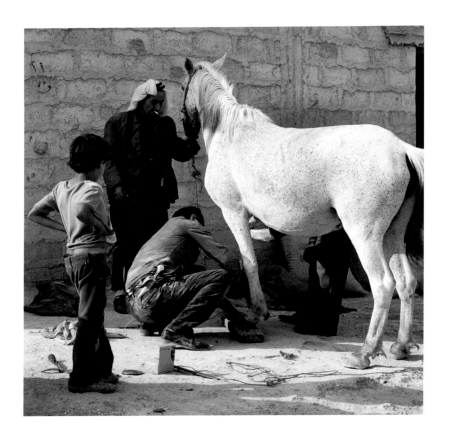

A village farrier at work in Al Bassa near Amman. RIGHT: The pink hue of the historic rock city of Petra, home of the Nabataeans, renowned ancient horsemen whose traditions continue to this day among the horse-breeding tribes of the Wadi Araba.

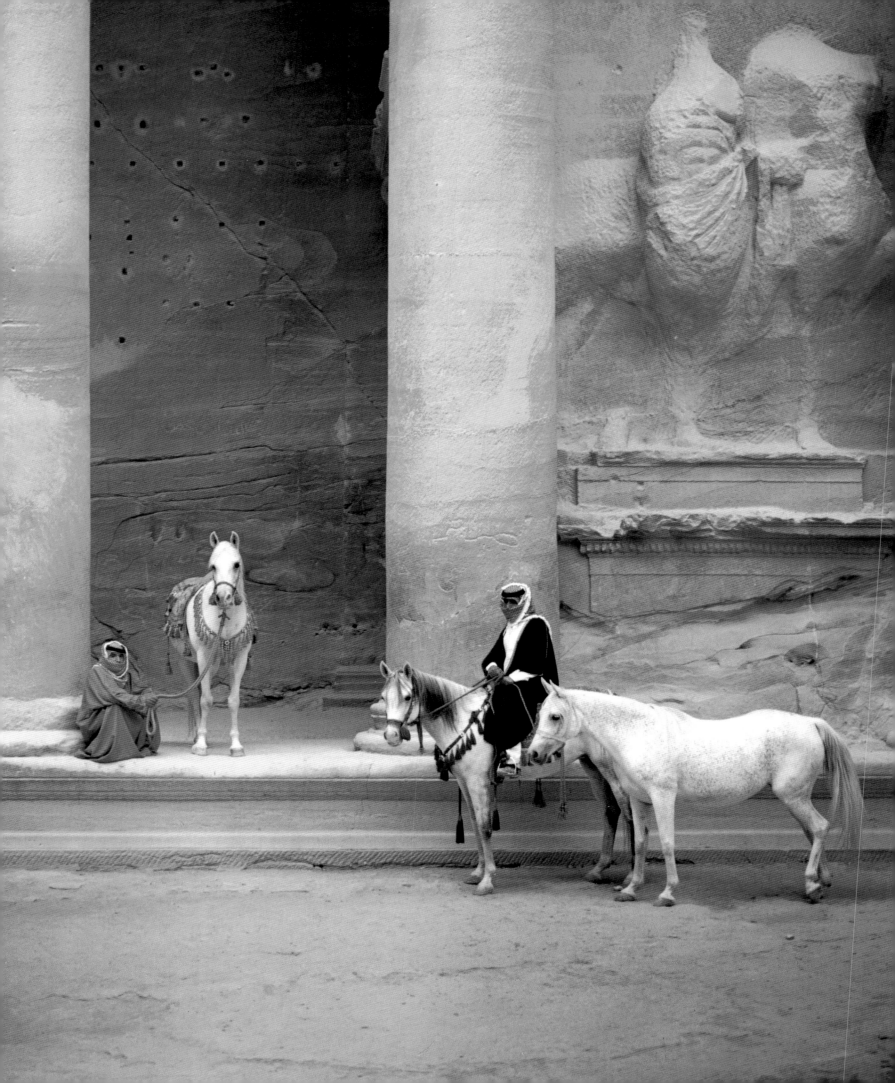

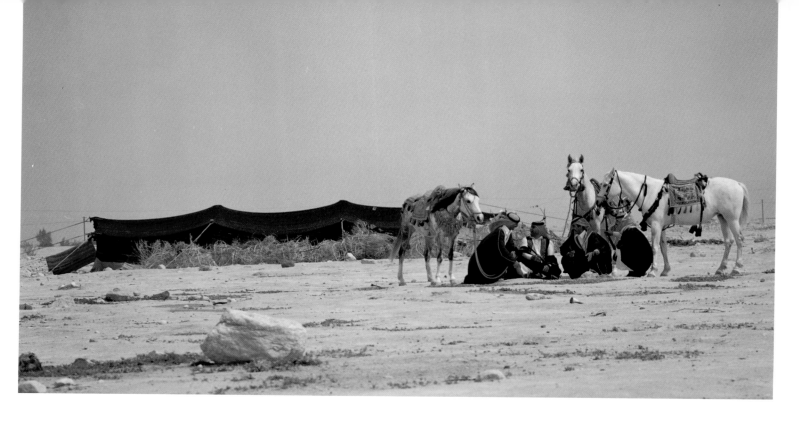

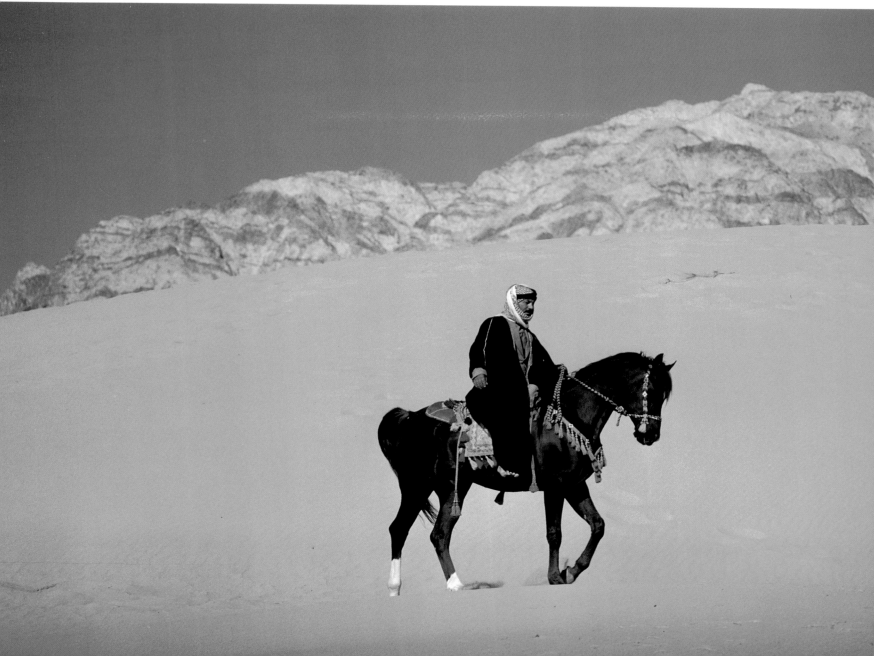

*T*he majesty of time. OPPOSITE: *Desert horsemen, desert homecoming, desert traditions – traditions maintained to this day by no one more strongly than the Jordanian Royal Family.*
ABOVE RIGHT: *The late King Hussein and Queen Noor.*
BELOW RIGHT: *Princess Alia al-Hussein, the late King's eldest daughter, a world figure in the promotion of the Arabian breed.*

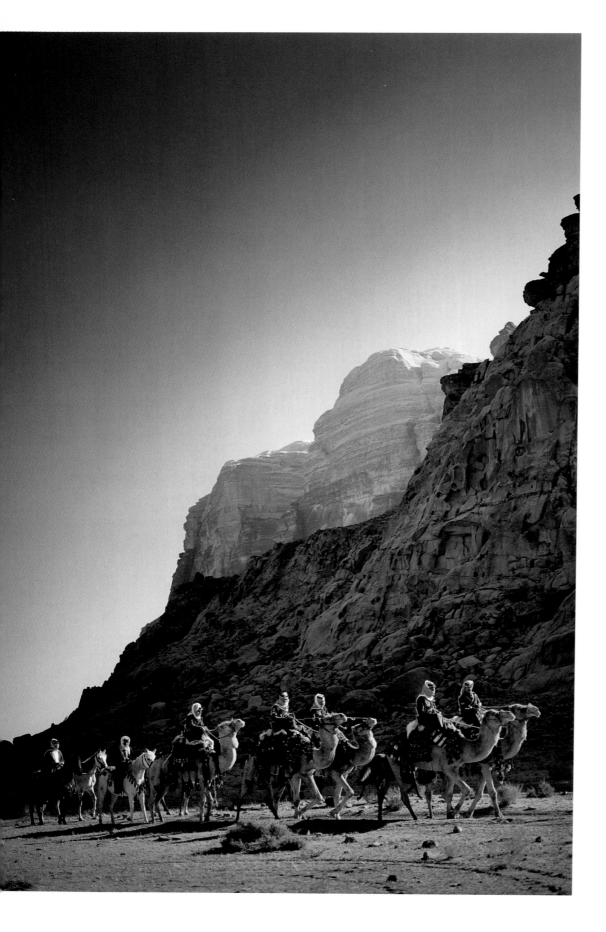

The Royal Jordanian Guard on patrol in the spectacular setting of the Wadi Rum. Both the horse and the camel are still used by this traditional desert soldiery. ABOVE: An old Bedu tribesman with his treasured possession. OPPOSITE: Petra, horse and nature.

The sculptor thus
Chiselled her, beauteous
Symbol of beauty, then
Passed from mortal ken;
She that he dreamed upon
Unaging, changeless, liveth on.
UMAR ABU-RISHA

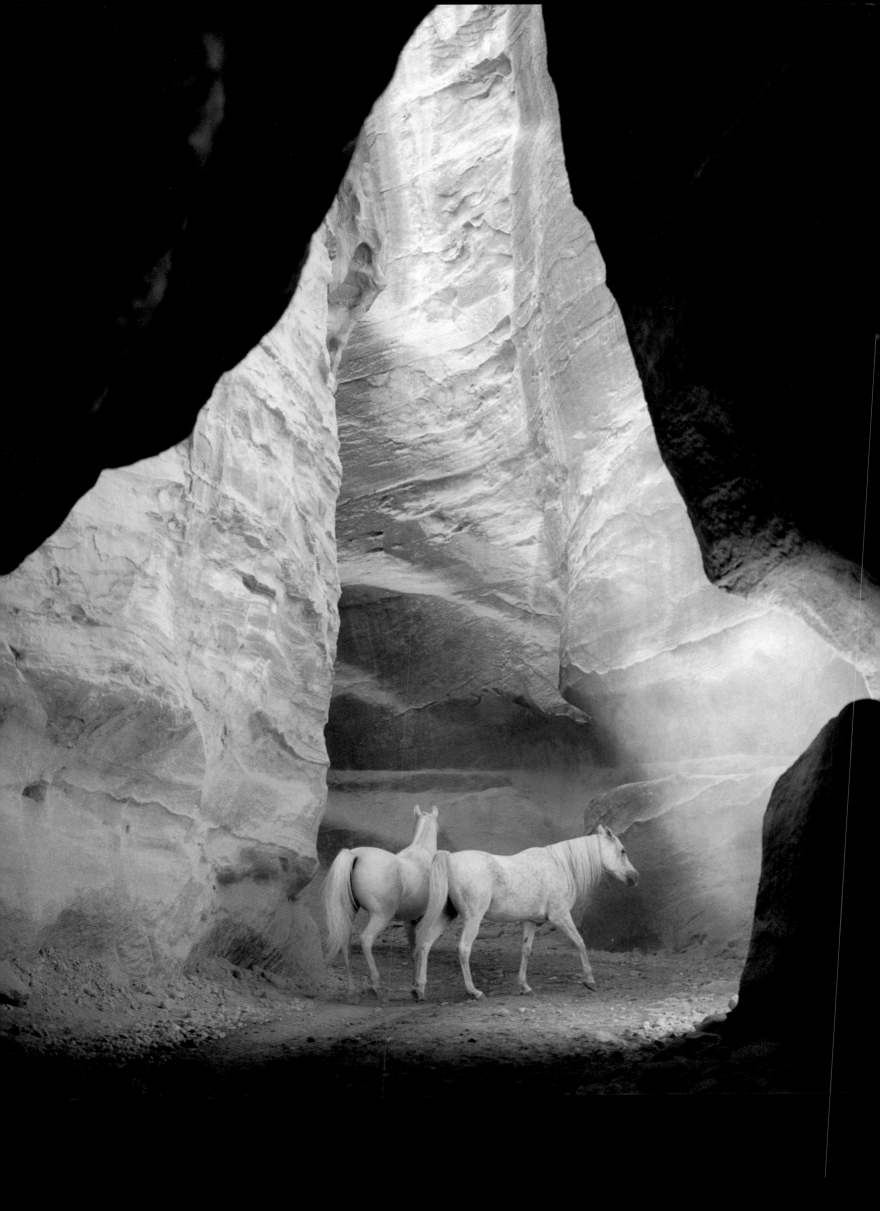

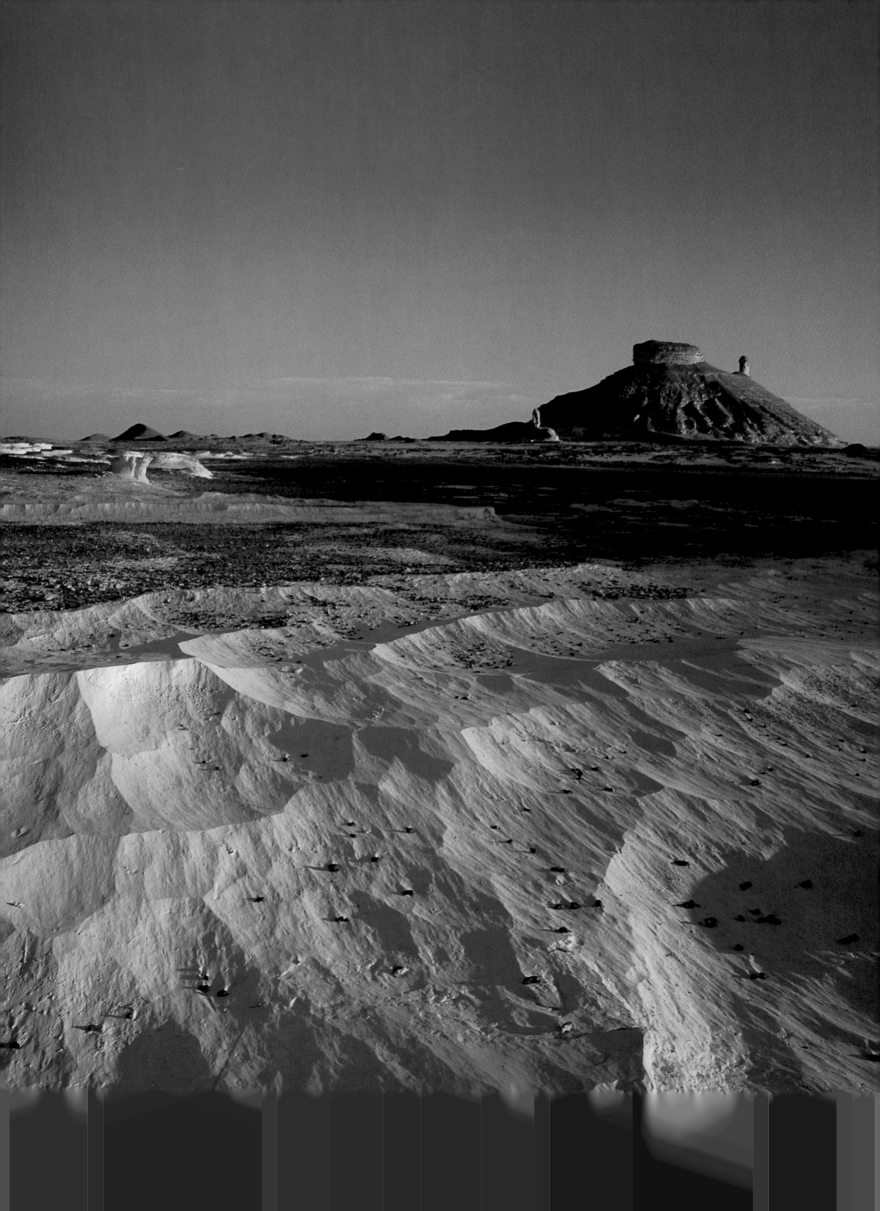

EGYPT

Abbas Pasha I and later Ali Pasha Sherif sent emissaries into the desert to purchase Arab horses for collections

which were to become the essence of legend. The Egyptian Agricultural Organization continues the work of

breeding the classic Arabian horse started by the Egyptian princes and the Royal Agricultural Society.

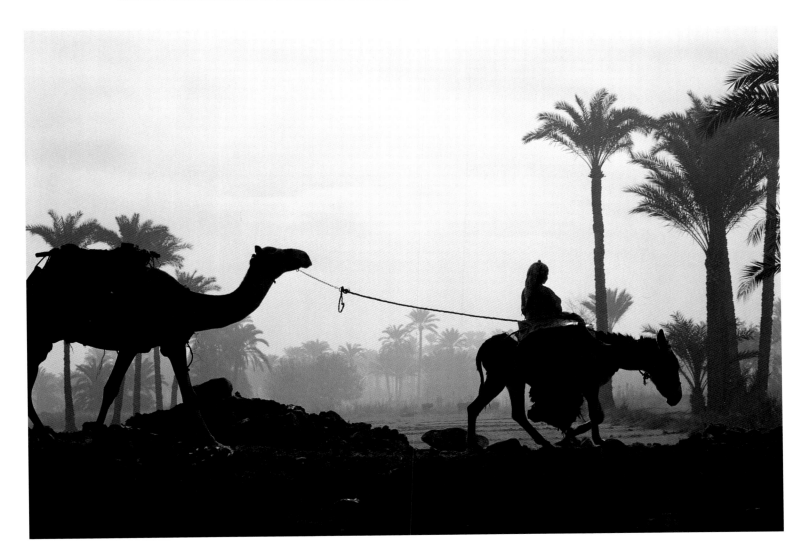

The White Desert between Bahariya and the Farfara Oasis in the Western Desert. ABOVE: The River Nile, cradle of civilization.

Upon the Nile an ancient shrine, entrancing
Majestic stands, inspired of poetry,
And there my alien soul was oft-times dancing
To the slow rhythm of Time's minstrelsy …
Abd al-Aziz Atiq

A true Pharaonic Prince, the stallion
Madi. OPPOSITE BELOW: Bayoumi, the groom,
and the mare Kot El Koloub at the Rabab Stud.
RIGHT AND BELOW: Egyptian brides.

Bride of the Palms! the night pales to its
ending;
Unslumbering I wait for thy return;…
Come! and my breast shall lighten to descry
thee,
And all its night of darkness disappear.
ABD AL-AZIZ ATIQ

When you come to Paradise, you will meet
a winged ruby-coloured horse to mount and
to fly wherever you want.

AL-DAMIRI (14TH CENTURY)

O gift of God to all mankind!
In joy serene my way I find,
Attended by thy magic might,
To secret charms and true delight.

ABD AL-RAHMAN AL-KHAMISI

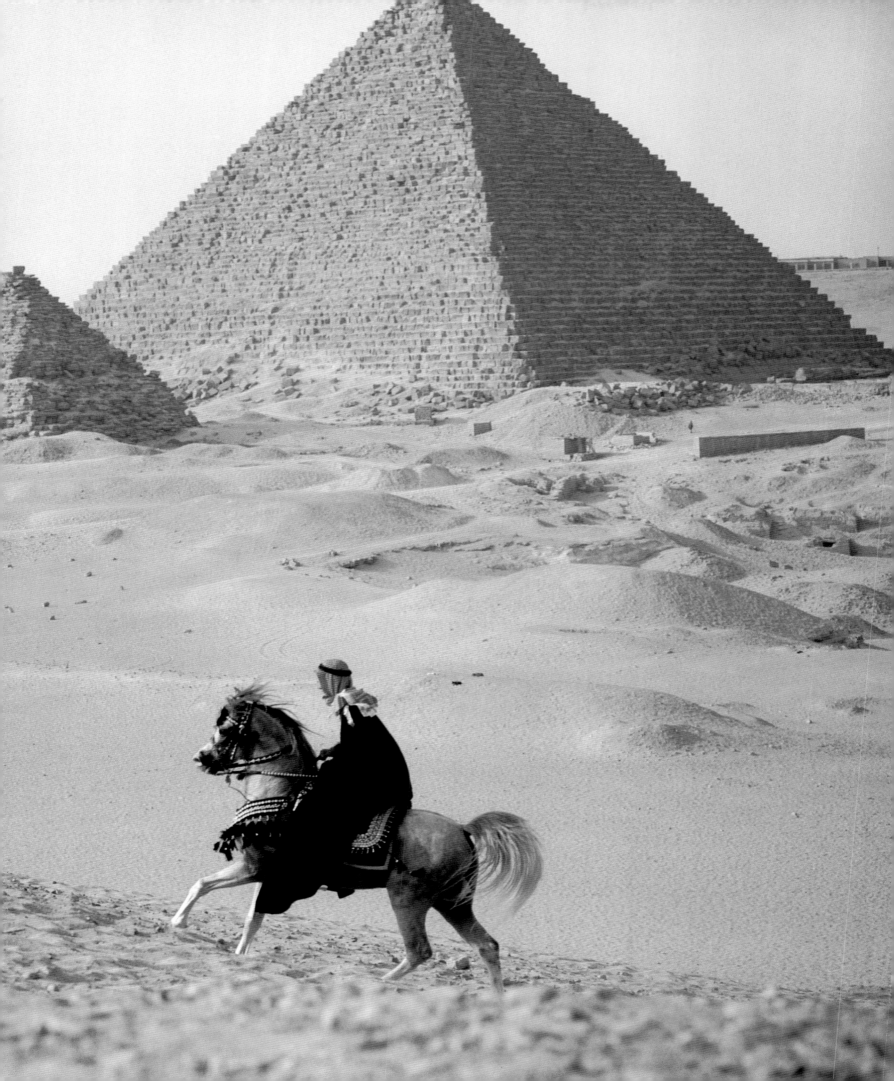

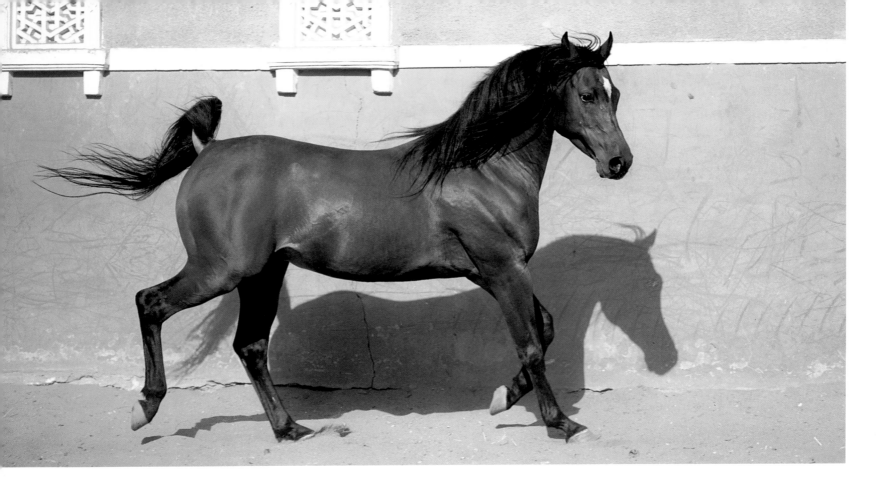

*G*waher (Jewel) in action at Al Badeia,
one of the largest private studs in Egypt.
LEFT: El Zahra, kitted out to catch the fancy of any
suitor. OPPOSITE ABOVE: Sokkar Maakoud, champion
stallion bred by Danni el-Barbary of the Shams El
Assil stud near Cairo. OPPOSITE BELOW: Young colts at
the El Zahra State Stud. The mares and stallions at
El Zahra are descendants of the finest
bloodstock to come out of Arabia in the
18th and 19th centuries.

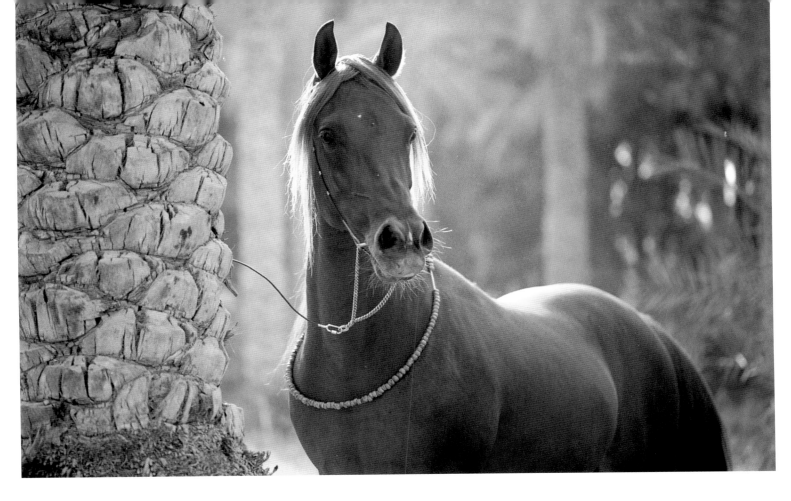

An opportunity not to be missed at the Al Badeia stud farm belonging to Nasr and Hassan Marei. ABOVE: Mrs Danni Wegdan al-Barbary, one of Egypt's top breeders. LEFT: Anybody home?

God commands, and we pursue
The divine unreachable:
Beauty, and devotion true,
These alone life's secret tell.

MAHMUD ABU 'L-WAFA

154

MOROCCO

Morocco has had a long association with the Arab horse and introduced the breed into the Iberian Peninsula through the Moorish invasion of Spain in the 7th century. The Royal Stables at Bouznika, one of the finest examples of modern Islamic architectural style in the Arab world, have imported horses from France and Spain, but in recent years mainly from America. However, original bloodlines are still maintained.

The stallion Hassan, one of the chief sires at the Royal Stables of King Hassan II. OPPOSITE: Bouznika, the Moroccan Royal Stables. The late King Hassan II was a keen horseman and an ardent proponent of the breed.

The expression in a horse's eye is like a blessing on a good man's house.
The Prophet Mohammed

The director of the Bouznika Royal Stables,
Amid Abdelamid, with the mare Georgie Girl.
BELOW: Horse and groom at exercise.
OPPOSITE: Arabesque motifs, enough to inspire
any painter.

They came with tails aloft,
pure-bred stallions.
BENI QAYS

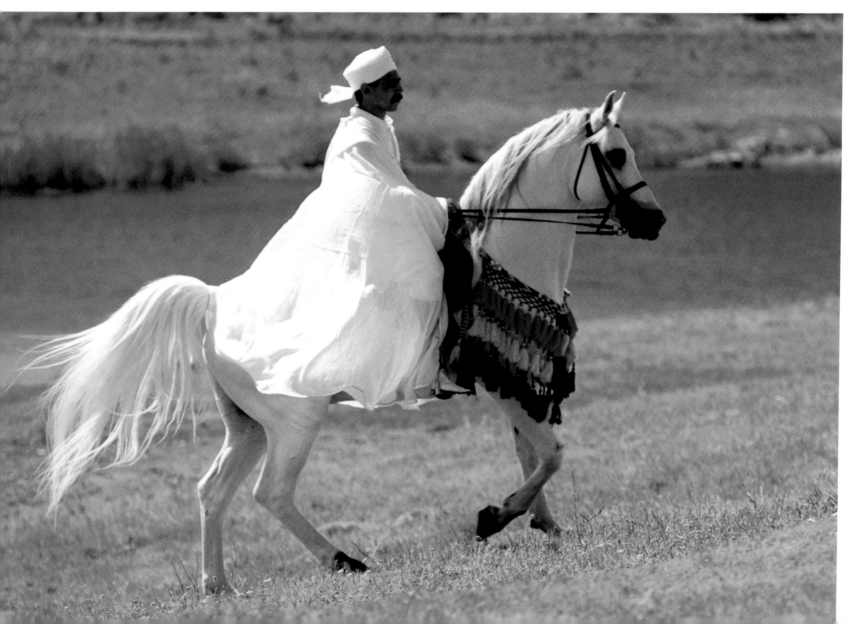

SPAIN

The influence of Arab culture in Spain has been considerable and, from the earliest years, Arab horses have been valued for their special qualities. Kings, dukes and dons once imported horses from Syria for their studs, while today private owners such as Princesa Teresa de Borbón and Diego Mendez Moreno, as well as the Yeguada Militar, are dedicated to the task of breeding fine Arabian horses.

L̶oose box at the Yeguada Militar, the state stud located near Jerez de la Frontera, which was established in 1893 by Royal Decree.
OPPOSITE: La Cascajera stud in Seville, owned by Don Luis de Ybarra.

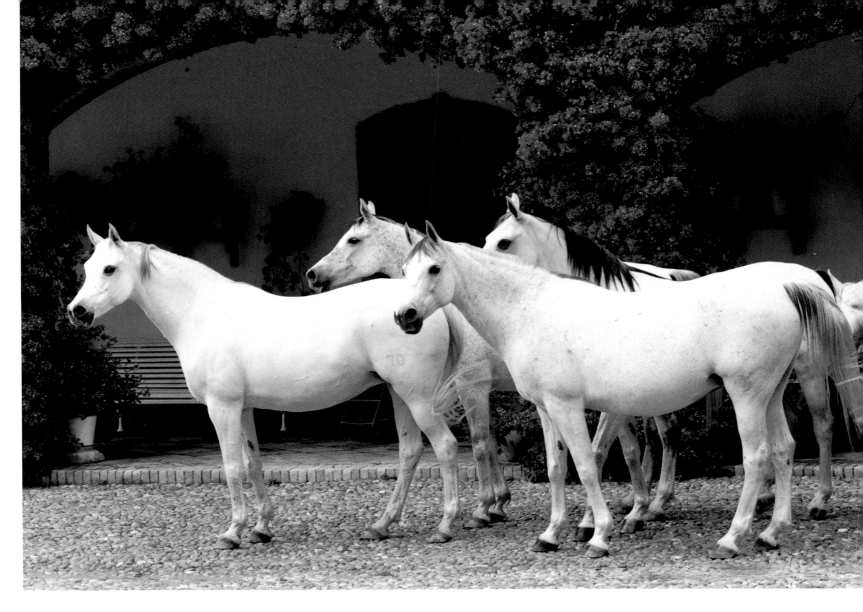

The Yeguada Militar. ABOVE: Thirty years of breeding by the Ybarra family at La Cascajera. RIGHT: Abha Hamir, world-famous champion mare owned by Marieta Salas at Ses Planes stud in Palma de Mallorca.

A thousand horse, the wild, the free,
Like waves that follow o'er the sea.
FROM 'MAZEPPA' BY LORD BYRON

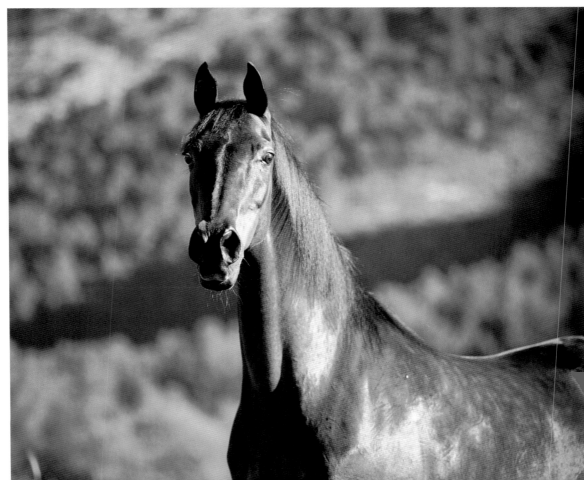

Señora Mariangeles Bravo de Delclaux on her stallion Zorba. BELOW: Juan Carlos with the colt Uxmal from the Yeguada Estiviel near Toledo. OPPOSITE ABOVE: Señora Sole Domecq, of the famous Domecq sherry family, with her stallion Freigal from the Yeguada Domecq-Ybarra, located near Jerez de la Frontera. OPPOSITE BELOW: Angel taking the broodmares to pasture at the Mazarrazin stud near Toledo.

The late Duke of Veragua (ABOVE LEFT) and his grand-daughter Christina Valdes (BELOW LEFT) striking the same pose out of the album of history at the Valjuanetes stud in Castile. BELOW RIGHT: The Valjuanetes stud was once the oldest in Spain for the breeding of fighting bulls for the corrida. Its owner, Cristóbal Colón XV, Duke of Veragua, decided to breed Arabian horses instead from 1926. The Duke, a direct descendant of Christopher Columbus, was murdered during the Spanish Civil War by a leader of a gang who had been his servant, after being forced to sign over his famous stud. OPPOSITE ABOVE: Juan Entrecanales enjoying an early Sunday-morning trot at the Yeguada Estiviel.

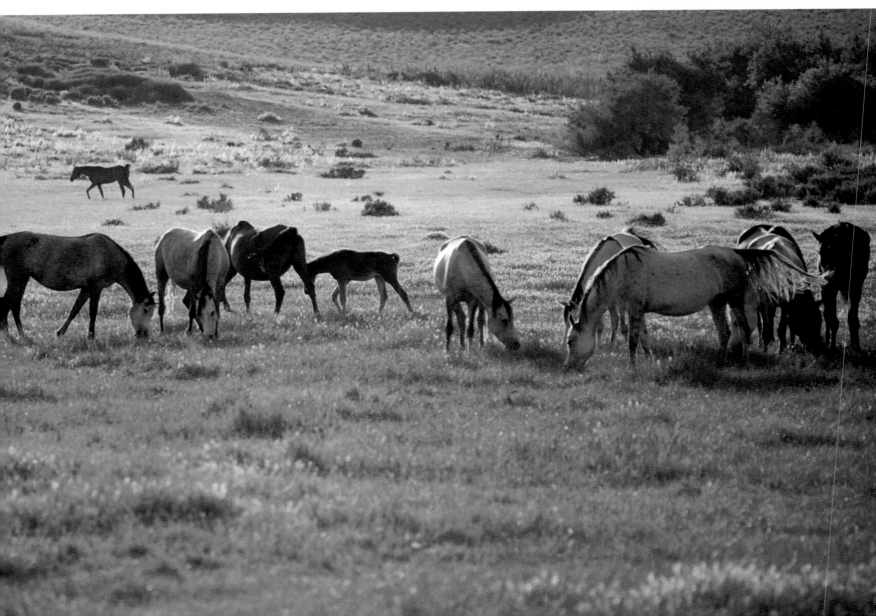

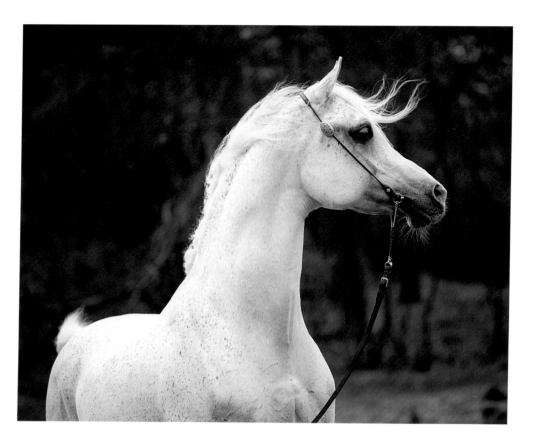

THE NETHERLANDS

THE FIRST ARAB HORSES IMPORTED TO THE NETHERLANDS WERE MOSTLY FROM ENGLAND, ALTHOUGH A FEW ARRIVED AS GIFTS FROM SAUDI ARABIA TO QUEEN WILHELMINA.

Although a late starter in the breeding of Arab horses, Holland has become famous for some of its world-class breeders, such as Robbie Den Hartog, and for its champions, like these at the Rikki Hoeve stud (LEFT) and the Vlasakker Arabians (BELOW).

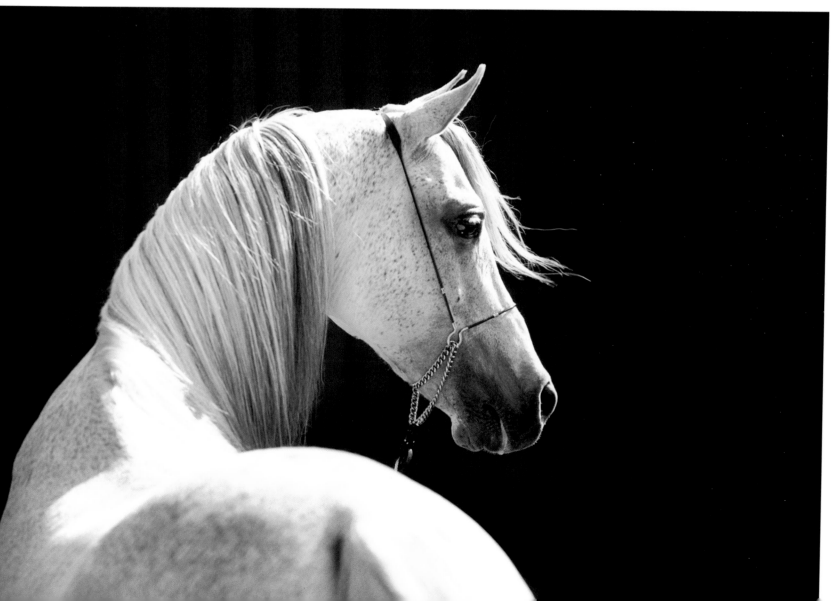

FRANCE

THE FRENCH, INCLUDING THE EMPEROR NAPOLEON, WERE EARLY IN RECOGNIZING THE ENORMOUS VALUE OF ARAB BLOOD FOR THE IMPROVEMENT OF HORSE BREEDING IN THEIR COUNTRY, AND MANY STALLIONS WERE IMPORTED FROM NORTH AFRICA AND THE MIDDLE EAST. AT FIRST, FEW PURE ARABS WERE BRED, BUT TODAY THE BREED HAS RAPIDLY GAINED IN POPULARITY.

French breeders are world leaders in Arab horse racing, having introduced bloodlines from Tunisia, Algeria and Morocco to the state breeding stud at Pompadour. RIGHT: The stallion Masan of the former Mabrouka Arabians stud.

*Four things greater than all things are —
women and horses, power and war.*
RUDYARD KIPLING

169

Grasse on the Côte d'Azur, the perfume centre of the world, is where the Munoz family breed Arabians at their M'El Arab stud. RIGHT: The Philstrom family dedicate their life to the Arabian at their Haras de la Petite Porcelette stud in the wild splendour of the Camargue. BELOW: One of the important annual events in the international racing calendar, the Grand Prix de Chantilly-Pur-Sang-Arabes, sponsored these last few years by Sheikh Zayed bin-Sultan al-Nahyan, Ruler of Abu Dhabi and President of the United Arab Emirates.

BELGIUM

Although the breeding of Arab horses in Belgium is relatively young — the Arab Horse Society was only founded in 1975 — the country has a growing number of enthusiasts.

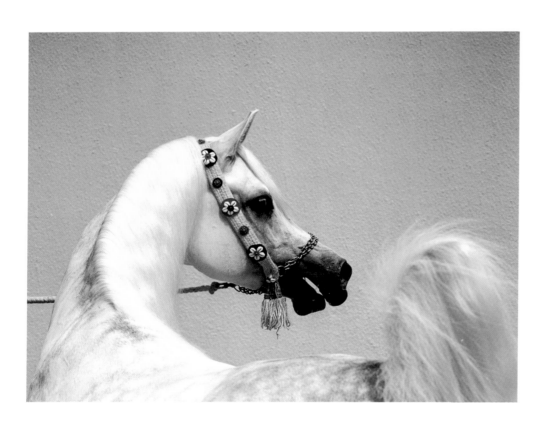

A world champion, G Tamin, belonging to the Al Shaqab stud in Qatar on a visit to Belgium. RIGHT: Beauty, elegance and style at the Arminta stud.

… light on his airy crest his slender head
His body short, his loins luxuriant spread …
VIRGIL

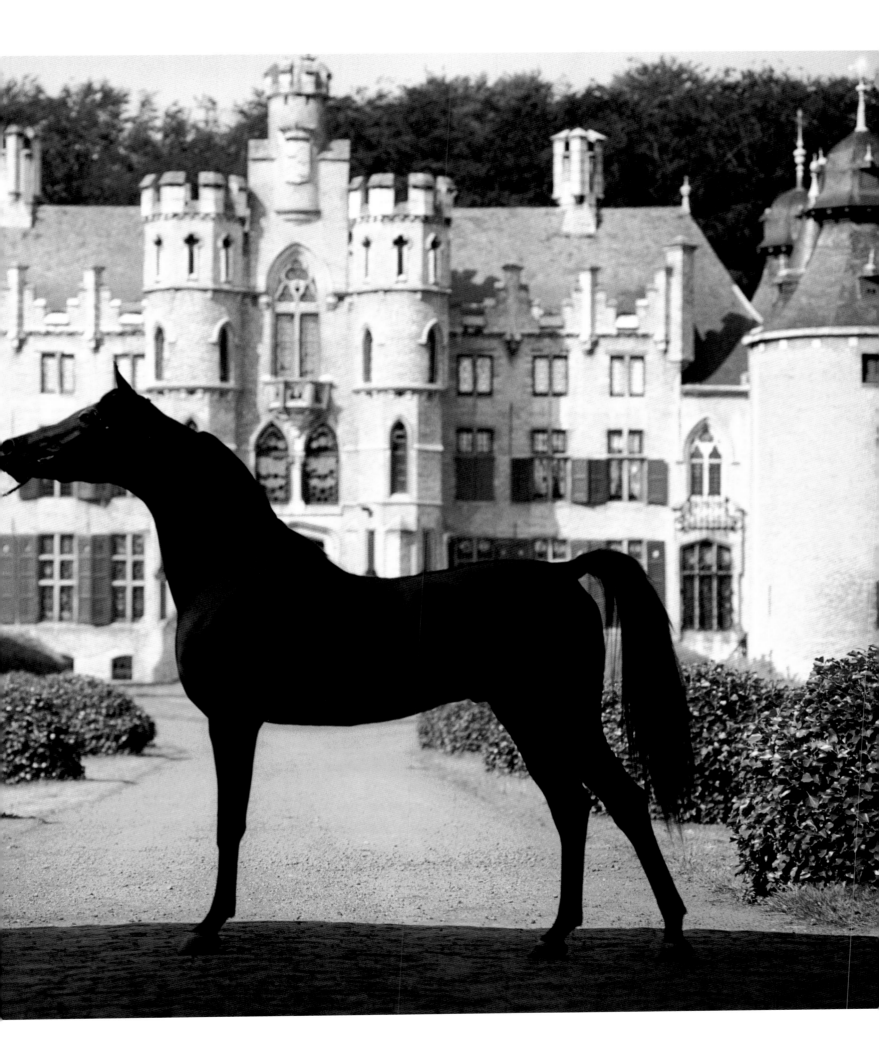

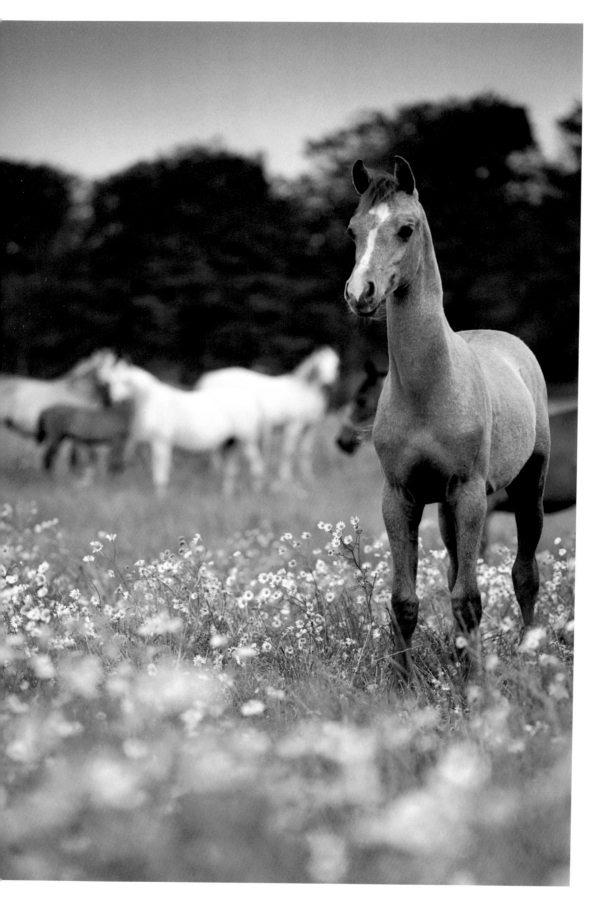

DENMARK

During the 18th and 19th centuries, the Royal Stud of Denmark was famous throughout Europe for its horses. However, it was only in the 1940s, after Erik Lindgren obtained some Arab circus stallions, that the Danes started on the road to breeding Arabians. Other breeders followed, importing horses from England, Germany, Sweden and Babolna in Hungary.

Springtime at the Calbar stud, with a new crop of foals.

In every breed man seeks the best,
And so this bitter task was theirs;
And who could braver face the Test
Than offspring of the desert mares?
FROM *THE ARAB TEST* BY WILL OGILVIE

SWEDEN

BEING RELATIVELY CLOSE TO POLAND, IT IS NO
WONDER THAT SWEDEN'S ARAB HORSES COME
MOSTLY FROM THAT SOURCE. HOWEVER, THE FIRST
ARABS, WHOSE BLOODLINES STILL EXIST, WERE OF
ENGLISH ORIGIN, BROUGHT TO SWEDEN BY
COUNTESS PENELOPE LEWENHAUPT.

*Vicky Sorenson spending a quiet morning break
with a friend at Blommeröd Arabstuteri, a leading
Swedish stud. RIGHT: Horse and nature in harmony at
the Claestrop Arabian stud belonging to Count and
Countess Lewenhaupt.*

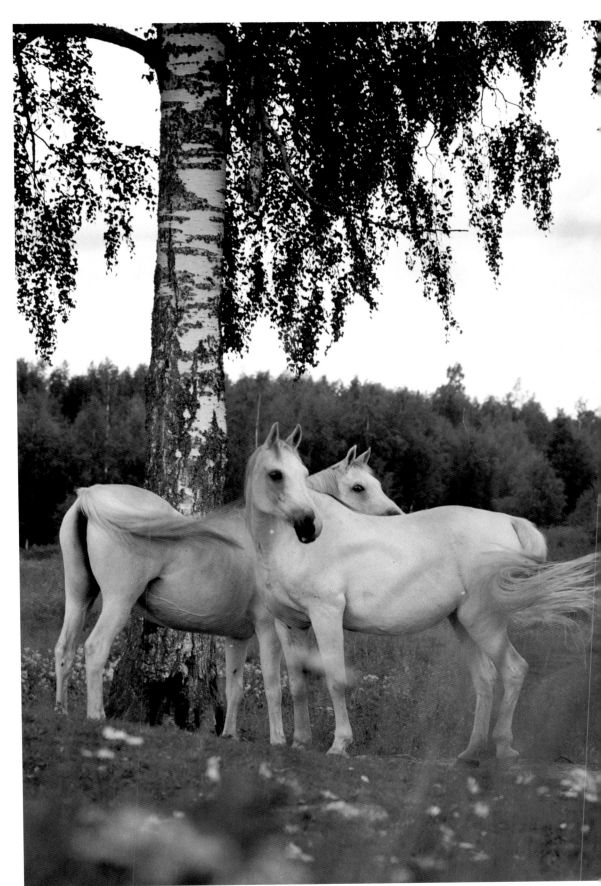

*Y*erba *(LEFT) taking the waters at Hammargren Arabians. ABOVE: The mare Sapala amongst the summertime pastures of Midingsbrate at Beit El Kheil Arabians.*

The tie that bound the Arab to his horse was not material, but spiritual,
for the bedouin, like the American Indian, possessed an understanding of
nature and realised his kingship with all life.

FROM J. FORBIS, THE CLASSIC ARABIAN HORSE

GERMANY

GERMANY HAS, IN THE HORSES AT MARBACH, THE OLDEST RECORDED PURE-BRED ARAB

BLOODLINES IN THE WORLD. KING WILHELM I OF WÜRTTEMBERG FOUNDED THE ORIGINAL

GERMAN STUD AT WEIL IN 1816, AND TODAY GERMANY IS THE LARGEST ARAB HORSE

BREEDING COUNTRY IN EUROPE.

*Horse at home at Sax Arabians near Altfraunhofen. RIGHT: Mares returning
to stables before sunset at the Om El Arab stud, one of Germany's most
successful breeding farms.*

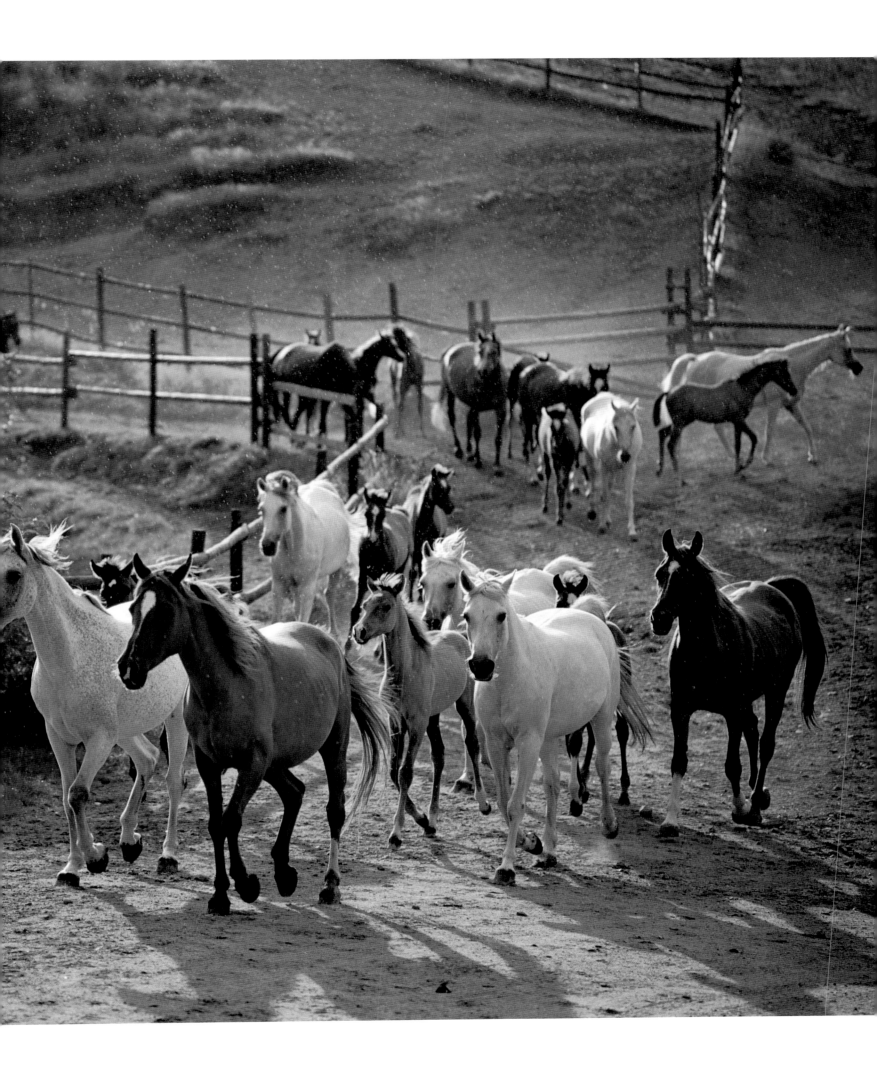

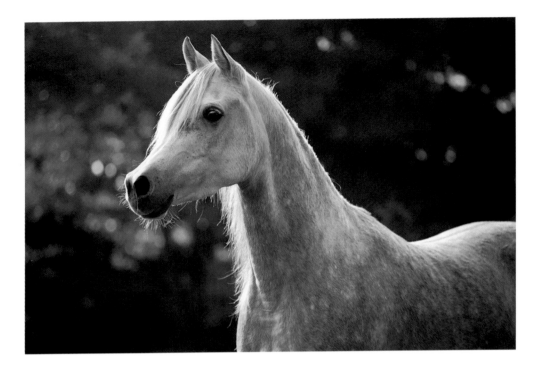

German beauties of the Katharinenhof stud near Bremen, one of the world's finest Arabian breeding studs. OPPOSITE: Reinhard Sax, another leading German breeder, shows off his own beauties in the Black Forest — meet Narissa and Kuma.

Not thin his forelock, nor humped his nose,
* no weakling of limb;*
preferred is he in the dealing of milk, well
* nurtured at home.*
Each leg apart in its gallop seems to stream
* with a rush*
of speed as though from a bucket of water
* poured o'er the field.*
SALMAN IBN-JANDAL

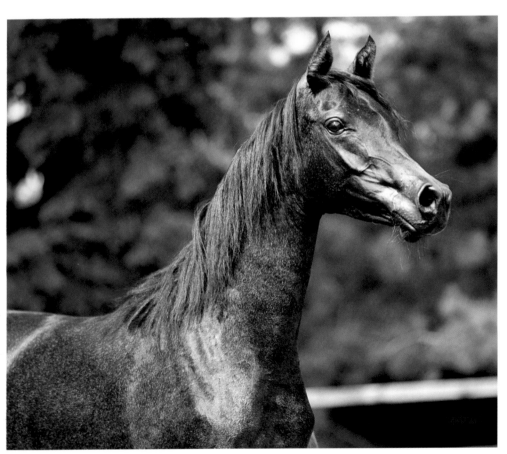

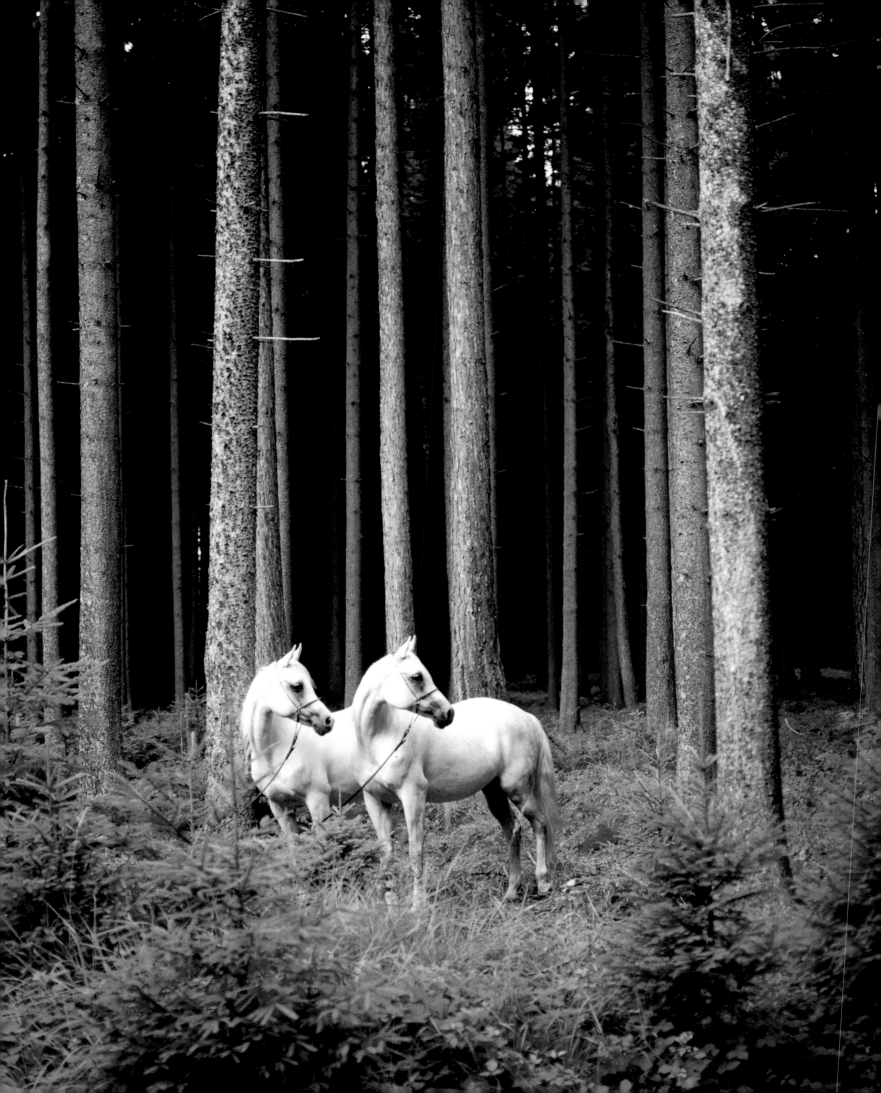

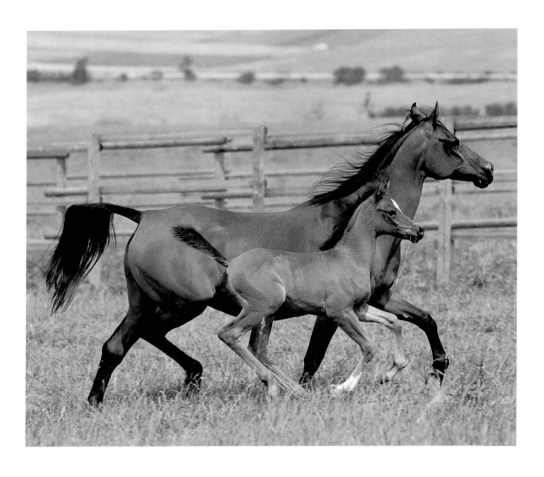

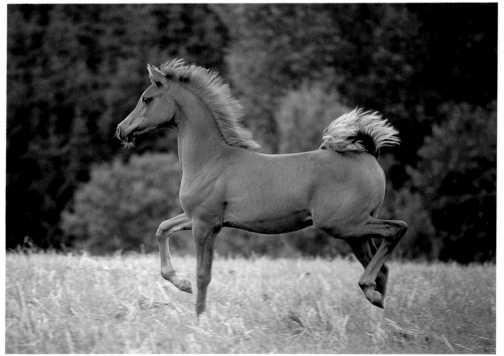

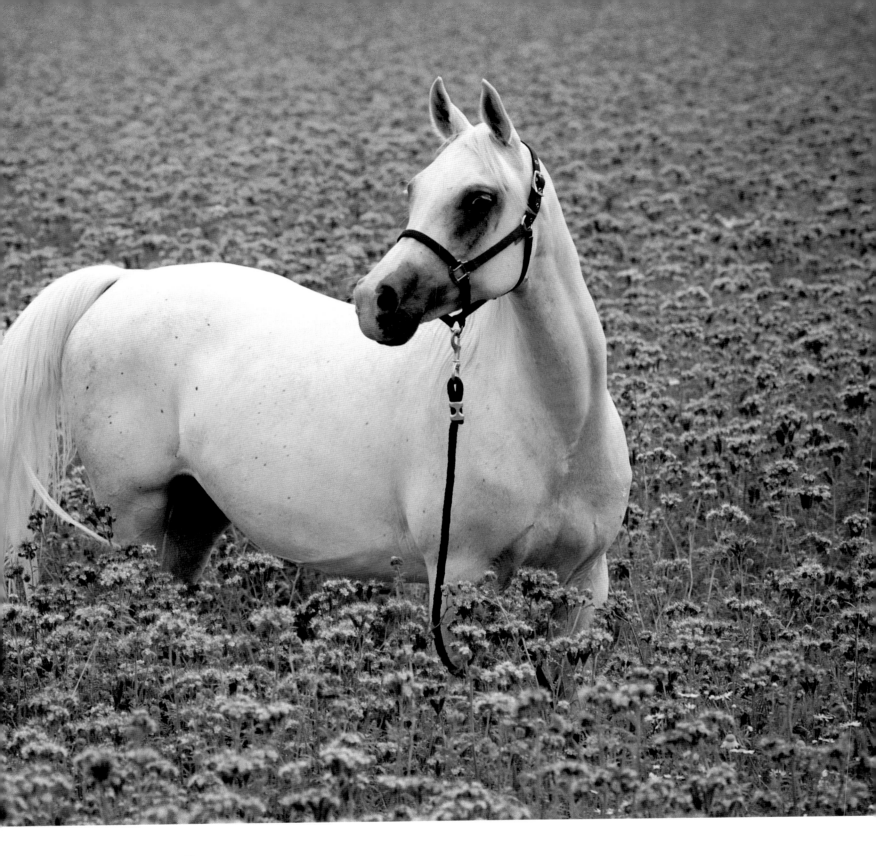

Lilac-tinted fields and pastures green. OPPOSITE ABOVE: Semiramis enjoys showing her new filly foal how to run
in the pastures of the Gestüt Schwarzwald-Baar in Bad Durrheiha.

The three most precious possessions are a mare,
followed by her daughter in foal with a filly.
OLD ARAB SAYING

GERMANY

Heinz Merz's mares and foals setting the scene at his Om El Arab stud. OPPOSITE ABOVE: Dr Hans Nagel, one of the world's leading authorities on the Arabian breed, and the owner of the world-famous Katharinenhof stud, here shown with Salaa El Din. OPPOSITE BELOW: Tiffaha, a world champion bred by Dr Nagel and now at the Ariely stud in Israel.

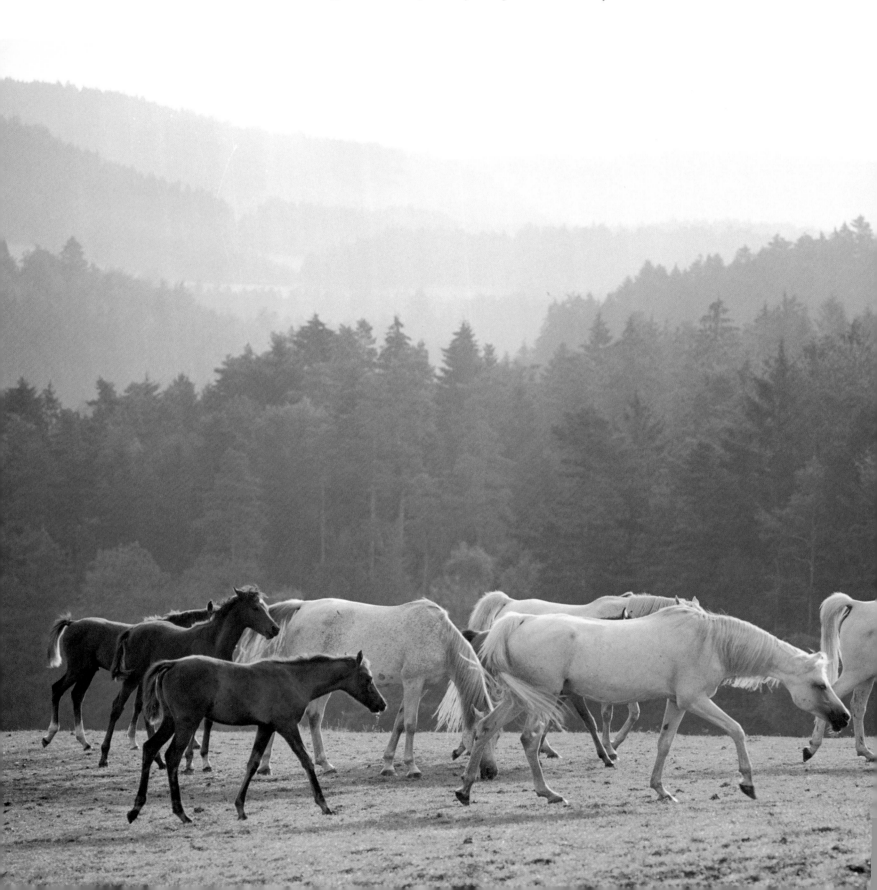

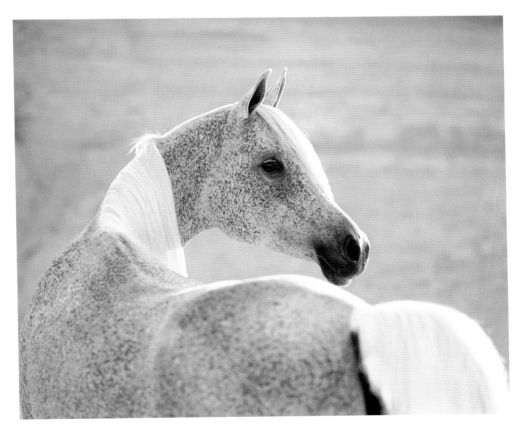

Classic portrait of Arabs at Sylvia Garde Ehlert's stud. ABOVE: Two statues, one sculpted by man, the other by nature. RIGHT: The roaring stallion Malik El Nil belonging to the Kauber Platte Araber Gestüt of Heiner Buschfort.

The Arabs congratulated each other on
three things: the birth of a boy, the emergence
of a poet in their midst, or the foaling
of a mare.

IBN-RASHID OF KAIROUAN (1064)

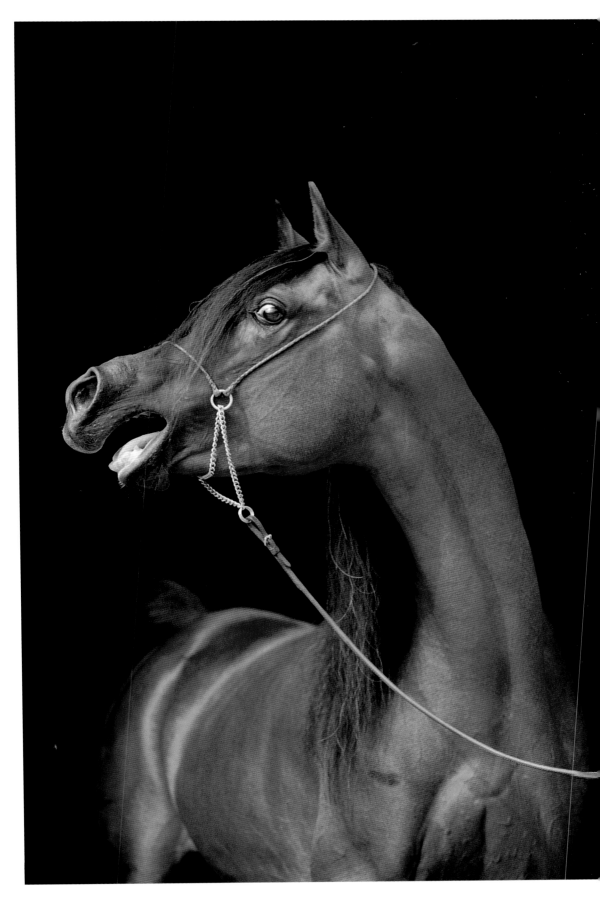

POLAND

The Polish princes were great horsemen who looked to the Arabian as the finest and best. Horses from their studs were later to become the foundation stock of the great state studs of Janow Podlaski and Michalow. Today, Polish Arab horses are much sought after and admired the world over.

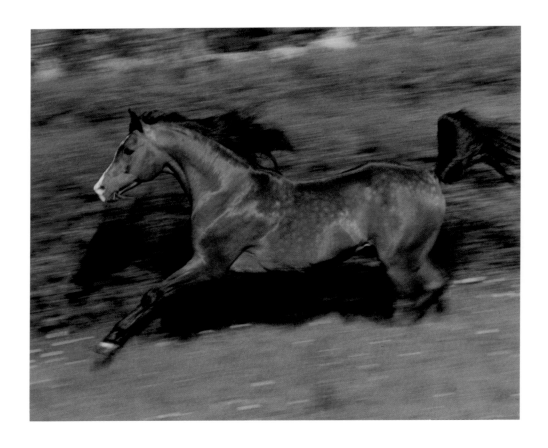

*S*treaked lightning. Banat, arguably the best son of the legendary Bandola, seen here exercising the lens speed of the photographer. RIGHT: Fellow would-be champions gallop back to the stables at Michalow, the largest state stud in Poland, established after the devastation of the Second World War.

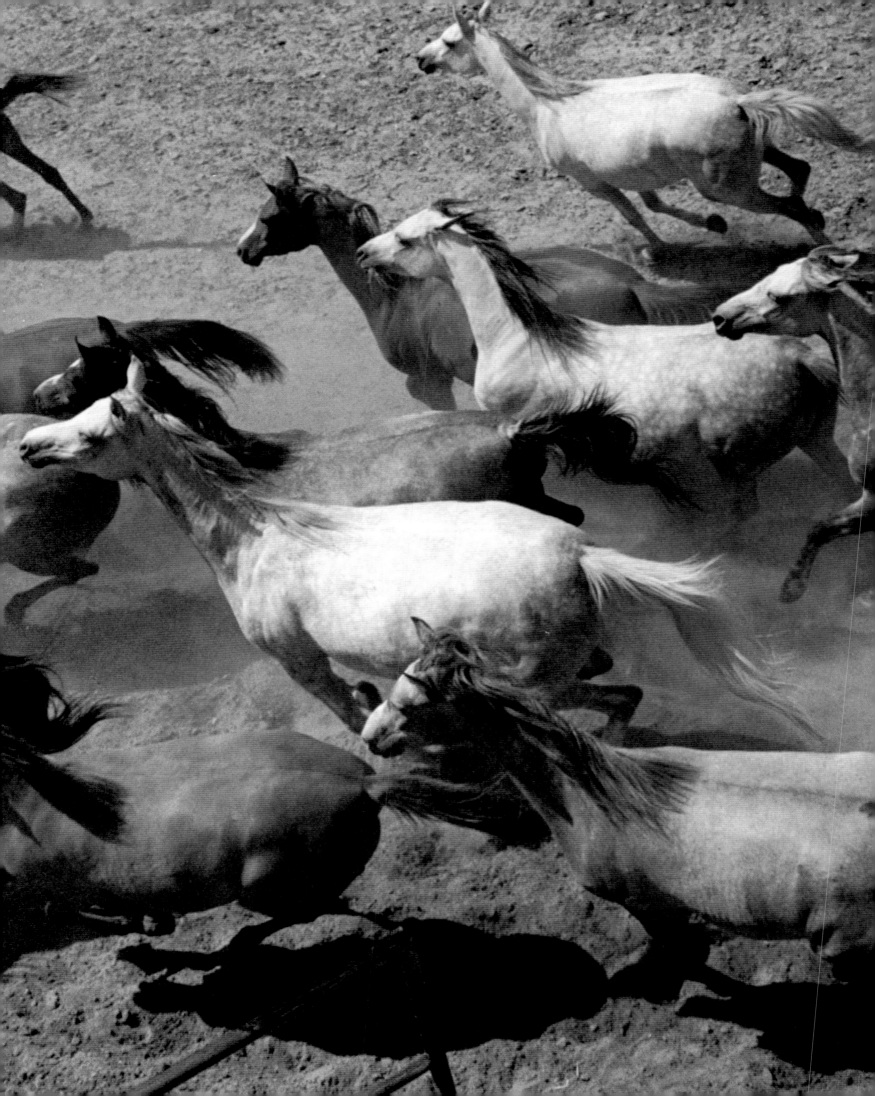

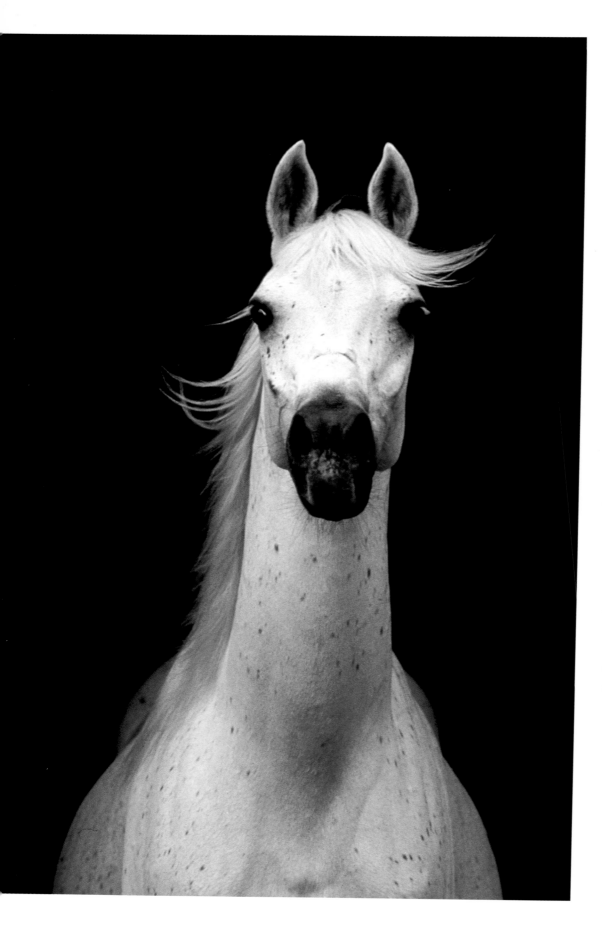

*P*edigrees of Polish Arabians date all the way back
to 1803, the year in which Prince Jerome Sanguszko
organized his first expedition to the heart of Arabia to
purchase the pure-bred desert horse. Some of their
magnificent descendants trace their lineage back into
the mysterious sands of the East, including champions
such as Euforia (LEFT) and Eukaliptus (OPPOSITE), here
being attended to at the Kurozweki stud.

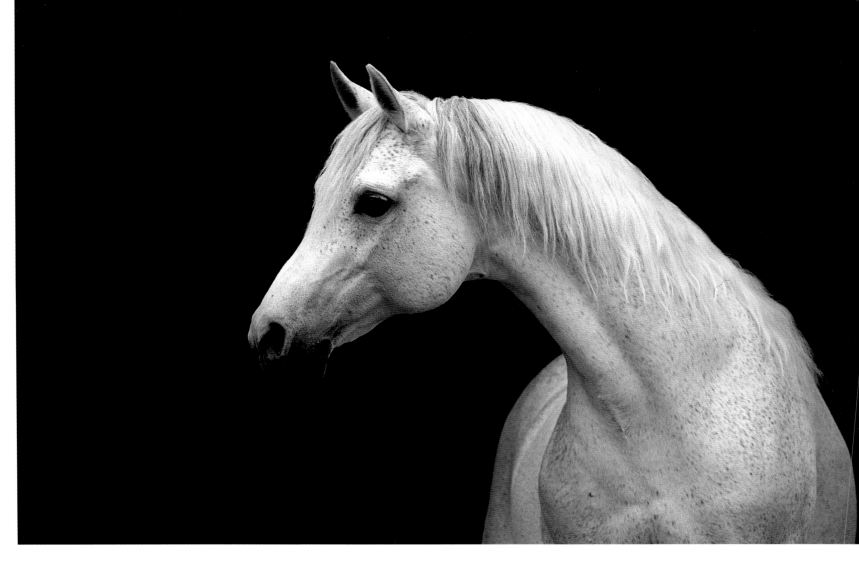

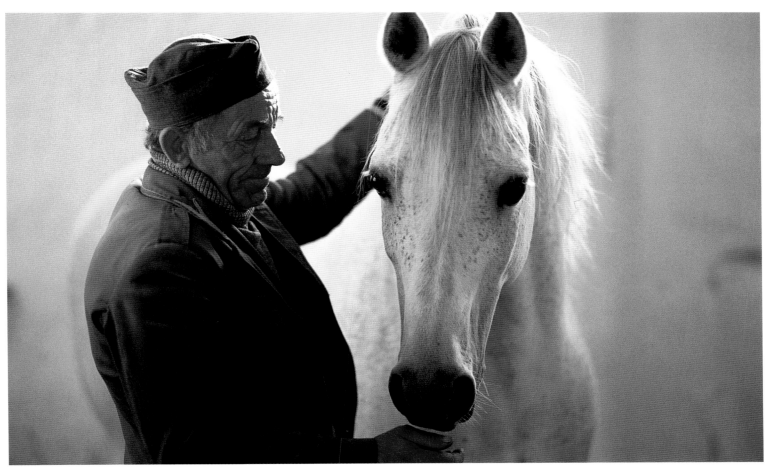

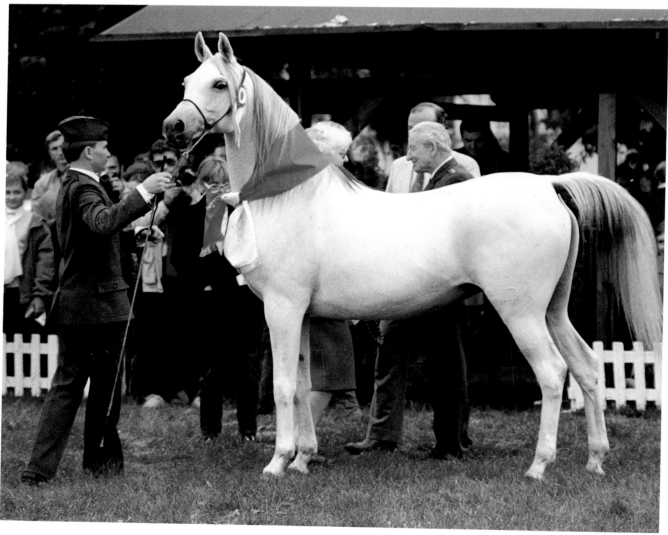

*A*rab horse breeding today is big international business, where top sires or dams can fetch over $1,000,000 each. Two and a half centuries ago, in 1735 to be precise, The Sporting Gentleman's Dictionary complained over the 'intolerable prices' demanded for the 'right Arabian horses' exported from Scanderoon (Alexandretta) — as much as '£500, £1,000, £2,000 and even £3,000'. Nothing much has changed

OPPOSITE ABOVE: *A mare being covered at the Kurozweki stud.*
OPPOSITE BELOW: *World Champion Etruria being garlanded at the renowned Janow Podlaski stud, with Janow's director Andrzej Krzysztalowicz standing directly behind the horse.* BELOW: *Pesal, another Polish champion, struts around his paddock at the Bialka stud.*

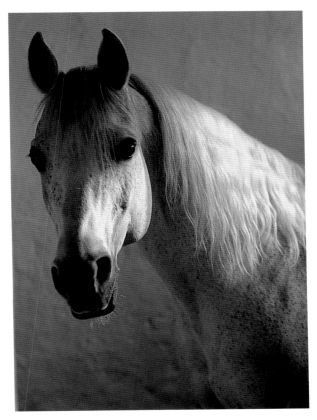

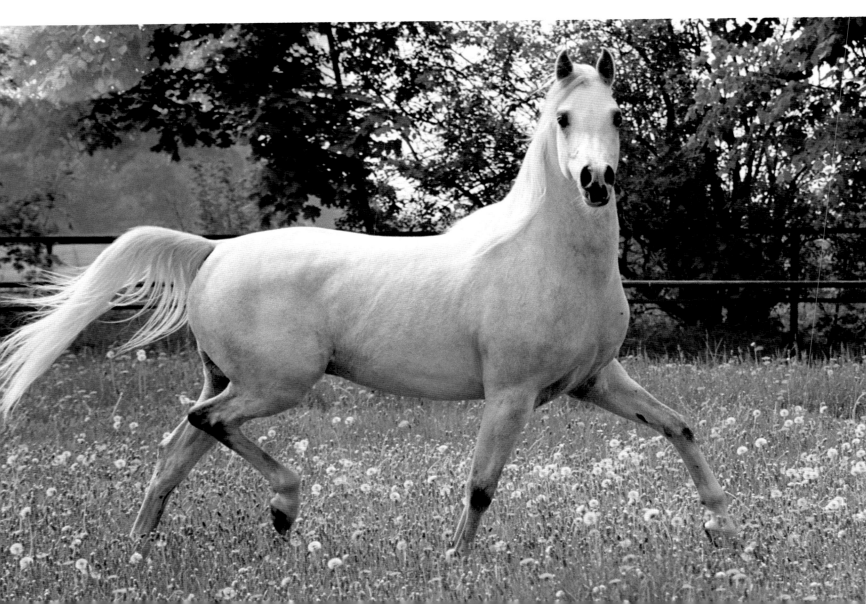

RUSSIA

The Russian Arabs at Tersk enjoy world-wide renown. They were founded on French, Crabbet and Polish bloodlines, acquired in the 1930s and 1950s. Later, the arrival of Aswan from Egypt was to have a huge impact on their breeding programme.

The Tersk state stud has become justly famous in the post-war years for its breeding of fine Arabians such as Palas (OPPOSITE), here exercising his dominance over his surroundings.

So did this horse excel a common one,
In shape, in courage, colour, pace and bone.
WILLIAM SHAKESPEARE

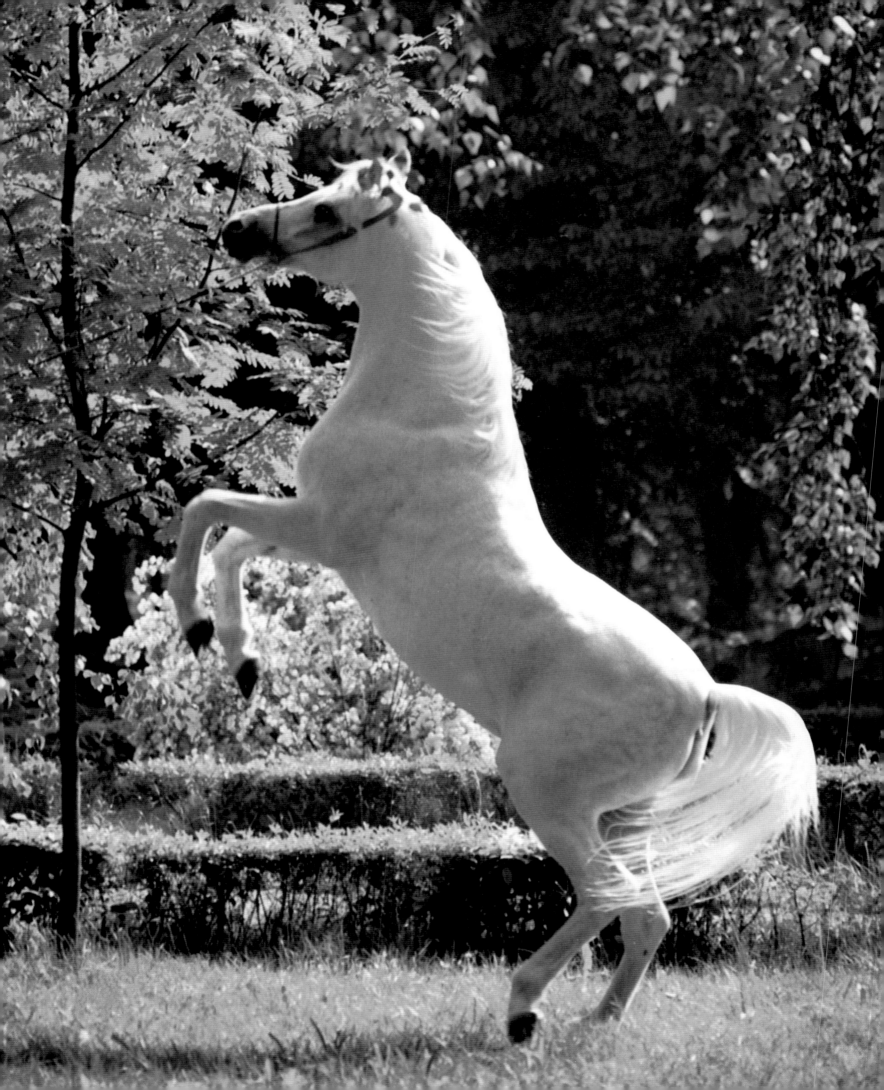

Russian Arabs are much sought after by pure-bred horse enthusiasts the world over. BELOW: Broodmares at pasture in Tersk.

Her stride swallows the distance
Yet her canter becomes
A soft cushion.
She stands high over the earth,
Deep of girth and lean of flank
As the bounding saluki.
Long is her neck which joins
A delicate throat.
Her large head flexes with ease,
Yea, it is likened unto a rich
Merchant's safe.
BAHRAINI POET

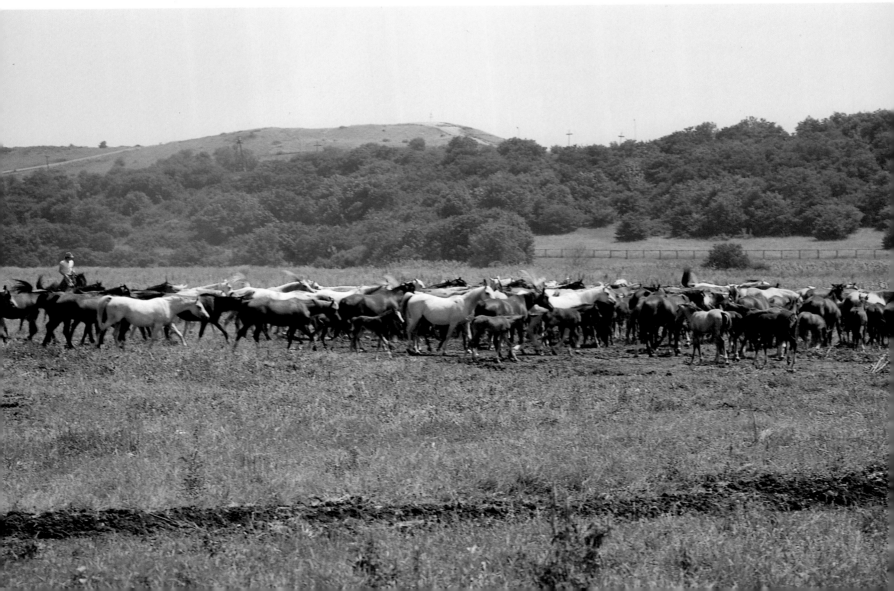

HUNGARY

THE GREAT STUD OF BABOLNA CAN CLAIM TO BE THE OLDEST IN THE WORLD. HERE THEY STILL BREED WONDERFUL ARAB HORSES

AND ALSO SHAGYAS, A BREED WHOSE FOUNDATION SIRE WAS A GREY STALLION BRED BY THE BANU SAKR TRIBE IN JORDAN IN 1830.

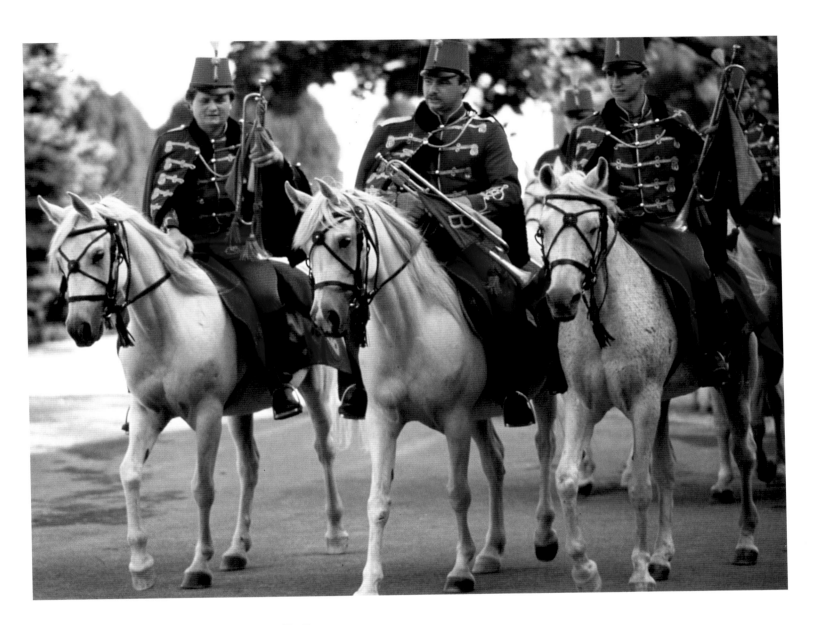

Mounted musicians in Hussar uniforms astride Arab mares.

*Of all the horses of my armies, the ones which best endured the weariness
and miseries of war were the solid bays.*

MOUSSA, THE CELEBRATED CONQUEROR OF NORTH AFRICA AND SPAIN

STEEPED IN TRADITIONS AND WITH THE OLDEST AND MOST BEAUTIFULLY ORNATE STABLES COMPLEX IN EUROPE, BABOLNA CONTINUES ITS COLOURFUL TRADITIONS TODAY.

*H*alim Shah I. BELOW LEFT: *The Shagya stallion Kemir IV left 35 foals at Babolna, since being foaled himself in 1971.*

*T*he chestnut stallion Ibn Galal I.
BELOW: *Broodmares out in the paddocks in front
of the Babolna barns.*

I weep for a land fashioned to beauty fair
Beyond compare;
I weep for a heritage of glory and fame,
A hard, far aim.
I weep for spirits too indolent to urge men
To battle again;
I weep for the splendour of empire and the
 boast
Turned all to a ghost.

KHAIR AL-DIN AL-ZIRIKLI

AUSTRIA

Although Austria is famed for the Lippizaner 'Dancing White Horses' of the Spanish Riding School, Arab horse breeding has become established only relatively recently. Horses have been imported from America, Germany, Poland and Egypt as foundation stock for the leading studs.

An Arabian in Austria. OPPOSITE ABOVE: *The triple champion stallion Essteem at La Movida Arabians.* OPPOSITE BELOW: *Animal locomotion in an Alpine setting.*

He has the thighs of a gazelle,
The legs of an ostrich;
At the gallop his stride is that of the wolf,
At the canter that of the desert fox.
ARAB POET

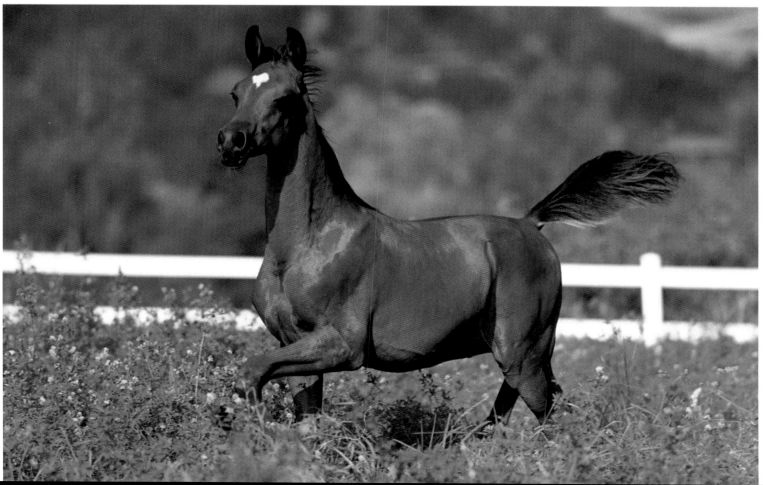

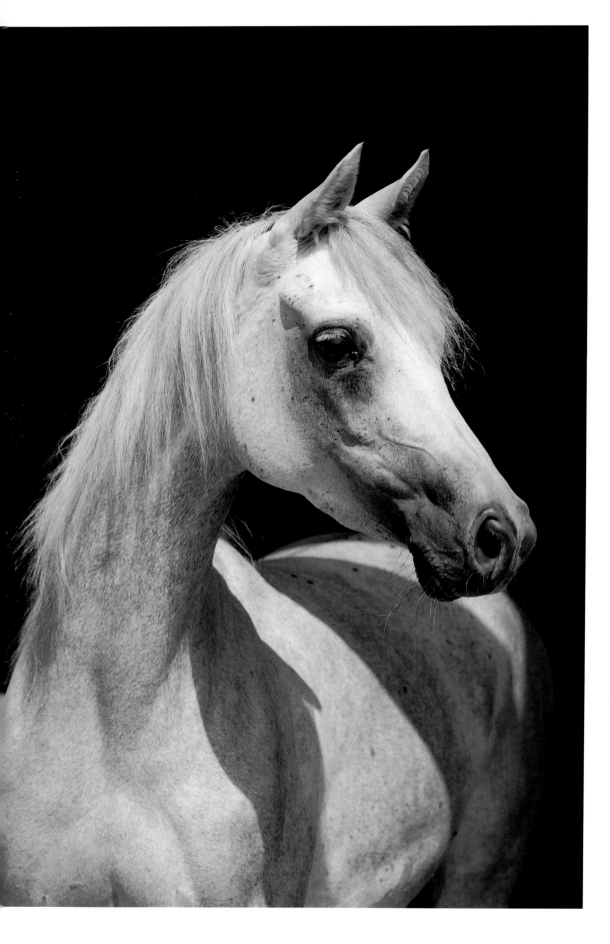

SWITZERLAND

SWITZERLAND AS A COUNTRY IS A RELATIVE
NEWCOMER TO THE WORLD OF THE ARAB HORSE.
BREEDERS HAVE LOOKED TO NEIGHBOURING
COUNTRIES FOR FOUNDATION STOCK.

*Paradise on earth is found on the back
of a good horse,
In the study of good books, or
Between the breasts of a woman.*
ARAB POET

*Exotic Arabian beauties bred in the pristine
pastures of the Swiss Alps. LEFT: Refined precision and
elegance, the hallmark of the Swiss, exemplified by the
work of breeders such as Urs Aeschbacher.
OPPOSITE ABOVE: Waseema, owned by Peter Stoessel.
OPPOSITE BELOW: A Nayla Hayek creation
from her Hanaya stud.*

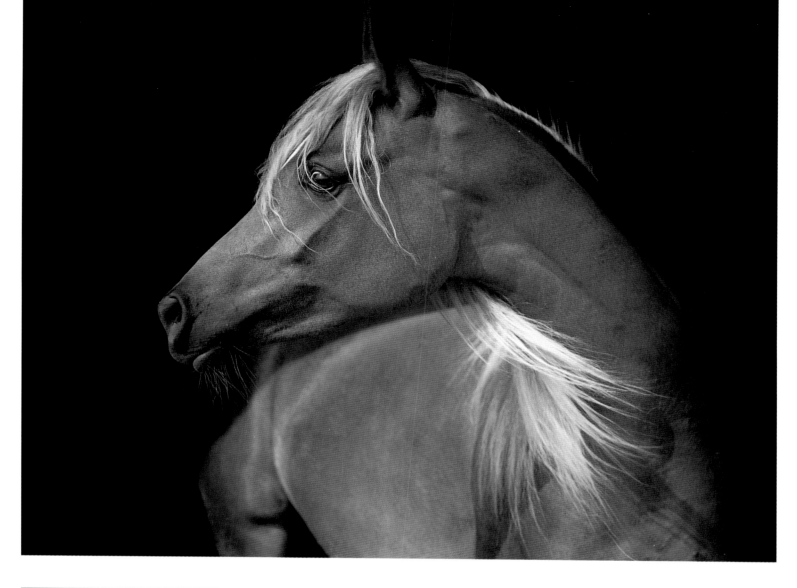
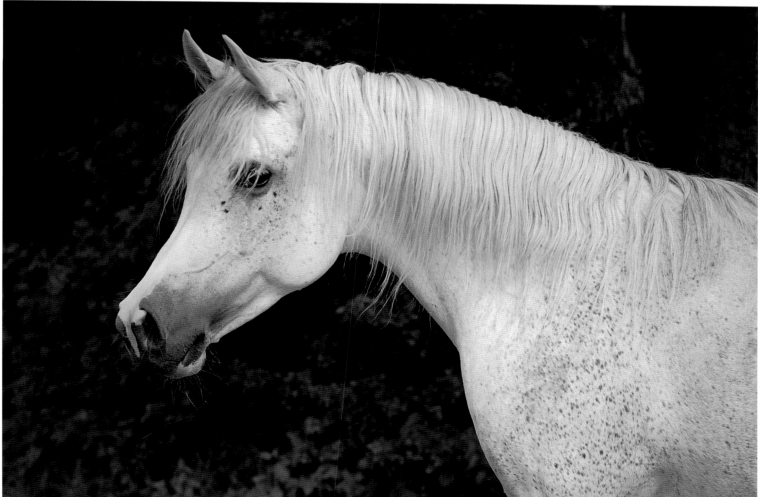

*T*hroughout the ages, the horse has been the symbol of superiority, triumph and victory. Swiss breeders treat their Arabs with the reverential care that is their due, and here the results show.

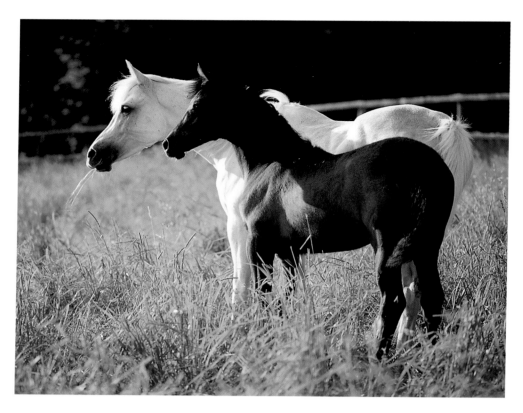

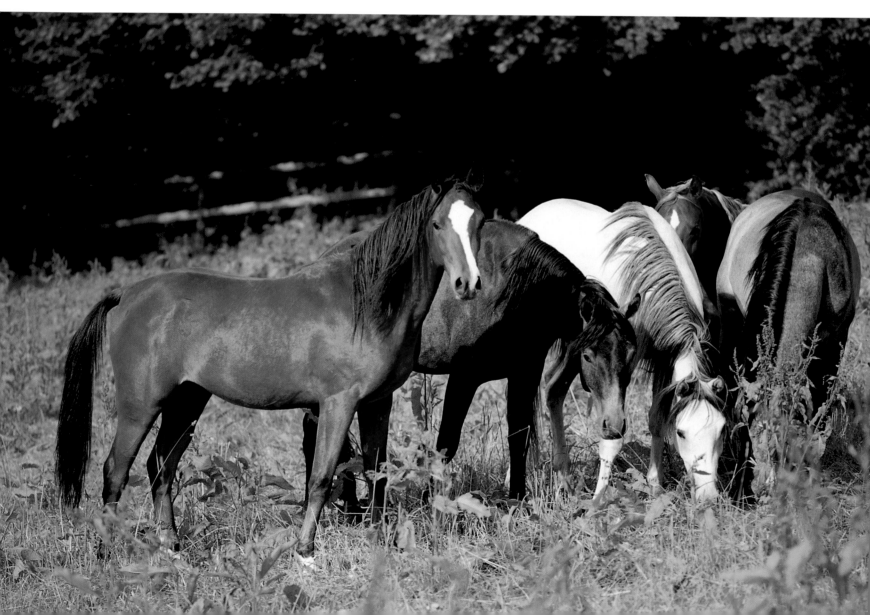

ITALY

MANY ARAB HORSES WERE IMPORTED TO ITALY FROM THE DESERT IN EARLIER CENTURIES, AND THESE WERE FOLLOWED BY HORSES

FROM EGYPT AND CRABBET; BUT PRESENT-DAY BREEDERS HAVE CONCENTRATED MOSTLY ON POLISH, EGYPTIAN AND RUSSIAN

BLOODLINES, WITH MANY IMPORTS FROM THE USA. THE ARAB HORSE IN ITALY IS ENJOYING GROWING POPULARITY.

A Russian Arab in a classical Italian setting at the Florioli stud near Lake Garda.

Daily companions at the 50 Campi stud.
BELOW: The stallion Nimroz photographed in an old
Italian monastery. OPPOSITE ABOVE: Jaricha, Asisa,
Amaria, Avutarda and Rabora holidaying in Tuscany
at the Altesino stud. OPPOSITE BELOW: A walk through
the vineyards back to the villa.

GREAT BRITAIN

British pure-bred bloodlines dominated Arab horse breeding in the first half of the 20th century throughout most of the world, due largely to the influence of Lady Anne and Wilfrid Scawen Blunt's Crabbet Park stud. This was set up in the latter part of the 19th century with horses personally selected by the Blunts on their desert journeys into the heart of Arabia.

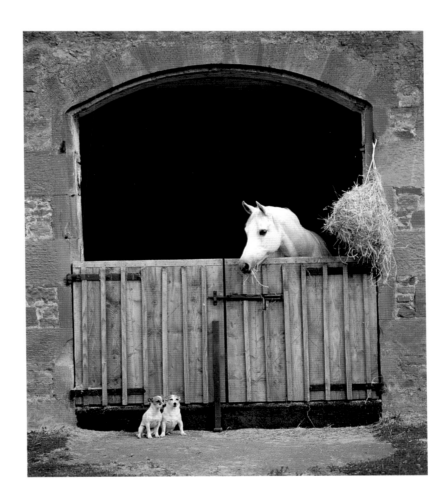

*T*he Lake District provides the scene for some field action at the former Roswaithe Arabians stud farm. ABOVE: Guarding the stable door at Rowchester Arabians stud.

She is one of those steeds of the race that stretch themselves fully in their gallop, springing and light of foot, pressing on in her eagerness.

YAZID, ARAB POET AND WARRIOR, COMPANION OF THE PROPHET

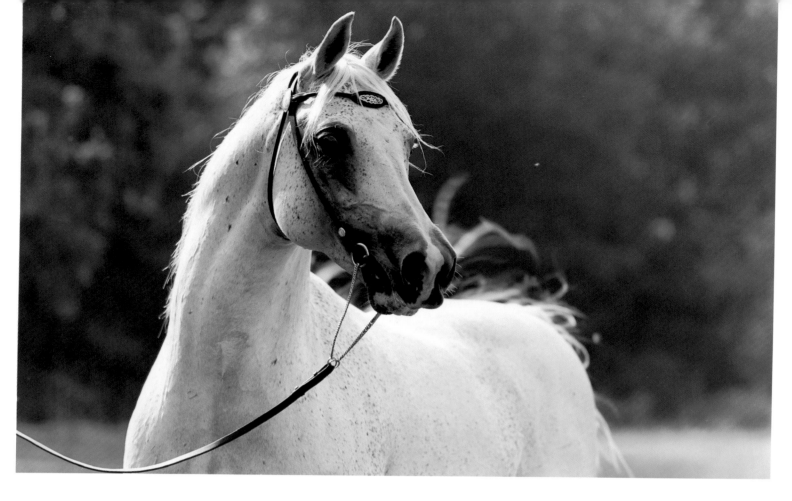
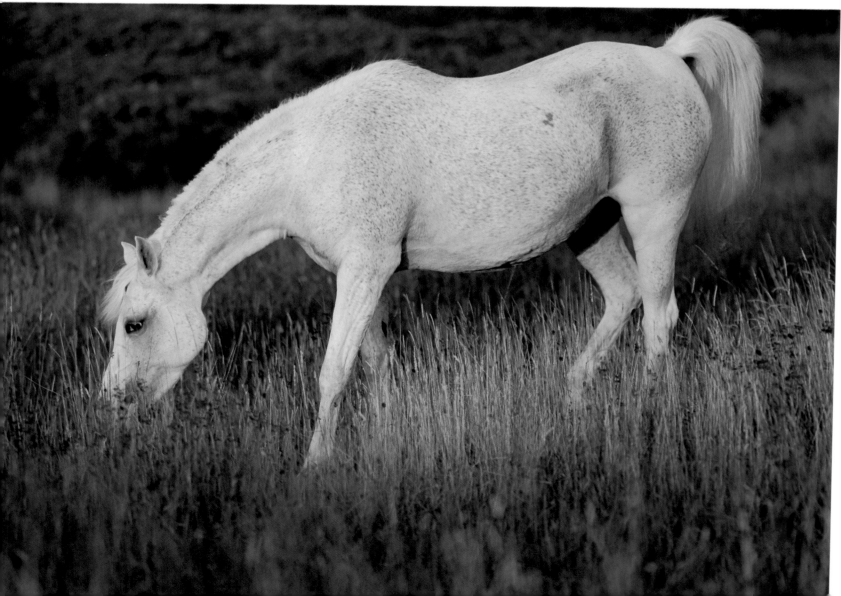

*O*ut of place, but not out of focus.
RIGHT: Veronica Mann-Wernsten, Swedish
horsewoman, in an idyllic setting at the W-Arabians
stud owned by her husband Anders. *BELOW:* Rolling
Stone Charlie Watts, a leading English Arab horse
afficionado, takes his 'groupies' for a walk at his wife
Shirley's Halsdon Arabian stud.
OPPOSITE ABOVE: The stallion Narim at Jane Kadri's
Al Waha Arabian stud. *OPPOSITE BELOW:* A grazing
mare unmoved by the camera's intrusions.

*A*rabians at the gate! Mr David Brown's horses on a visit to Belvoir Castle. ABOVE: Girls and horses getting ready for competition at Malvern, the Arab Horse Society's Summer Show. RIGHT: The stallion Golden Flambeau after winning at the Royal Windsor Show in 1988.

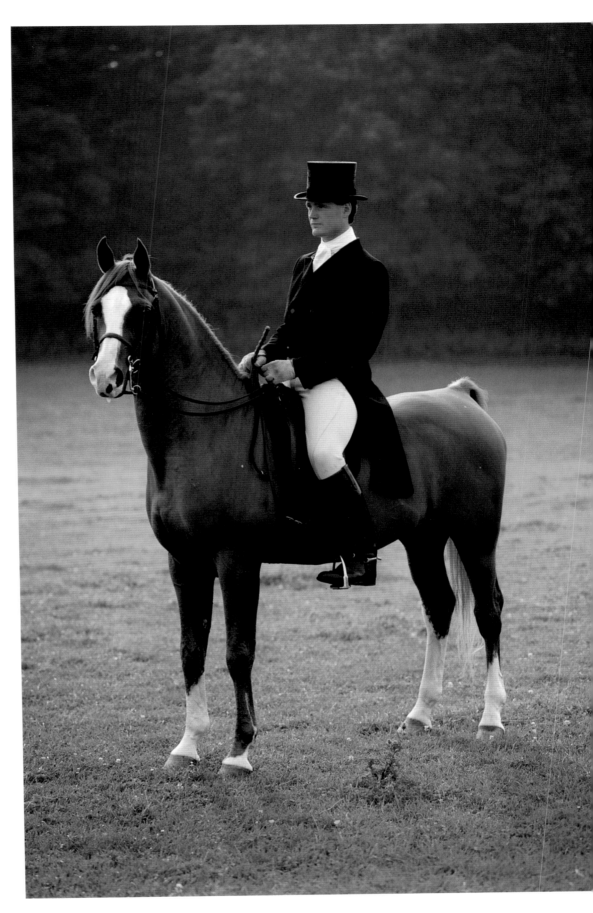

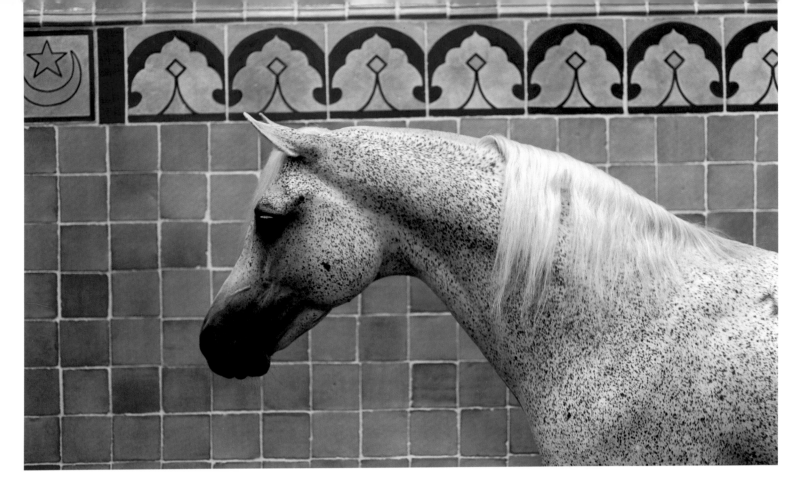

A well-mannered beauty awaits an indoor shower in the tiled bathroom splendour at Shirley and Charlie Watts' stud. RIGHT: The champion stallion Ibn Estasha. OPPOSITE: Even the Lake District's wet and stormy summer weather can't cool this stallion's hot-blooded temper.

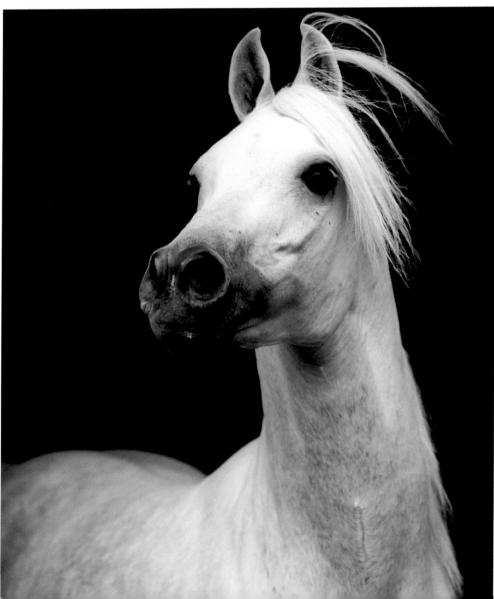

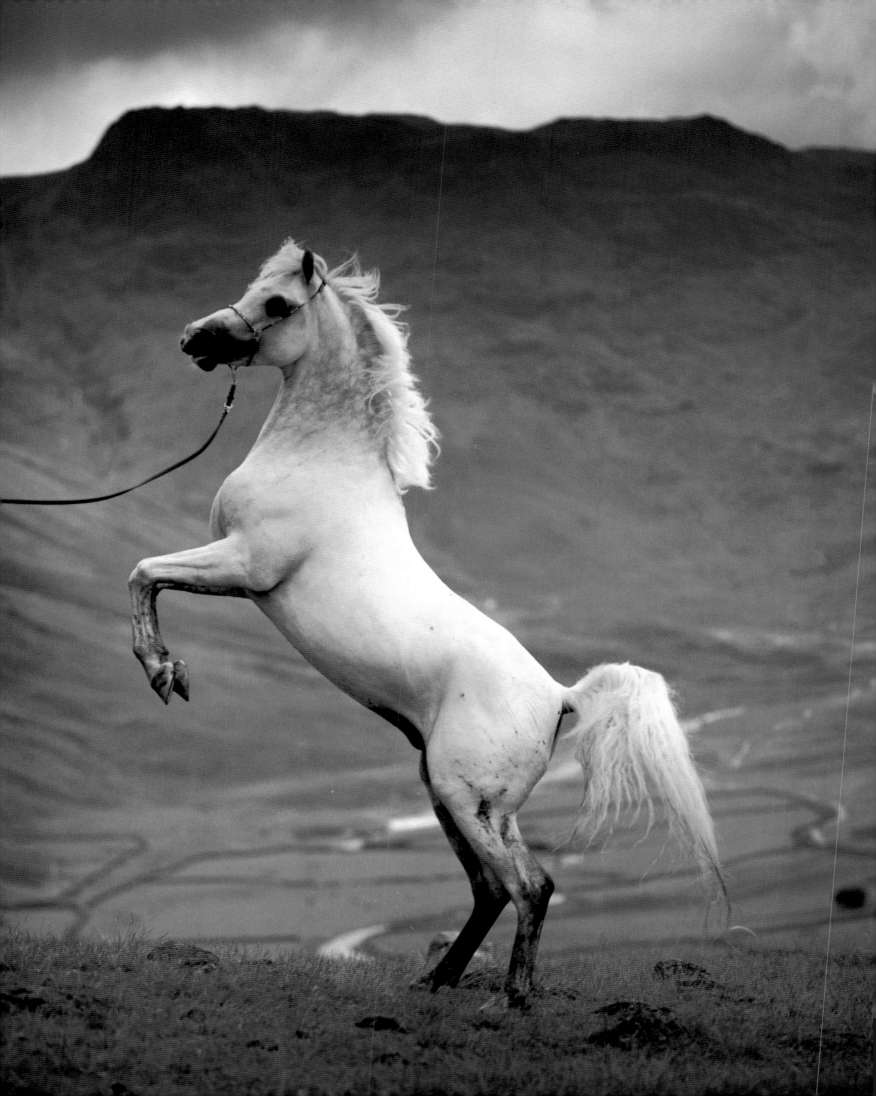

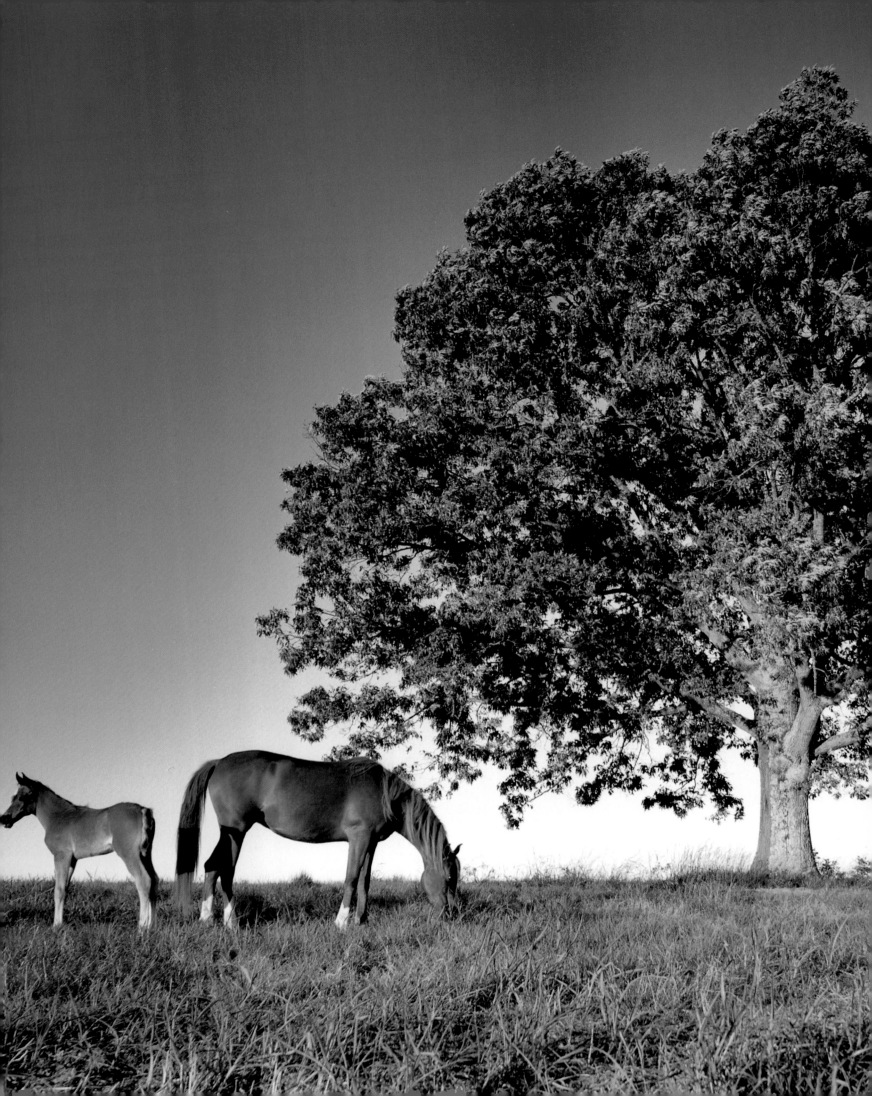

UNITED STATES

THE MAJORITY OF THE FAMOUS ARAB STUDS OF AMERICA IN THE EARLY YEARS OF THE 20TH

CENTURY WERE FOUNDED ON HORSES FROM THE CRABBET PARK STUD IN ENGLAND. IN

1906, HOMER DAVENPORT, ONE OF MANY ITINERANT AMERICAN DESERT TRAVELLERS, WENT

IN QUEST OF THE ARAB HORSE WITH THE HELP OF A LETTER FROM PRESIDENT 'TEDDY'

ROOSEVELT, AND RETURNED FROM SYRIA WITH A GROUP OF STALLIONS AND MARES.

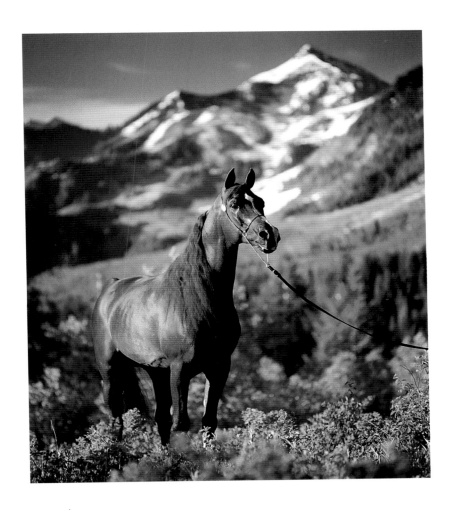

*Arkansas skyline at Cadron Creek Arabians. ABOVE: Utah's Rocky Mountains form
a backdrop for Russian Arabians at the Taylor Ranch.*

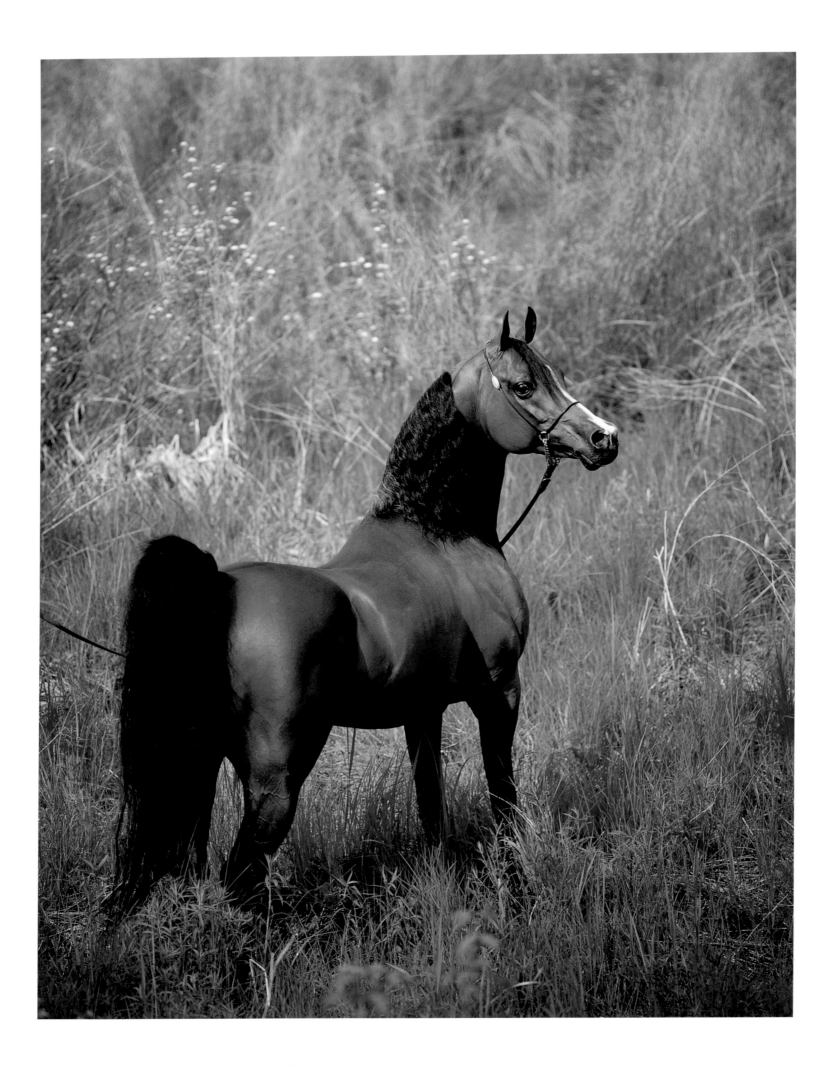

*F*ine Arabian bloodstock in Kentucky horse country at the Peregrine Ranch. RIGHT: No star can match these Egyptian starlets, Samantha and Selket, out of the stables of Ansata Stud in Arkansas. BELOW: In Texas, Hollywood heart-throb Patrick Swayze vies for attention with his stallion Tammen, a favourite Arab, at his Thistlewood Farm.

*C*alifornians do things differently. LEFT: At the San Simeon Stables belonging to the Hearst
Ranch, with the 'Enchanted Hill' of William (Citizen Kane) Randolph Hearst's legendary
castle of Xanadu in the background. ABOVE: Back to the range in Texas at Gardner Bloodstock.

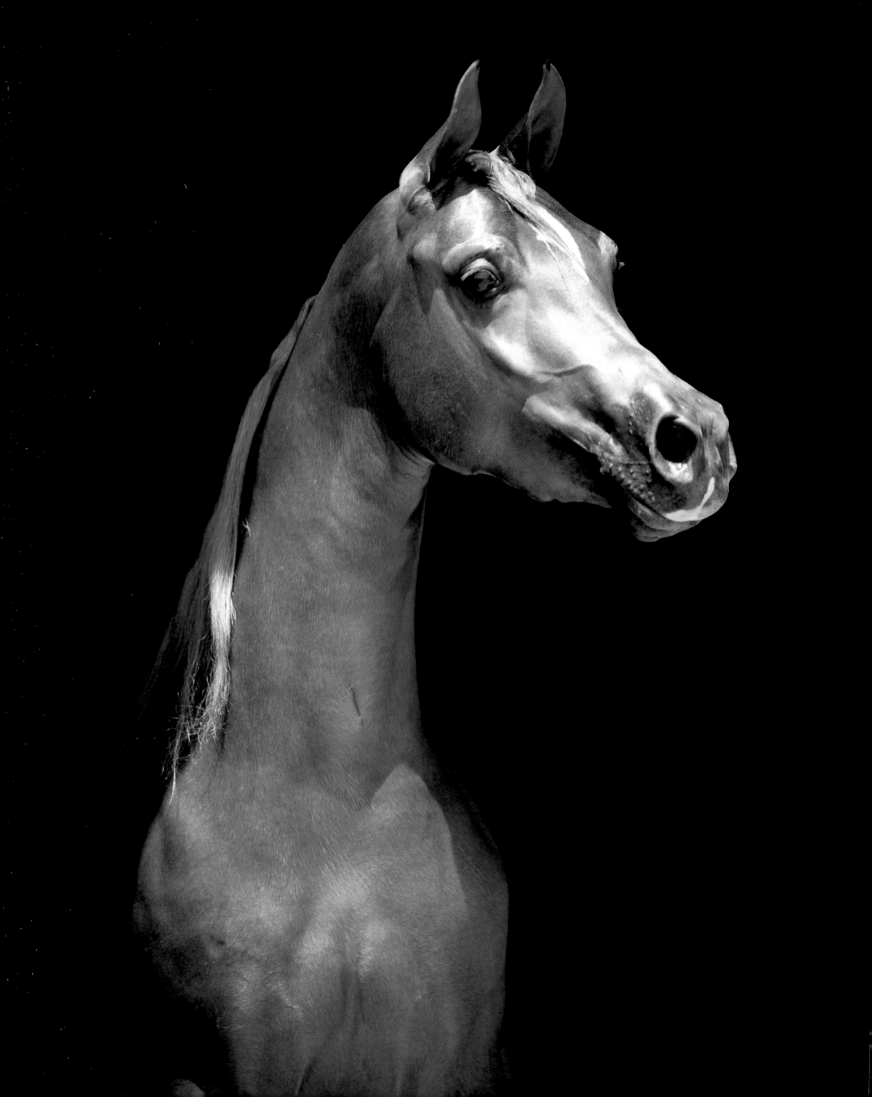

Early promise of stardom at the Four Star Arabians stud farm in Minnesota. RIGHT: Judith Forbis is one of the foremost authorities on the Arab horse and a renowned breeder of Egyptian Arabian bloodlines at her Ansata Arabians stud. BELOW: Champion stallion Aladin at the Taylor Ranch.

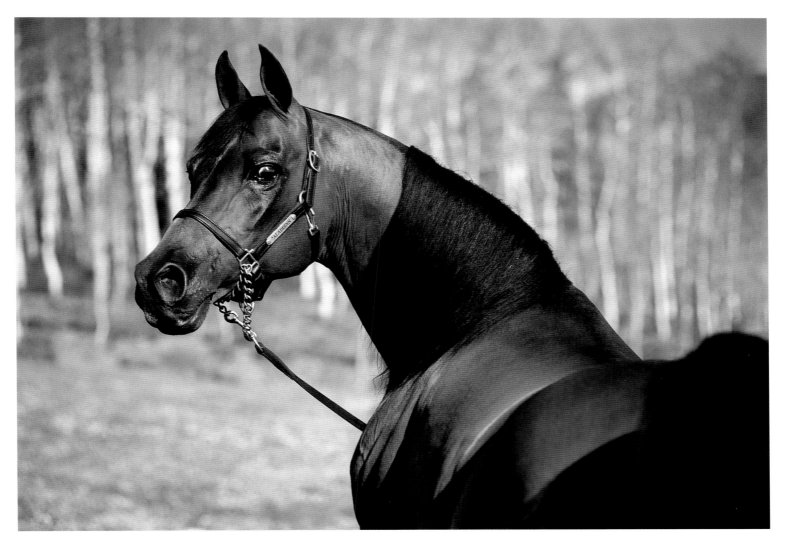

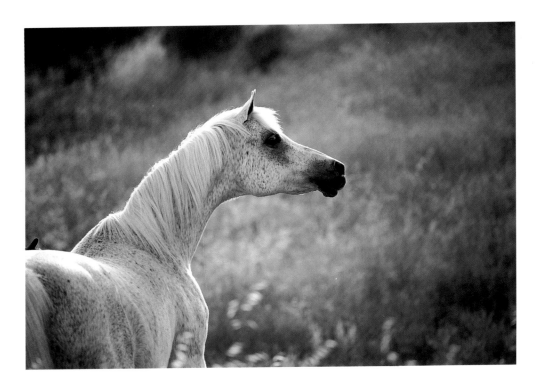

Californian gold. TOP: *Cameo's Jewel at the Rancho Bulakenyo.* ABOVE AND OPPOSITE: *The Arabian horse reaches the Pacific Ocean.*

The build of the Arab is perfect. It is essentially that of utility.
HOMER DAVENPORT, AN AMERICAN DESERT SEEKER AFTER THE ARAB HORSE

*N*orth and South, East and West, the Arabian
conquers America. *ABOVE: Thundering skies create a
magical setting at the Chapel Farm stud in Georgia.
LEFT: Egyptian stallion at the Cabreah Stud in Texas.
OPPOSITE: Poetry in motion, and so much devotion:
the stallion Iemhotep — out of a Pharaonic frieze
sculpted in the USA.*

BRAZIL

Arab horse breeding in Brazil started with horses from Argentina and England, but is today dominated by American imported bloodlines. Brazil must be numbered among the top six countries in the world for the number of Arab horses registered in its stud books.

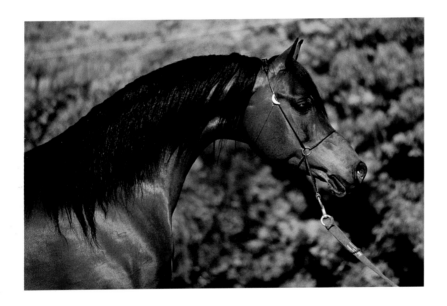

In a little over thirty years, Brazil has become a leading world centre for the breeding of Arabians, the home to such renowned stallions as Ali Jamaal (ABOVE), owned by Señora Maria Helena Perroy. RIGHT: Mare, freedom and the Brazilian sand.

The swiftest of horses is the chestnut;
The most enduring the bay;
The most spirited the black;
The most blessed is he that has a white forehead.
THE EMIR ABD-EL-KADER

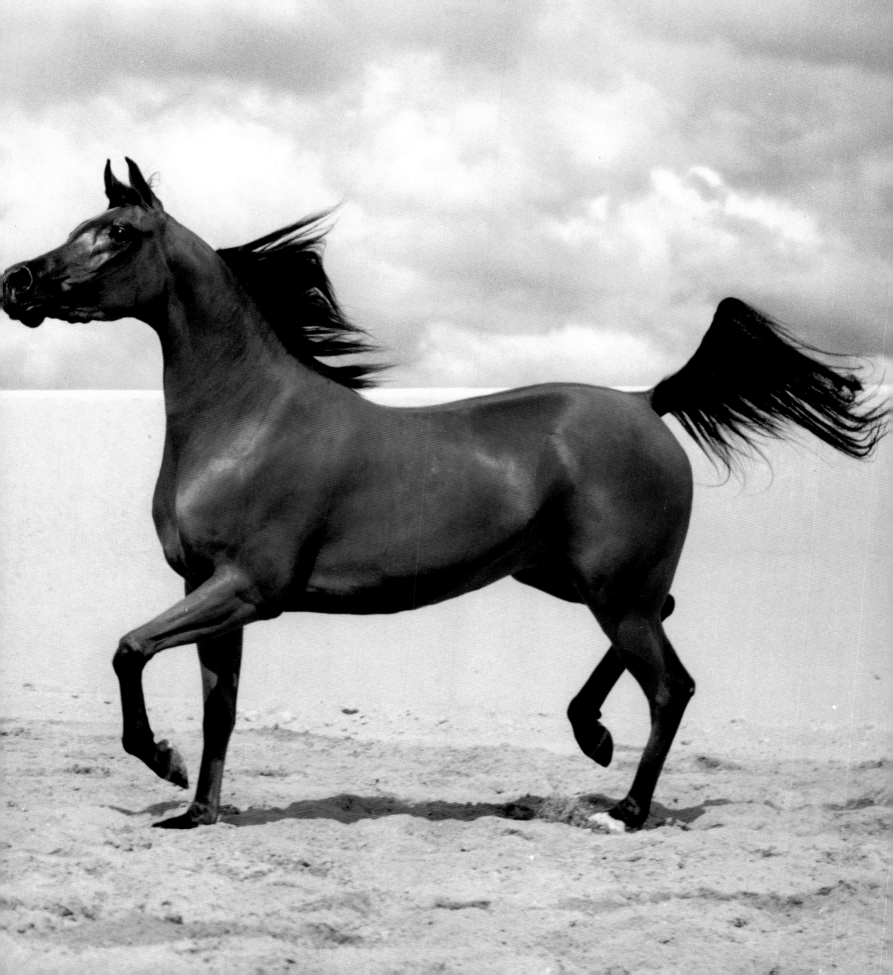

URUGUAY

Uruguay's Arab horses and their breeders are closely associated with those of their neighbour, Argentina. It is interesting to note that in Uruguay, as in other countries in South America, many of the studs use their horses for work on their *estancias*.

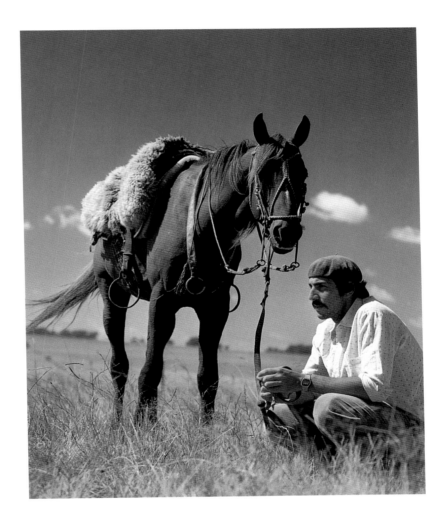

South America's vast grasslands are ideal horse and cattle country and the Arabian has adapted to its new role as the gaucho's sturdy and trusted companion in cattle herding.
ABOVE: *The aboriginal Charrua Indians were a hunter-gatherer people who cared little for outsiders ... except for the Arab horse.*

ARGENTINA

HERNAN AYERZA TRAVELLED TO SYRIA IN 1892 AND RETURNED WITH HIS FIRST ARAB HORSES.

A FURTHER DESERT JOURNEY AND PURCHASES FROM CRABBET PROVIDED THE FOUNDATION

FOR HIS EL ADUAR STUD. DESCENDANTS OF THESE HORSES STILL CONTINUE TO FLOURISH, BUT

MANY OF THE BIG BREEDERS IN ARGENTINA TODAY HAVE TURNED TO NORTH AMERICA FOR

FRESH BLOODLINES.

*Arabians on the pampas herding cattle. RIGHT: Horses and gaucho chasing the waves
of the Atlantic Ocean at Las Cortaderas stud.*

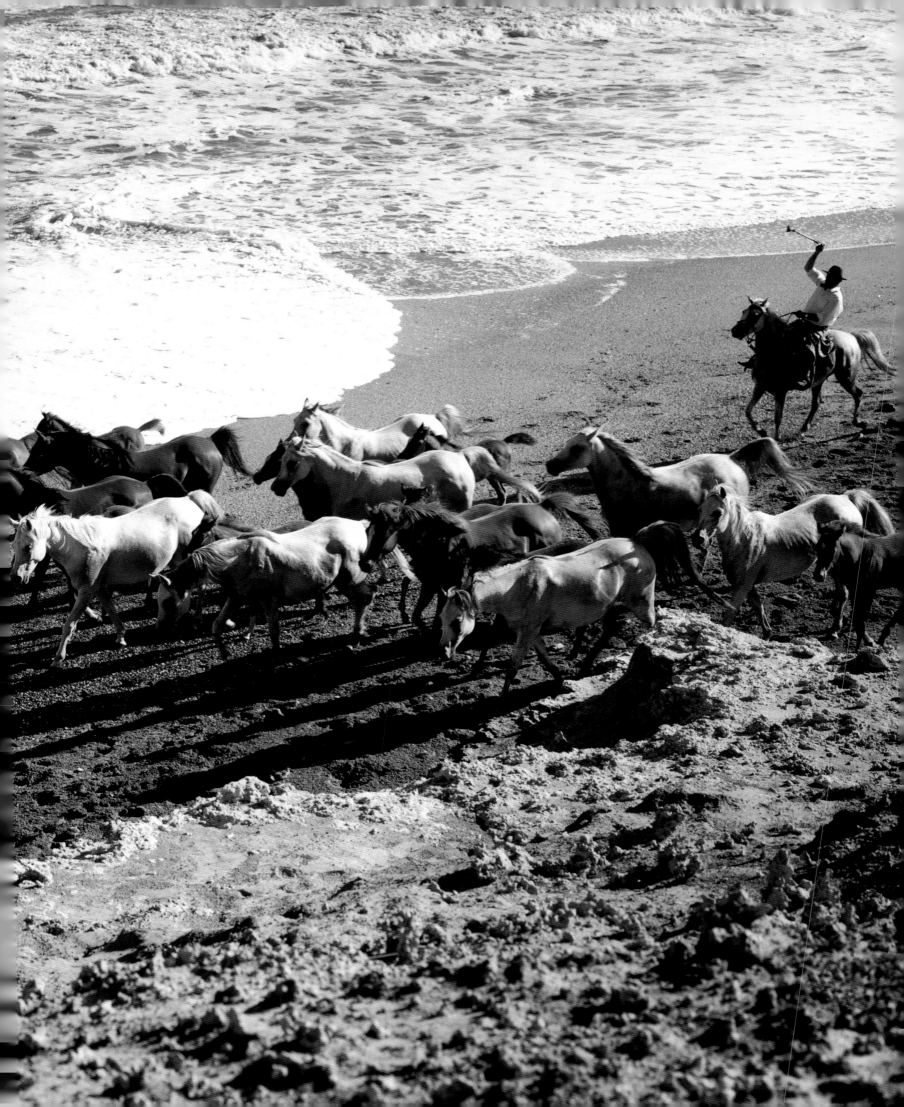

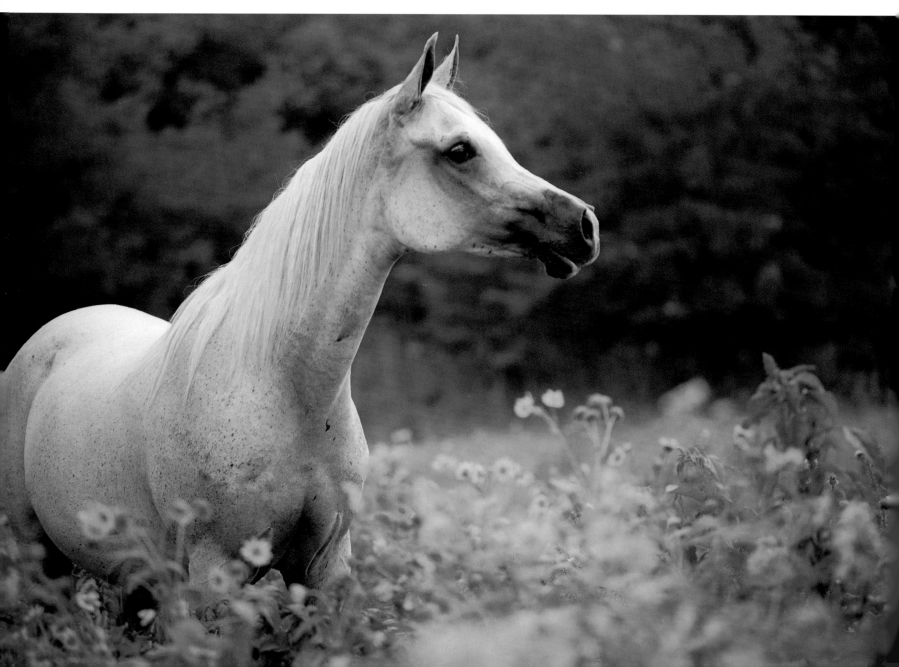

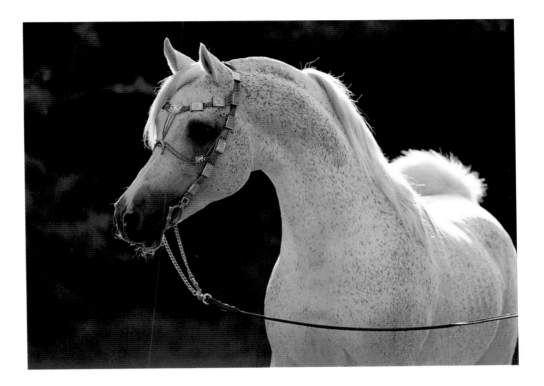

*C*ount Federico Zichy-Thyssen bought his first
Arabian at the age of seventeen and his enthusiasm
has grown ever since, as have the number of his
Arabians. OPPOSITE BELOW: The lovely grey mare
My Zahara at the Mayed stud in Buenos Aires
Province. RIGHT: The truly magnificent World
Champion El Shaklan, Lord of the Estancia and
pride of Count Zichy-Thyssen. BELOW: Yet another
beauty, the mare Silver Kandelei of the Mayed stud.

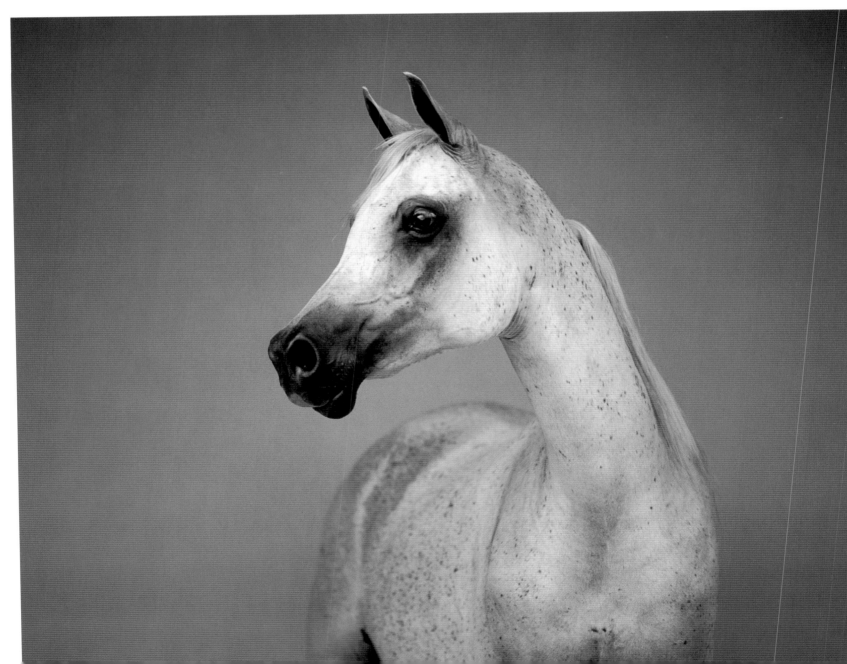

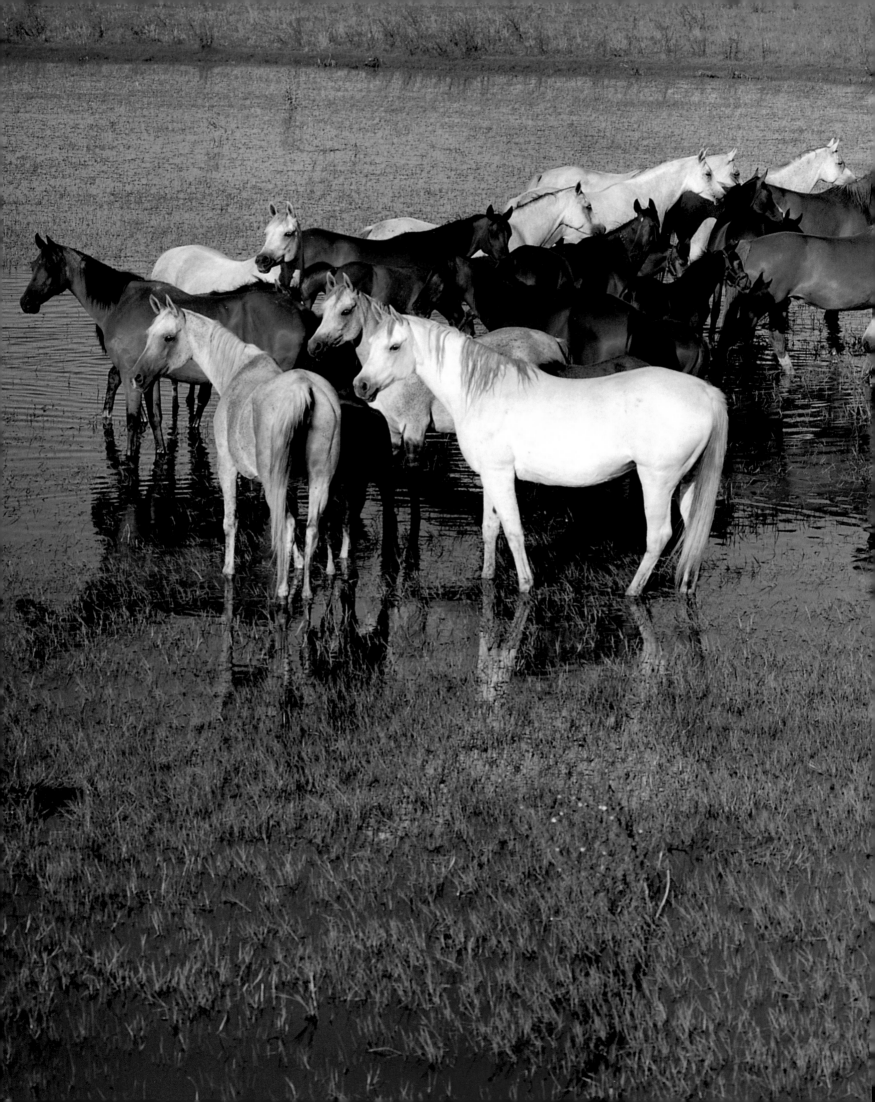

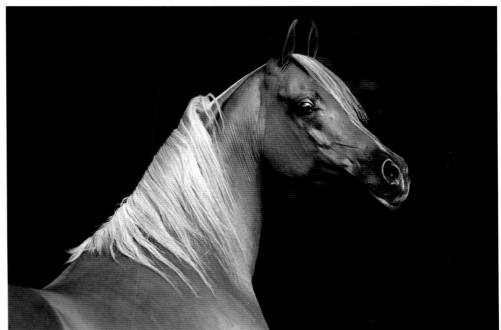

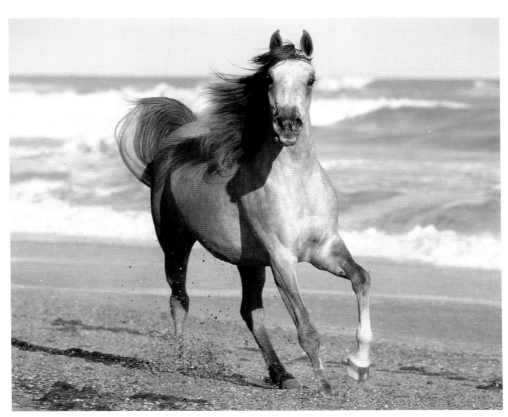

*B*roodmares at La Catalina stud in Buenos Aires Province. TOP: *It's in the genes ... Shayllyn,* *an El Shaklan offspring.* ABOVE: *The mare Alexandria, belonging to Las Cortaderas stud.*

SOUTH AFRICA

SOUTH AFRICA'S ARAB HORSES TODAY DESCEND FROM IMPORTATIONS MADE IN THE 1940S
AND AFTER. MR ORPEN BOUGHT THE STALLION JIDDAN FROM ENGLAND AND LATER
INSTIGATED THE PURCHASE OF SOME ARABS FROM THE ROYAL AGRICULTURAL SOCIETY AND
THE INSHASS STUD IN EGYPT. THE MAJORITY OF IMPORTS, HOWEVER, HAVE BEEN OF ENGLISH
BLOODLINES, AND MORE RECENTLY FROM THE USA.

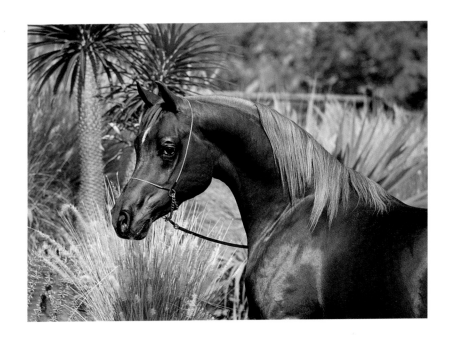

The stallion Halluj of the Minhab Arabian stud near Bloemenfontein.
OPPOSITE ABOVE: *Riding through African bush country at the Johrhremar stud
farm in Klerksdorp.* RIGHT: *Arabians loose in lion and leopard country.*

*And in truth she has ever been to me a precious possession,
born and brought up in our tents.*
YAZID, ARAB POET AND WARRIOR, COMPANION OF THE PROPHET

238

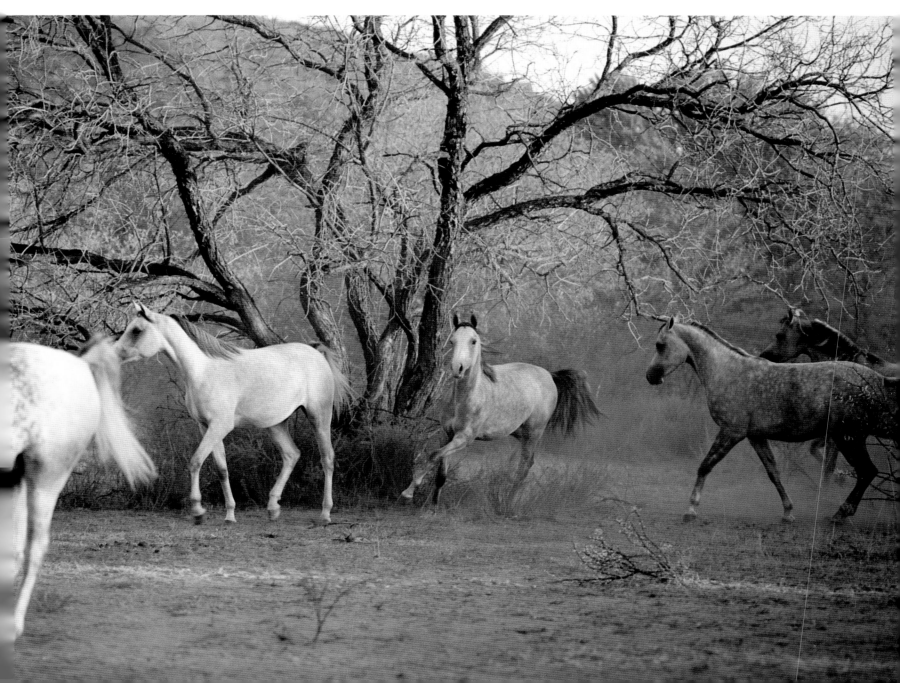

AUSTRALIA

The Arab horse came to Australia with the first European settlers. It became known for speed, stamina and as an improver of all other breeds. Selection for working qualities ensured the maintenance of desert-bred virtues. Today, Australia has the world's second-largest Arab registry and produces world-class Endurance and Show Arabians.

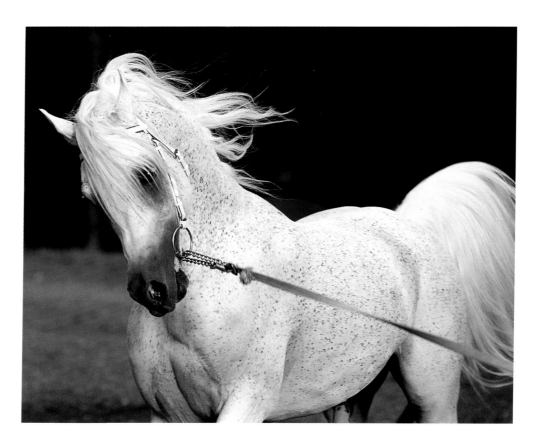

The stallion Asfour, a celebrated sire at the famous Simeon stud.
RIGHT: To fly without wings — the stallion Tristram Jalahd.

The white stallion trumpets to his mares,
His mane is a wave breaking,
His tail a silver waterfall of beauty.
AUSTRALIAN WRITER

*P*ilbara Park Prediction *(TOP)*, a past Australian Champion Colt. *ABOVE:* The mare Zaria.
RIGHT: Broodmares at Mulawa Arabian stud.

Blessed Be Ye O Daughters of the Wind.
THE PROPHET MOHAMMED

242

Belbowrie Wishing Moon and foal investigate a strange object. OPPOSITE BELOW: The stallion courts his mare. RIGHT: Pride and majesty, the stallion Vision.

Have not our horses come to us from our ancestors
And shall we not in turn to our sons bequeath them.
ROBIA EL-KHEYL (C. 50 BC)

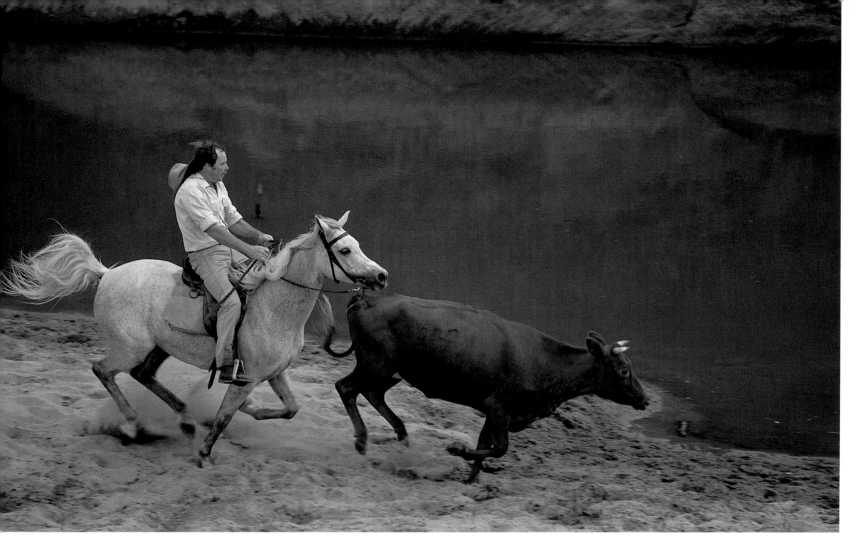

*T*he Australian Arabian is show horse, endurance horse and work horse. Vast sheep and cattle stations provide rider and horse with the chance to roam free while working together.
OPPOSITE ABOVE: *The stallion Hanorr rounding up a beast.*
OPPOSITE BELOW: *An Australian Champion Stallion, Fame Maker R.*
RIGHT: *Noted breeder Marion Richmond of Simeon stud with a young mare.* BELOW: *The stallion Cedardell Shahreza.*

Stars or lightning. Flashes will rise at the pounding of his hooves …
AUSTRALIAN WRITER

… He swalloweth the ground with fierceness and rage.
JOB 39:24

GLOSSARY OF TERMS

abd slave

abu father of

akid war leader of a tribe

asil pure-bred (from *asl* origin)

awaj crippled

banu (also *beni*) plural of *ibn*

Bedouin nomad tribal Arabs, camel and
horse breeders

bey governor of a district in Turkish-held land,
a courtesy title

beyt es-shaar black tent (house of hair)

bint daughter (plural form: *banat*)

el-kebir the older (feminine: *el-kebira*)

el-saghir the younger, smaller
(feminine: *el-saghira*)

emir king

faras mare

ghazu raid

haj pilgrimage to Mecca

hamad the great Syrian desert

hojjah certificate of pedigree

ibn/bin (also *ben*) son of

imam religious leader

jebel mountain

jibbah prominence of forehead

kadish impure

khamsah five

khedive title of Turkish viceroy of Egypt

Mamelukes Ottoman military caste

mitbeh arch of throat

Nejd central plain of Arabia

pasha Turkish governor; also a title of
respect

sheikh chief of a tribe; also a title of respect

sherif descendant of the Prophet Mohammed

sultan ruler of a Moslem state

COLOURS

masculine	feminine	
abrash	*barsha*	red
adham	*dahma*	dark brown
ahmar	*hamra*	red bay
asfar	*safra*	white
ashgar	*shakra*	chestnut
aswad	*sauda*	black
azrek	*zerka*	blue grey
maa wardi	*maa wardi*	rose grey

THE GREAT HORSE-BREEDING TRIBES OF ARABIA

THE ANAZEH TRIBES

The Anazeh tribes of northern Arabia owned camels and mares; they were a great confederation stretching from Aleppo in the north to Jebel Shammar in the south. Groups within the confederation included:

The Sebaa, including the Gomussa (Ibn Mirshid); the Resallin (including Misrab Abadat); Duam Mesekha (Ibn Kardush); Moayaya (Ibn Hedeb); Amarat (Ibn Haddal). This wealthy tribe possessed the best horses and were situated northeast of Damascus to Dayr az-Zor.

The Roala, including Jelaas (Ibn Shaalan). This was the most powerful tribe of the desert, inhabiting the northern desert, south of Damascus.

The Fedaan, including Mehed (Ibn Sbeyni); Shmeylat Ajajera Khrysa (Ibn Keshish). The Fedaan were a warrior tribe south of Aleppo.

The Wuld-Ali (Ibn Smeyr), an ancient tribe.

The Ibn Haddal (Ibn Hemasdi), a large and powerful tribe.

The Ibn Hesenneh (Ibn Meziad).

THE SHAMMAR TRIBES

The Shammar, including Jerba (Ferhan Ibn Sfuk); Saekh Ghaet.

Allies of the Shammar included the Zoba (Al-Hamoud), situated in Mesopotamia; Haddadin (Ibn Worshan); Tai (Abd al-Rahman); Jess Albu Hamid; Jiburi; Ajauri; Jerifa; Baggara.

OTHERS

The Ajman (Ibn Hithlain), found east of Riyadh to the Gulf.

The Qahtan (Ibn Hadi, including Banu Hajar), most southerly of the horse-breeding tribes.

The Muteyr (Al-Dawish), situated south of Hail.

The Muntifik (Ibn Saadun). A powerful tribe inhabiting Iraq, on the right bank of the Euphrates below Hillah.

The Oteybeh (Ibn Naeydha), found east of the Harb in the central desert.

The Banu Khaled (Al-Ajran).

The Banu Hussein (Al-Nejib).

The Dhafir (Ibn Sueyti), situated around the Shatt al-Arab, Mesopotamia.

The Banu Sakr (Ibn Haditha; some say the Banu Sakr are of the Anazeh).

The Majali (Al-Majali).

The Harb (Ibn Mutib), situated about Medina.

STRAINS OF THE ARABIAN HORSE

KEHILET
- ajuz
- abu jenub
- ahdab sundah
- akhras
- amayur
- anz el derwish
- arnabieh
- azbarieh
- bayarieh
- dajjanieh
- dhibyah
- dukhieh
- el abbadieh
- el athir
- el dunais
- el ishi
- el krushieh
 - krushieh el ghandur
- ghazalieh
- halawieh
- hallujieh
- hedilieh
- heifieh
- harkah
- humatieh
- jawish
- jaisi jaisi
- jellabieh
- jenah el teyr
- johariah
- kawwalieh
- keniah
- khamsieh
- kharas
- kurs
 - umayr
 - zefifi
- mesenneh
- mehayet
- mimreh
 - hallibieh
 - muabhaliyah
- milhah
- mindal
- mindakhieh
- mirreh
- muhid
- mukhalladiah

- musonieh
- muyil
- naufalieh
- naij
- nowagieh
 - nowagieh debbe
- om jereys
- om ma'ariff
- om sura
- ra'ha roaha
- ras el fedawi
- rodanieh
- shawafieh
- sheneynah
- sherif
- shilu
- sheyka el sheikh
- shuaila
- suwaitieh
- tamri
 - tamri sharji
- tehiran
- treyshi
- um argub
- umayr
- wadnat khursanieh
- zakub
- ziada
- zibberieh
- zorayr

SEGLAWIEH
- araj
- arjebi
- as'af
- daalan
- dalia
- el abd
- el sakt
- injemi
- ibn dureyba
- jerba
- jedranieh
- marighieh
- nejmet es subh
- obeyri
- rimalieh
- sheyfieh
- sudanieh

DAHMEH
- kunayhir
- mejelli
- nejiba
- om amr
- shahwanieh

HAMDANIEH
- jiflieh
- simrieh

HADBAH
- al mahdieh
- enzahi
 - mushaitib
 - el ferd
 - el zaiti
- el dahirieh
- hakshah
- ibn zahmul
- jawlah
- jafil

ABEYEH
- abu jereys
- al dasim
- dahwa
- durajiyah
- el hudr
- hadfeh
- hunaydis
- hurma
- kharishyeh
- obeyd
- shuwaiyiri
- sherrakieh
- suhaimieh
- tamhur

MANAGIEH
- giddili
- hedrujieh
- ibn sbeylieh
- sidli
- slajl

SHUEMAH
- sabbah
- zahi

TUWAISAH
- alkami
- kiad

RISHEH
- arjasi
- sherabi

SA'DAH
- haub
- togan

SAMHAH
- el gomeya
- hafi

JILFEH
- duhwa
- jad'allah
- stam el bulad

RABDAH
- kesheybah
- zalla

MILWAH
- sharbah

MELEYHAH
- jereybah
- treyfi

MAWAJ
- hammad

MLOLESH

KRAY

KUBEYSHAH
- el omeyr
- zefifieh

ARABIAN HORSE ORGANIZATIONS, REGISTRIES AND SOCIETIES

WAHO (World Arabian Horse Organization)
Executive Secretary WAHO, 1 Kembro Fields, Foxley Road, Malmesbury, Wiltshire SN16 0JF, United Kingdom

ECAHO (European Conference of Arab Horse Organizations)
General Secretary ECAHO, Entenstrasse 20, D-73765, Neuhausen, Germany

ALGERIA: Office National de Développement des Elevages Equins, 8 Rue Amrani Benaouda, 14000 Tiaret
ARGENTINA: Stud Book Argentino, Cerrito 1446-2, Buenos Aires Asociación Argentina de Criadores de Caballos Arabes, Tucuman 731-1 No. 2, Cuerpo 1049, Buenos Aires
AUSTRALIA: The Arabian Horse Society of Australia Ltd, Locked Bag No. 6, Windsor, NSW 2756
AUSTRIA: Verband der Vollblutaraberzüchter Österreich, Grubgütl, Wankham 7, A-5302, Henndorf am Wallersee
BAHRAIN: Amiri Arabian Stud of Bahrain, Crown Prince Court, PO Box 29199, Manama
BELGIUM: Belgisch Arabisch Paardenstamboek, Houterstraat 11, B-3620, Gellik-Lanaken
BELIZE: Belize Arabian Stud Book, PO Box 12, Beimopan
BRAZIL AND PARAGUAY: Associacão Brasileira dos Criadores do Cavalo Arabe, Av. Francisco Matarazzo No. 455 Pav. 11, 05031-900 São Paulo, SP, Brazil
CANADA: Canadian Arabian Horse Register, 801-4445 Calgary Trail South, Edmonton, Alberta TGH 5R7
CHILE: Sociedad de Fomento Agricola de Temuco, Avenida San Martin 838 Casilla 980, Temuco
COLOMBIA: Asociación Colombiana de Criadores de Caballos Arabes, Carrera 11 No. 82-01 Piso 6A, Centro Andino de Negocios, Lima, Peru
COSTA RICA: Costa Rican Arabian Horse Association, PO Box 666, Lancaster, Ohio 43130, USA
CZECH REPUBLIC: Association for Pure-bred Arabian Horses (ACHPAK), PO Box 60, 460 01 Liberec 1
DENMARK: Dansk Selskab for Arabisk Hesteavl, Hornbaekvej 666, Bistrup, 31 Hornbaek
EGYPT: Egyptian Agricultural Organization, Arabian Horse Breeding Administration, PO Box 63, Cairo 11511 The Arabian Horse Association of Egypt, 248 King Feisul Street, Al Haram, Giza
FINLAND: Finnish Arabian Horse Society, Niitykatu 7, SF-10600, Tammisaari
FRANCE: Service des Haras – SIRE, BP No. 3, 19231, Arnac-Pompadour CEDEX Association Française du Cheval Arabe, La Masselle, 30170, Saint Hippolyte du Fort
GERMANY: Verband der Züchter des Arabischen Pferdes, Bissendorferstrasse 9, D-30625, Hannover
HUNGARY: Babolna Co. No. Agricultural Combine, H-2943 Babolna, Meszaros
IRAN: Department of Equine Sports and Breeding, PO Box 17185-1171, Tehran
IRAQ: Iraqi Arabian Horse Organization, Al Mansour, PO Box 6016, Baghdad
ISRAEL: Israel Arab Horse Registry, Isan Center, Ben Gurion University, PO Box 653, 84105 Beer-Sheva
ITALY: Associazione Nazionale Italiana del Cavallo Arabo (ANICA), Viale Libertà 23, 43044, Collecchio (Parma)
JORDAN: The Royal Jordanian State Stud, The Royal Palace, Amman
KUWAIT: Hunting and Equestrian Club, PO Box 22436, Safat 13085

LEBANON: Society for the Protection and Improvement of the Arabian Horse in Lebanon, Hippodrome de Beyrouth, Avenue Fouad 1, Beirut
LIBYA: see Morocco
LITHUANIA: Lithuanian Horse Breeders' Association, Gedimino pr. 19, 2025, Vilnius
MOROCCO AND LIBYA: Chef de la Division des Haras, Ministère de l'Agriculture et de la Mise en Valeur Agricole, 25 Avenue des Alaouyines, Rabat, Morocco
THE NETHERLANDS: Arabische Volbloedpaardenstamboek in Nederland, Postbus 40306, 3542 AC, Utrecht
NEW ZEALAND: New Zealand Arab Horse Breeders Society Inc., PO Box 345, Manurewa
NORWAY: Norwegian Arab Horse Society, Brurbergveien 17, 3400, Lier
OMAN: The Royal Stables, PO Box 1070, Seeb International Airport
PARAGUAY: see Brazil
POLAND: The Agricultural State Property Agency, Horse Breeding Department, Ul. Wspolna 30, 00-930, Warszawa Polish Arabian Horse Breeding Society (PAHBS), Stadnina Kone w Janowie Podlaskim, 21.505, Janow Podlaski
PORTUGAL: Associacão Portuguesa de Criadores de Racas Selectas, 2 Rua D. Dinis, 1200, Lisboa
QATAR: Qatar Arabian Horse Registry, Race and Equestrian Club, PO Box 7559, Doha
ROMANIA: Autonomous Administration for Horse Breeding, 4 Blvd. Ion Ionescu de la Brad, Sect. 1, COD 71592, Of P 18, Bucharest
RUSSIA: The Russian Arabian Stud Book, c/o Rosplemconzavod, 3A Orlikov per, 107139 Moscow
SAUDI ARABIA: Arabian Horse Centre, PO Box 33840, Riyadh 11458
SLOVAKIA: Narodny Zrebcin, Topolcianky, Parkova 13, 951 93 Topolcianky
SOUTH AFRICA: The Arab Horse Society of South Africa, PO Box 14554, Bredell 1623
SPAIN: Comision del Registro Matricula (SBE), Paseo de Extramadura 445, 28024, Madrid Asociación Española de Criadores de Caballos Arabes, Hermosilla 20, 28001, Madrid
SWEDEN: Swedish Arab Horse Registry, Box 47, S-24521, Staffanstorp
SWITZERLAND: Schweizer Zuchtgenossenschaft für Arabische Pferde, Spitzstrasse 12, CH-8155, Niederhasli
SYRIA: Ministry of Agriculture and Agrarian Reform (MAAR), Al Jabri Street, Damascus
TUNISIA: Fondation National d'Amélioration de la Race Chevaline, 2020, Sidi Thabet
TURKEY: Ministry of Agriculture, Tarim Orman Ve Koyisleri Baskanligi, Yuksek Komiserler Kurulu Baskanligi, Akay Cad 15/4, Ankara
UNITED ARAB EMIRATES: Emirates Arabian Horse Society, PO Box 26888, Abu Dhabi
UNITED KINGDOM: The Arab Horse Society, Windsor House, Ramsbury, Wiltshire SN8 2PE
USA: The Arabian Horse Registry of America Inc., 12000 Zuni Street, Westminster, Colorado 80234 International Arabian Horse Association, 10805 East Bethany Drive, Aurora, Colorado 80014
URUGUAY: Sociedad de Criadores de Caballos Arabes, Juan Carlos Gomez 1255 esc. A, Montevideo 11000
VENEZUELA: Asociación Venezolana de Criadores de Caballos Arabes, Calle Atarigua, Qta Malu, Urb el Pedregal, Barquisimeto Edo Lara 3001
ZIMBABWE: Arab Horse Society of Zimbabwe, PO Box 6043, Morningside, Bulawayo

BIBLIOGRAPHY

Ali, Prince Mohammed, *Breeding of Pure-bred Arab Horses,* Paul Barbey's Printing Office, Cairo, 1935

Archer, R., *The Versatile Arabian Horse,* J. A. Allen, London, 1996

Archer, R., Pearson, C. and Covey, C., *The Crabbet Arabian Stud, its History and Influence,* Alexander Heriot and Co., Northleach, Glos., 1978

Blunt, Lady A., *Bedouin Tribes of the Euphrates,* John Murray, London, 1879

Blunt, Lady A., *A Pilgrimage to Nejd, The Cradle of the Arab Race,* John Murray, London, 1881

Borden, S., *The Arab Horse,* Borden Publishing Co., California, 1906

Brown, W.R., *The Horse of the Desert,* The Macmillan Co., New York, 1948

Brown Edwards, G., *The Arabian War Horse to Show Horse,* The Arabian Horse Trust of America, Colorado, 1969

Burckhardt, J.L., *Travels in Arabia,* Henry Colburn, London, 1829

Burckhardt, J.L., *Notes on the Bedouins and Wahábys,* H. Colburn & R. Bently, London, 1830

Craver, C., *Al Khamsa Arabians,* Thrift-Remsen, Illinois, 1983

Daumas, E., *The Horses of the Sahara* (9th edn, translated by S. M. Ohlendorf), University of Texas Press, Austin, 1968

Davenport, H., *My Quest of the Arabian Horse,* B. W. Dodge & Co., New York, 1909

de Moros, L., *En busca del caballo arabe,* Comision a Oriente, Noticias SA, Madrid, 1993

Doughty, C. M., *Travels in Arabia Deserta,* Cambridge University Press, Cambridge, 1888

Forbis, J., *The Classic Arabian Horse,* Liveright, New York, 1976

Gibbon, E., *The History of the Decline and Fall of the Roman Empire,* London, 1776–88

Guarmani, C., *Northern Nejd, Journey from Jerusalem to Anaiza in Kasim,* Press of the Franciscan Fathers, Jerusalem, 1866

Hamont, P. N., *Egypte depuis la conquête des Arabes sous la domination de Mehemet Aly,* Paris, 1847

Hecker, Dr W., *Babolna und seine Araber,* ISG Verlag, Graz, 1993

Lawrence, J., *The History and Delineation of the Horse,* London, 1809

Lawrence, T. E., *Revolt in the Desert,* Jonathan Cape, London, 1927

Lawrence, T. E., *Seven Pillars of Wisdom. A Triumph,* Jonathan Cape, London, 1935

Longford, E., *A Pilgrimage of Passion. The Life of Wilfrid Scawen Blunt,* Weidenfeld & Nicolson, London, 1979

Moray-Brown, J., *Riding and Polo,* Longmans, Green & Co., London, 1891

Niebuhr, C., *Travels through Arabia,* translated by R. Heron, Edinburgh, 1792

Palgrave, W. G., *Personal Narrative of a Year's Journey through Central and Eastern Arabia,* MacMillan Ltd, London, 1865

Schiele, E., *The Arab Horse in Europe,* Borden Publishing Co., California 1970

Upton, Major R., *Newmarket and Arabia,* King and Co., London, 1873

Upton, Major R. *Gleanings from the Desert of Arabia,* Kegan Paul & Co., London, 1881

Wentworth, Lady, *The Authentic Arabian Horse and his Descendants,* Allen & Unwin, London, 1945

Wrangel, A., *The Arabian in Arabia,* J. A. Allen, London, 1962

Youatt, W., *The Horse,* Longman Green, London, 1861

INDEX OF HORSES

INDEX OF PEOPLE, PLACES, SOCIETIES, STUDS AND TRIBES

Tabuk 112
Tadmor *see* Palmyra
Tahawi, the 42
Tai, the 49
Tankersley, Bazy 73
Tasmania 74
Taylor Ranch stud *217, 223*
Tell-El-Keladi 59
Tersk stud 44, 54, 57, 62, 64, 69, 72, 80, 194; *194, 196*
Texas 73; *221, 226*
Thaj *46*
Thebes *12*
Thistlewood Farm *219*
Thomas, Bertram *112*
Tigris River 52
Tihama 86
Toledo 61; *164*
Tomolillo 63
Toussan (second son of Mohammed Ali the Great) 34
Travellers Rest Farm 72
Trouncer, Thomas 42, 46
Troye, Edward 70
Tryon, Admiral 67
Tunisia *169*
Turba, battle of 48, 49
Turkey 12, 53, 54, 76; *45*
Turkey, Sultan of 47, 60

Ubayda 28
Uhlen, Bertil 63
Umm Qarn stud 52
United Arab Emirates 7, 50, 83, **94–111**
United Kingdom (England/Great Britain) 20, 22, 30, 38, 43, 44, 45, 46, 47, 51, 52, 53, 60, 61, 62, 66, 70, 74, 75, 76, 77, 78, 80, 82, 106, 174, **208–15**, 217, 228, 238; *21, 37*
United States of America 40, 41, 42, 44, 47, 51, 52, 57, 63, 64, 68, 69, 71, 72, 73, 75, 76, 77, 80, 82, 83, 156, 200, 205, **216–27**, 232, 238
Upton, Major Roger 15, 19, 21, 29, 32, 33, 74, 78
Urfa 53
Uruguay 76, 77, **230–31**
Utah *217*

Valdes, Christina (daughter of the Duke of Veragua)*166*
Valjuanetes stud *166*
Veragua, Duke of (Cristóbal Colón XV) 61, 69, 77; *166*
Veragua stud 61
Vernet, Carl *35, 45*
Vernet, Horace *4, 35*
Vesey, the Hon. Eustace 67
Victor Emanuel, King of Italy 36

Victoria, Queen of England 49, 60; *62*
Vienna *54*
Virgil *172*
Vlinkfontein stud 76
Volkers, Emil 36

Wadi Araba *140*
Wadi Auf *91*
Wadi Rum *144*
Wahhabis, the 34
Wail 13
W-Arabians stud *211*
Washington, George, President of the USA 9
Washington, Georges *18, 20, 29*
Watts, Charlie and Shirley *209, 214*
Wehrmacht 72
Weil stud 36, 40, 58, 60, 80, 178; *59*
Wellington, Duke of 74
Wentworth, Lady 44, 68, 69, 71, 72, 73; *39, 69, 70*
Weydan al-Barbari 44
Wheeler, John Alfred 66
White Desert *147*
Wilhelm I, King of Württemberg 36, 60, 178; *59*
Wilhelm II, King of Württemberg 60
Wilhelmina, Queen of the Netherlands 168

William IV, King of England 60
Winans, Walter 68
Windsor Castle 37
Winter-Cooke, the Hon. Samuel 75
Wootton, John 30
World Arab Horse Organization (WAHO) 64, 80
Wrangel, Alexis 83
Wuld-Ali, the 13, 16, 17, 56
Württemberg 36, 60, 178

Xanadu *221*

Yazid 21, 209, 238; *75*
Ybarra family *163*
Ybarra, Don Luis de 61; *160*
Yeguada Domecq-Ybarra *164*
Yeguada Estiviel *164*
Yeguada Militar 61, 160; *160, 163*
Yemen (Sabaa) 12, 13, **86–89**

Zabeel stables 51; *106*
Zarmah *91*
Zenobia, Queen *136*
Zichy-Thyssen, Count Federico 77; *235, 237*
Zietarski, Bogdan von 56, 59, 77
Zoba, the 52
Zubara 47

Waclaw Pawliszak, Capturing the Banner, *c. 1900.*
One of the true Sherribah el-Rech *(Drinkers of the Wind).*